# BEATLES ART
## Fantastic New Artwork of the Fab Four

*Edited By:* LINDA Webb & JEFFREY Webb

First Edition, 2006

Boxigami Books
DUNLAP, ILLINOIS

# BEATLES ART
## Fantastic New Artwork of the Fab Four

Copyright © 2006 by Boxigami Books
PO Box 340
Dunlap, IL 61525
USA

www.boxigami.com

ISBN: 0975417622

Library of Congress Catalog Card Number: 2006923528

Printed in Korea

First Printing: August 2006

Publisher's Cataloging-in-Publication
(Provided by Quality Books, Inc.)
      Beatles art : fantastic new artwork of the fab four. -- 1st
    ed.
      p. cm.
      Includes index.
      ISBN-13: 978-0-9754176-2-1
      ISBN-10: 0-9754176-2-2

      1. Beatles--Pictorial works.  2. Beatles--Social
aspects--Pictorial works.  3. Rock musicians--England--
Pictorial works.

    ML421.B4B4136 2006        782.42166'092'2
    QBI06-600031

Boxigami Books

# BEATLES ART

## Fantastic New Artwork of the Fab Four

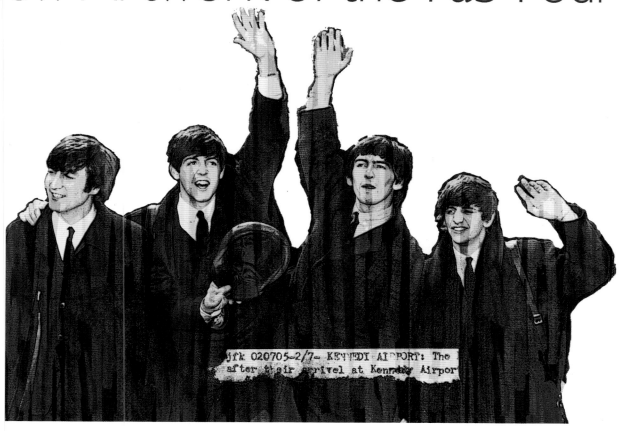

jfk 020705-2/7- KENNEDY AIRPORT: The
after their arrival at Kennedy Airpor

*Edited By:* LINDA Webb & JEFFREy Webb

**Boxigami Books**

DUNLAP, ILLINOIS

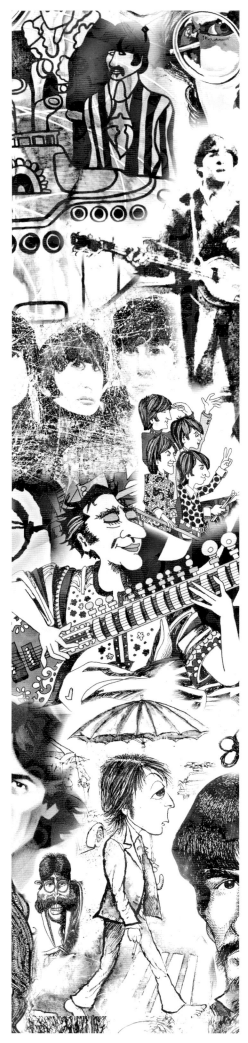

# FORWARD By Jock Bartley

It's no secret. The Beatles are the best rock and roll band ever. They were back then, they are today and will always be. Paul, John, George and Ringo changed the entire world and human experience like no other group could ever hope to.

First came Beatlemania, that cultural shock wave of mop tops, Beatle boots and "yeah yeah yeah." Those early days of hysteria and unparalleled chart-topping success set the stage. But it was the songs, those wonderful and amazing recordings between 1965 and 1969, that made The Beatles the greatest band ever. Each of those Beatle songs border on and sometimes exceed perfection. No longer were they simply made up of chords and chord progressions, verses and choruses. No longer was it just guitar parts, drum beats and great singing. Those individual recorded sounds became integral components of a pristine and magnificent whole. Each of those Beatle songs is a vivid painting, a unique landscape of delicious colors, textures and passions that allows you to be taken somewhere else. Listen to "Strawberry Fields Forever" or "Within You Without You" or "Taxman" or "A Day In A Life" or "Eleanor Rigby" or "Blue Jay Way." Those are not just well-written songs: They are emotionally powerful experiences, magical journeys. The genius of the songwriters was married to the recording magic that George Martin and the Fab Four produced. Together they created astonishing vistas no one had ever heard or seen before.

The Beatles invited you into an absolutely new world, one that had not existed until they created it. Many of their songs transcend music. In my opinion, a number of their songs are among the most significant works of art and inspiration ever created. And yet, they were just being who they were: fun-loving, irreverent, talented, young, working-class guys who were quite surprised they had taken the world by storm. In the calm eye of that storm, in the recording studio, George Martin, as no other producer of a musical group had before, allowed the lads total freedom to experiment and playfully explore. As the band's originality soared, he and his technical staff were constantly challenged to keep up. No one had ever recorded like that before. His team had to invent new devices and recording techniques on the spot: Major recording advances happened sometimes overnight. And what sensational music they made! We couldn't get enough.

They mirrored the world and at the same time, led it. We came of age with The Beatles. We lived with them through all their experimentations. They set trends and broke them. The fabric of society had been moved. And throughout, their overriding message was "love".

I'm a guitarist. I'm also a painter. I am blessed to have a few different ways my own creative juices can manifest and flow. At times, it's like being swept along in a river of childlike wonder and discovery. The Beatles helped show me that. I learned how to sing harmonies with The Beatles; I learned how to formulate guitar solos. As a late-blooming songwriter and lyricist, I'd learned early on from the masters: John, Paul and George.

Looking back, two events dramatically changed my life when I was barely a teenager. The first was the Ed Sullivan show on February 9, 1964. Any young person who saw that program and lived through the early Beatle years was different, somehow more receptive and hip, more cognizant of the world around them. In black-and-white television, that night rocked America as no other.

The second event happened to me a few years later when, as a classically and jazz-trained young guitarist who had just joined his first rock band, I heard Eric Clapton's solo on Cream's, "I Feel Free". In those few moments, the heavens open up for me. Suddenly, that was possible! Soloing free like that was what I wanted to do. Both were life-changing events for me – a metamorphosis, an awakening. And now, every time I hear "While My Guitar Gentle Weeps" and sink into that incredible and emotional painting, well...

The music of The Beatles connected on a very deep level to artists and non-artists everywhere. Subconsciously, people knew those songs were like evocative paintings or little movies, exciting visual stories told by mysterious storytellers that took the listener somewhere else. Everybody wants to be transported somewhere else, especially if they can be gone for three or four minutes—and come back refreshed! Simply, that was and is The Beatles.

The artwork in this book has been inspired by Beatles music. These varied images are bold and colorful, playful and serious. The artists within have put their soul and heart into these works. This book is a glimpse at how other people have translated the feelings that "the best band ever" gave them. None of these pieces assumes anything, nor attempts to do anything for the beholder. None try to be "great." They were inspired by true greatness.

It's a huge and humbling honor to have been asked to write this foreword. I was exhilarated and apprehensive. What could possibly be written? That I still miss George and John very much? That George Harrison's death was much more devastating to me that I would've guessed it would be? Last month at a truly fantastic Paul McCartney concert, I found my tears flowing a number of times during the show. This morning I'm reveling in three CDs back to back – Rubber Soul, Revolver and Sgt. Pepper's. It's wonderful to have The Beatles' musical legacy so close at hand, to have their incredible paintings to jump into. Thank you, gentlemen. You continue to enrich our lives.

Jock Bartley / Firefall

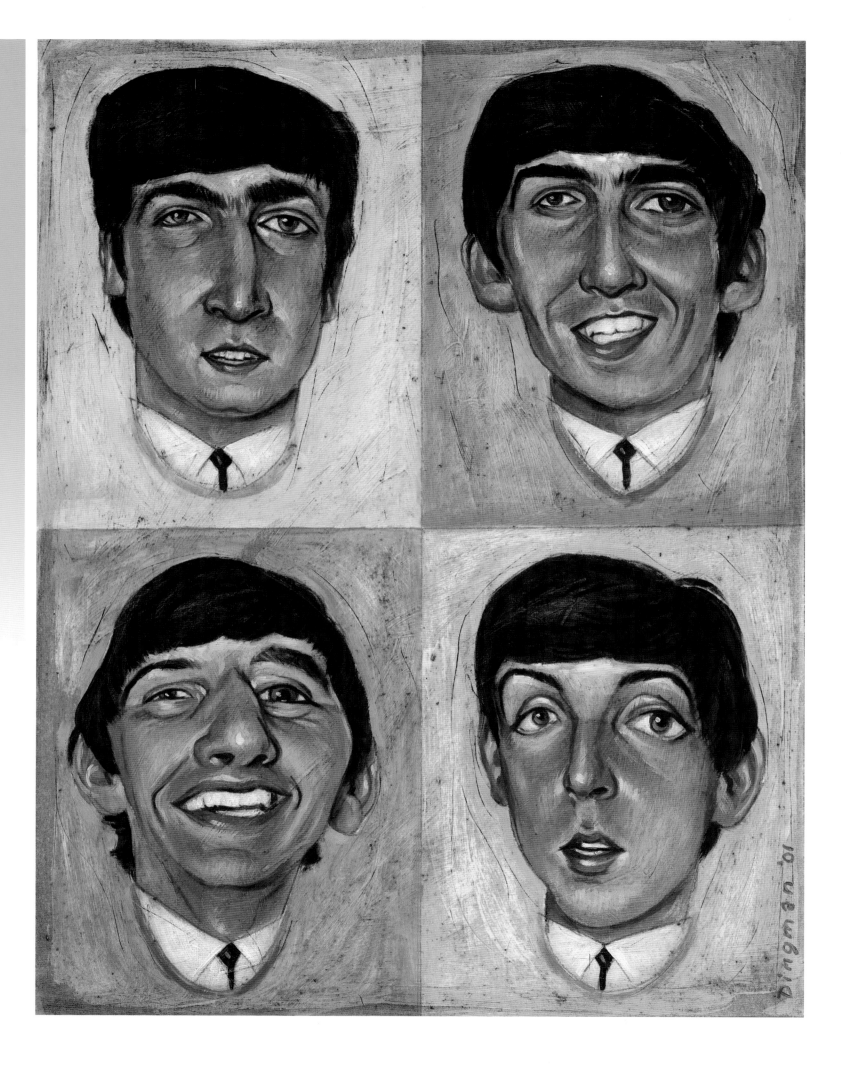

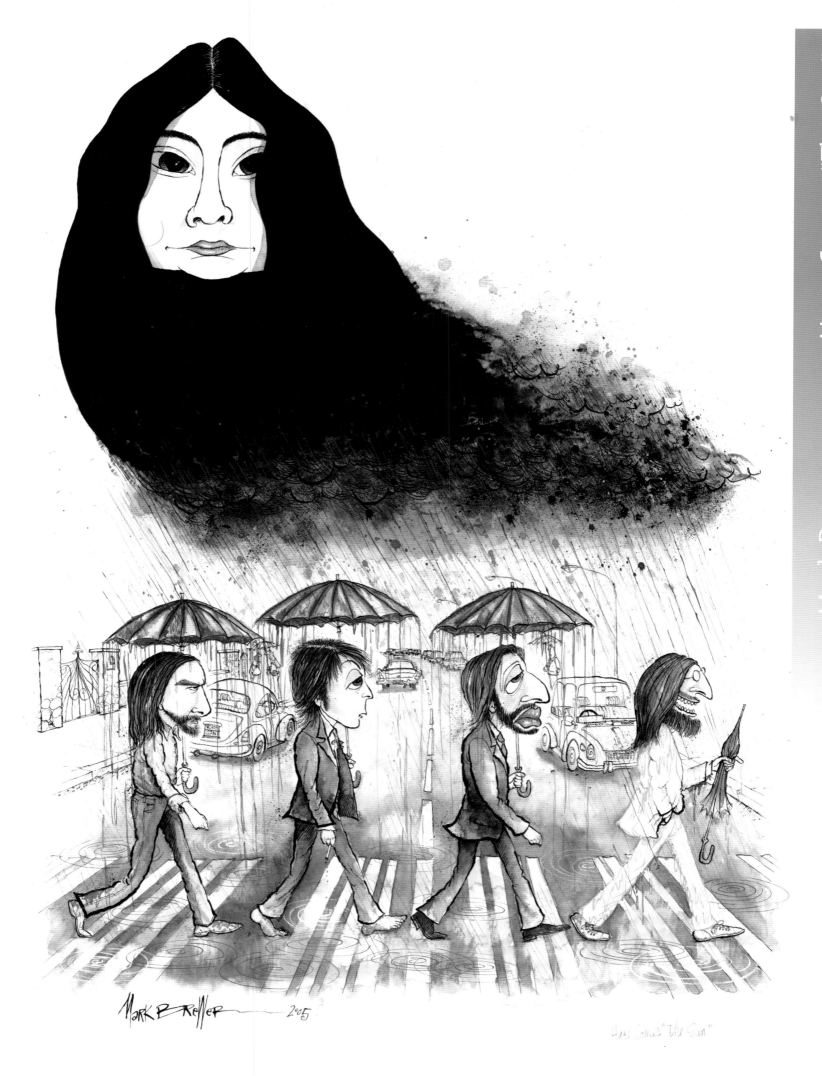

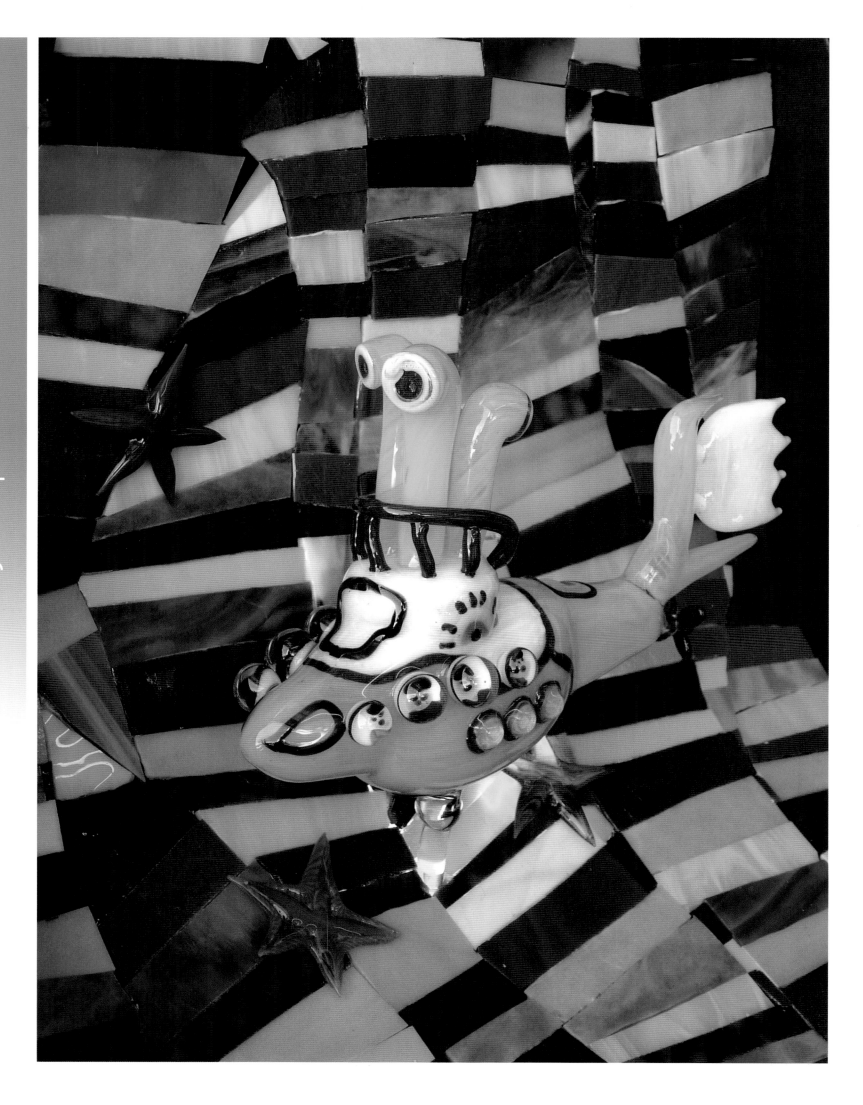

Artist: Jeremy Daniel

Title: Yellow Submarine

"'We're on a magical mystery tour...' These words capture the essence of my experience with The Beatles.

"The Fab Four breathed new life into the world of music. Their unconventional ideas stretched the boundaries and encouraged people the world over to follow their imaginations down unexplored paths. They had this exuberant approach to music, life and art that couldn't be denied. You never knew where they were going to take you. Some days would lead you to amazing, magical places and others to the depths of despair. You just had to approach all things with positivism and love, and everything would be all right. Their music conveyed all this and more.

"The Yellow Submarine was an essential part of The Beatles' search for truth and justice. In it, they set out into a strange and dangerous world. Armed only with their imaginations (and the imaginations of some great graphic artists), they succeeded against great odds.

"As an artist I've always seen the Yellow Submarine as a symbol of their desire to be different, to stand out as unique individuals. Their whimsical music, filled with joy and hope, has often inspired my artistic journeys. Their ideals of using your power for peace and for the good of all are something that I think we all need to see more of in the world today..."

Jeremy Daniel

*Glass blower Jeremy Daniel in his studio creating "Yellow Submarine".*

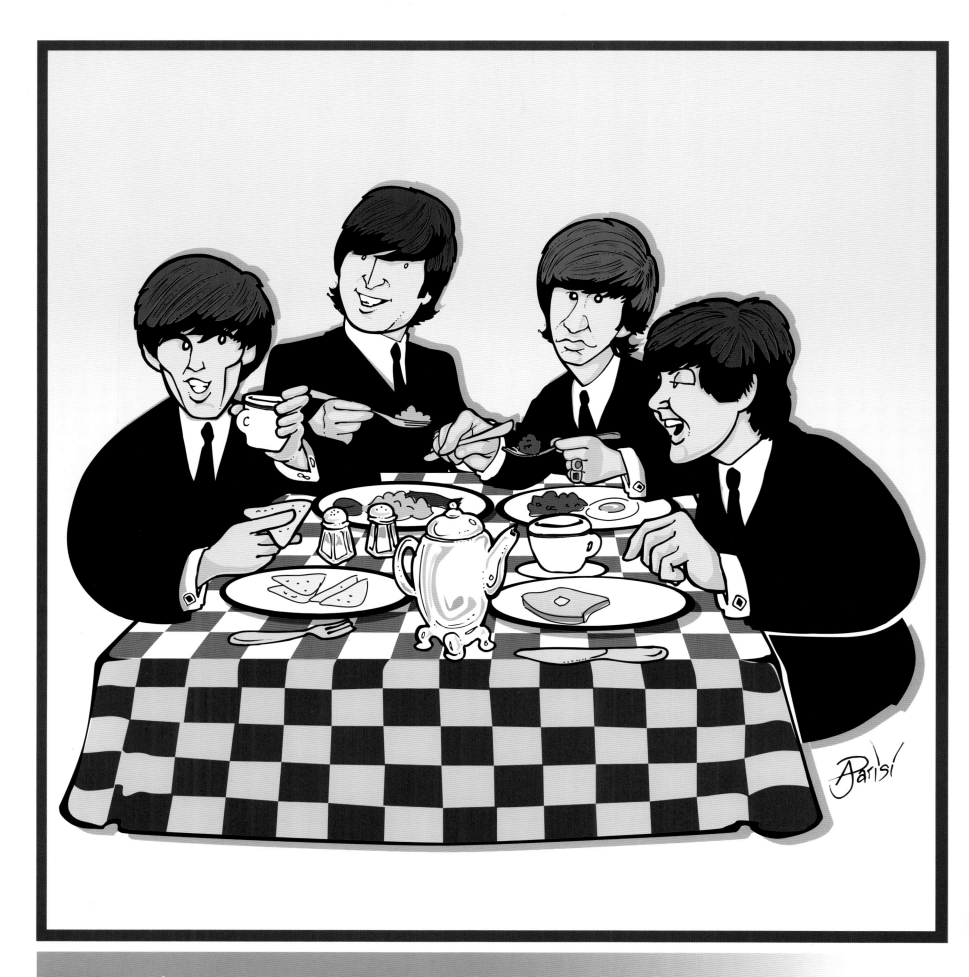

Artist: ANTHONY PARISI    Title: BREAKFAST WITH THE BEATLES

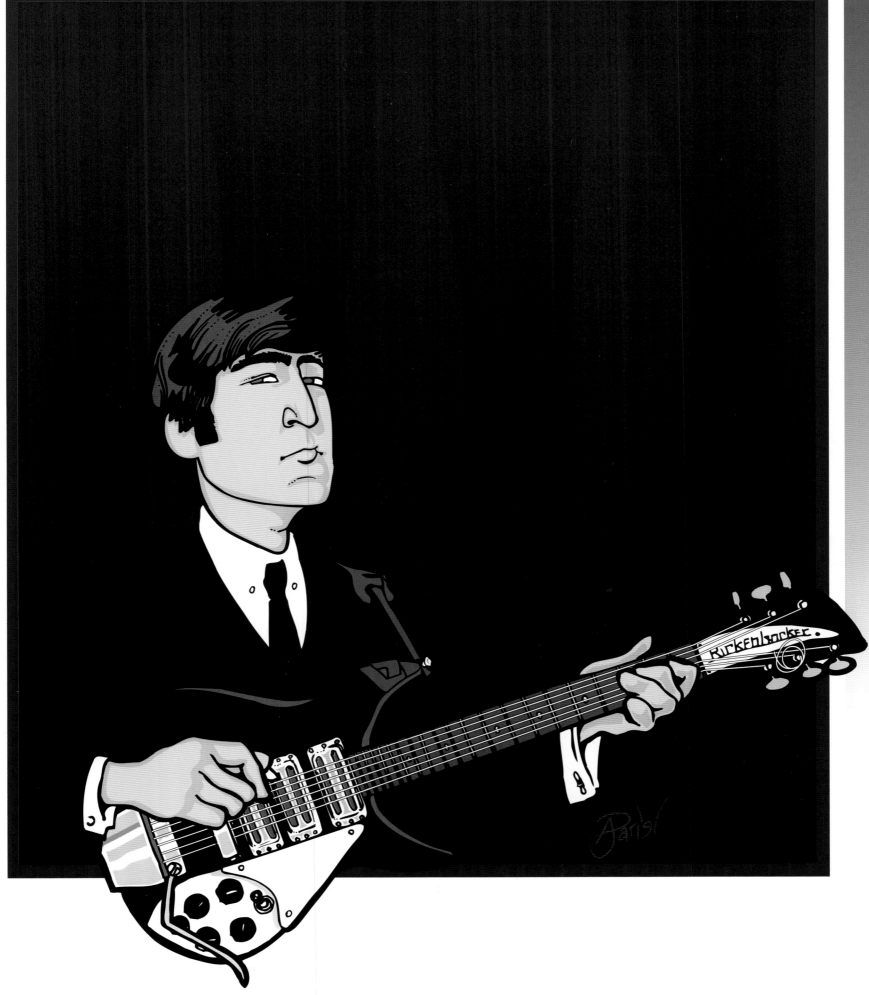

Artist: Anthony Parisi     Title: John & His 325

*Artist:* Sergey Parfenuk   *Title:* The Beatles

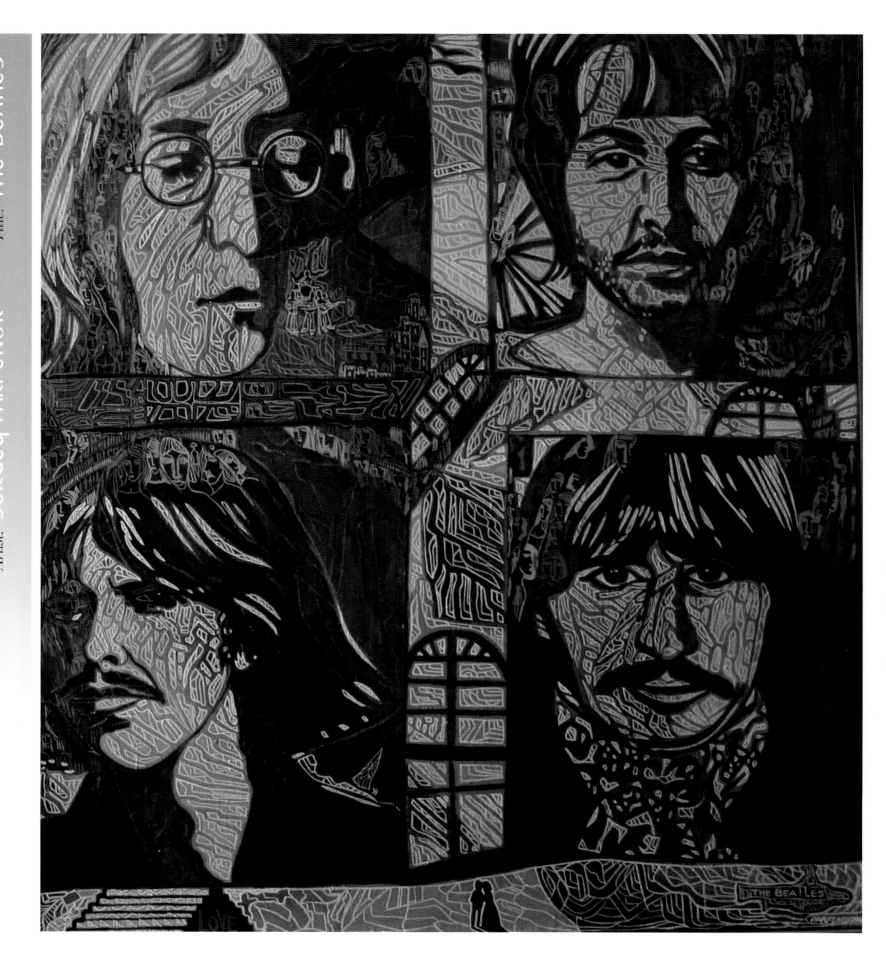

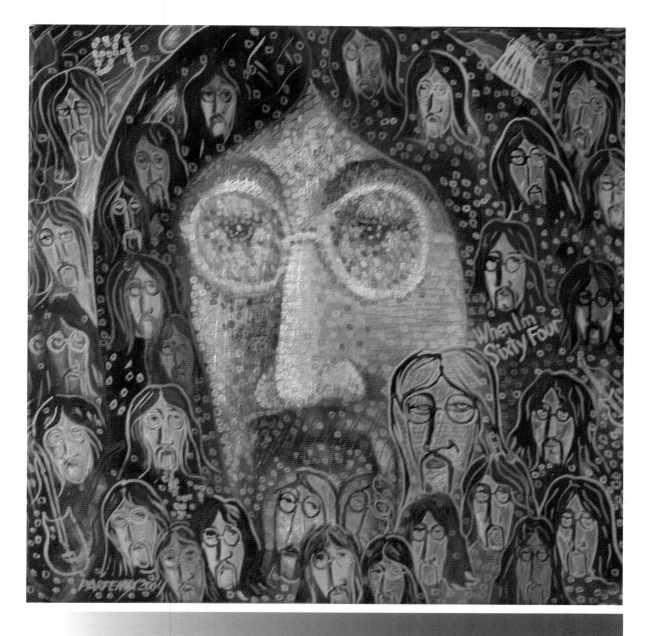

*Artist:* **Sergey Parfenuk**      *Title:* **John Is 64**

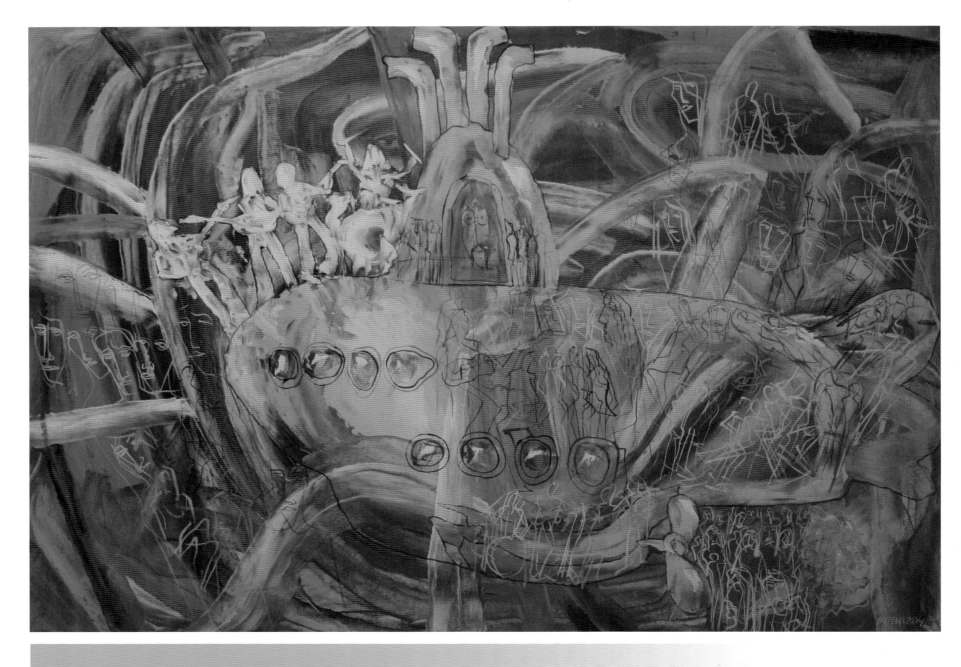

*Artist:* Sergey Parfenuk    *Title:* Yellow Submarine

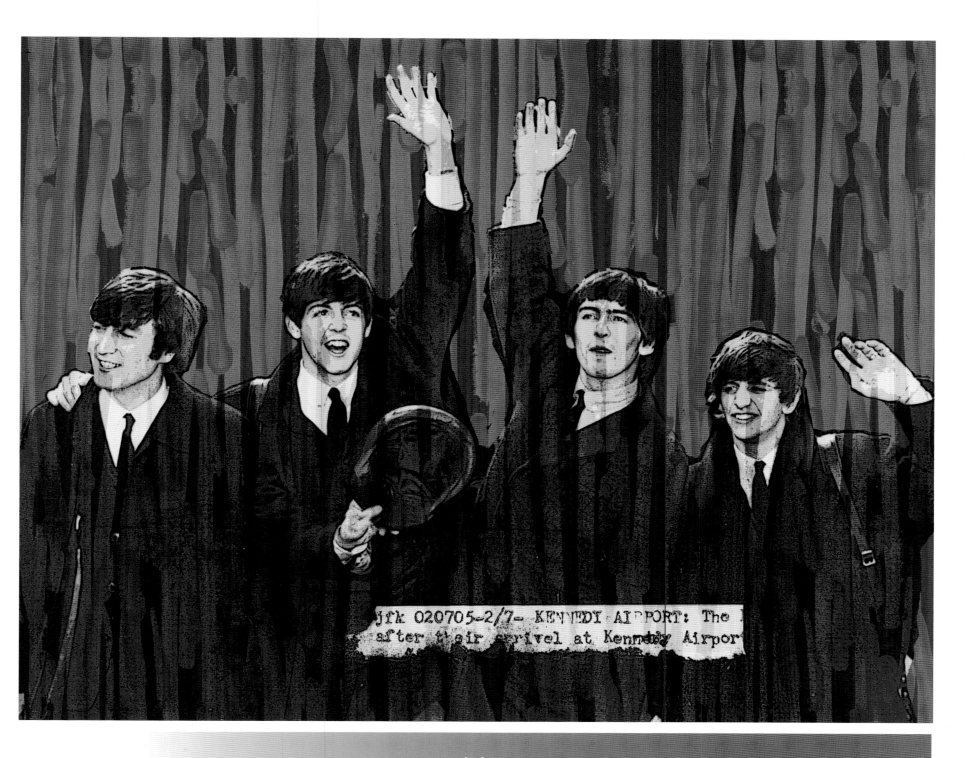

jfk 020705-2/7- KENNEDY AIRPORT: The
after their arrival at Kennedy Airport

*Artist:* LINDA WEBB  *Title:* ENGLISHMEN IN NEW YORK

"When I was young I wanted to be Paul. He was the cute Beatle, the hard-working, easy-to-like Beatle. By the time I got to college, I wanted to be John. Maybe it was his activism or his inner soul searching that appealed to me as a young adult. Later, I wanted to be Ringo. The quest to have fun and enjoy my life as if it would go on forever seemed an obtainable reality. As I became older I wanted to be George. His inner peace and spiritual stability felt like something I needed as I attempted to move further into adulthood.

"Today I have to ask myself: Which Beatle am I, really? The answer is simple. I'm all four! I believe there's a dash of Paul, a smidge of John, a pinch of George and a twist of Ringo in all of us, different elements harmonizing within us to make us whole. That's what makes The Beatles so special to millions of people around the globe. The unique qualities of their personalities speak to us through the music in new and inspiring ways at different stages of our lives. The simplest love song is just a catchy dance tune when you're a teenager, but then you hear its profound meaning as an adult. The Beatles' songs work on these multifaceted levels. That's why their music has endured.

"George Harrison once said that he was happy that The Beatles always presented a positive message in their music. Like him, I'm glad that the paintings I create are fun, happy images that hopefully make people smile and feel good. I love The Beatles. I love everything about them. But mostly I love the impact they've had on my life."

Joe Lacey

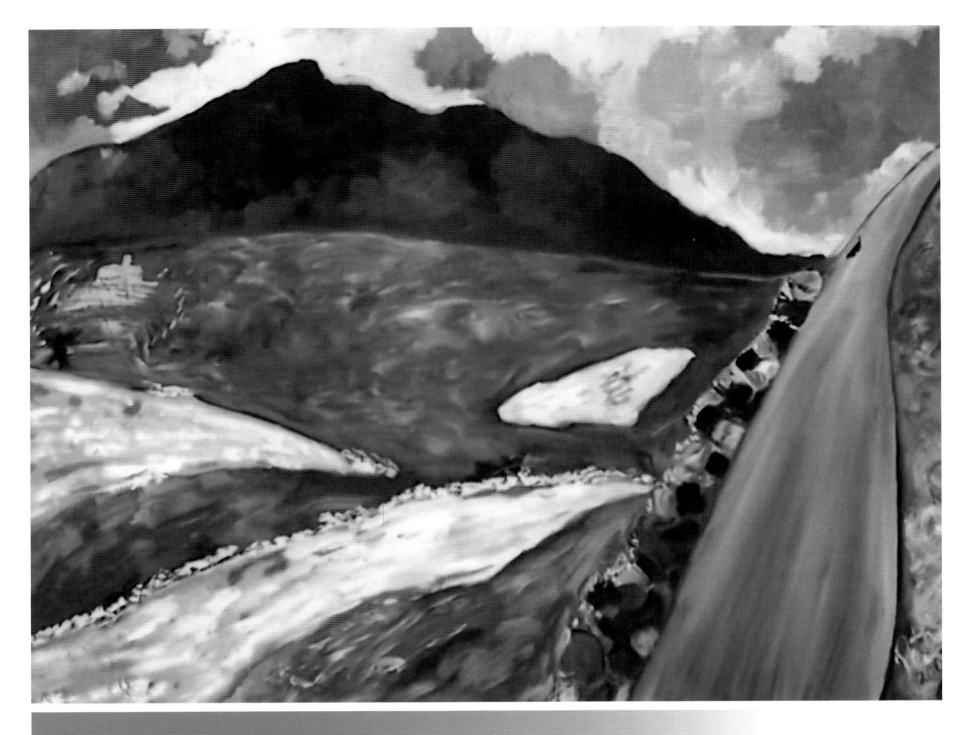

Artist: Peta Wright                Title: Yellow Submarine

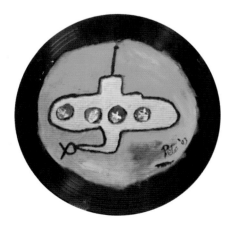  

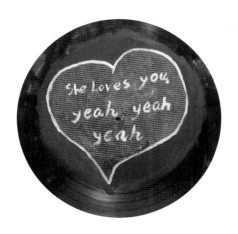

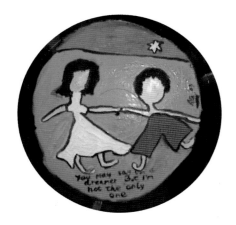

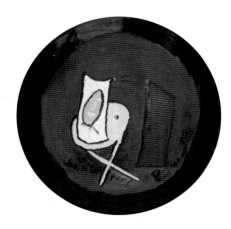

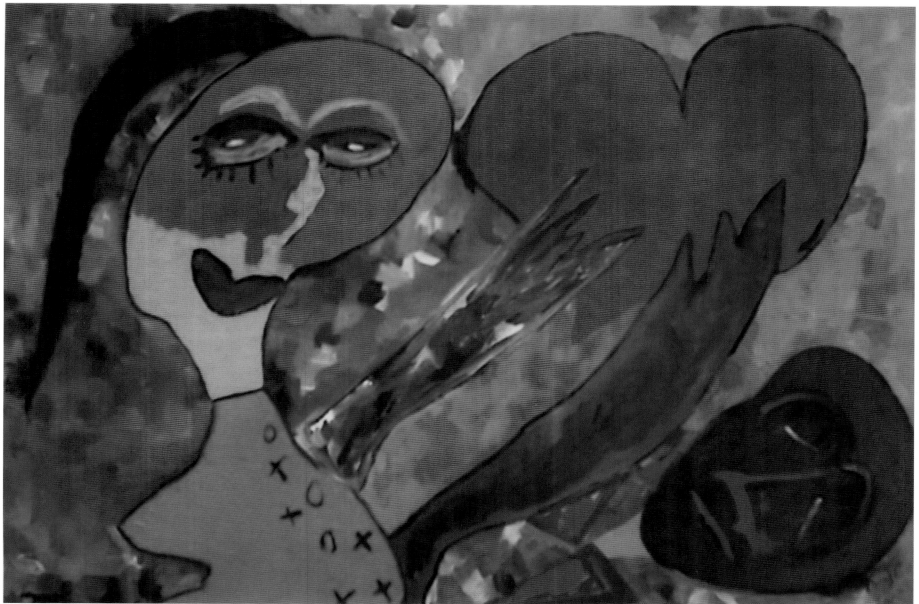

*Artist:* PETA WRIGHT          *Title:* SHE LOVES YOU

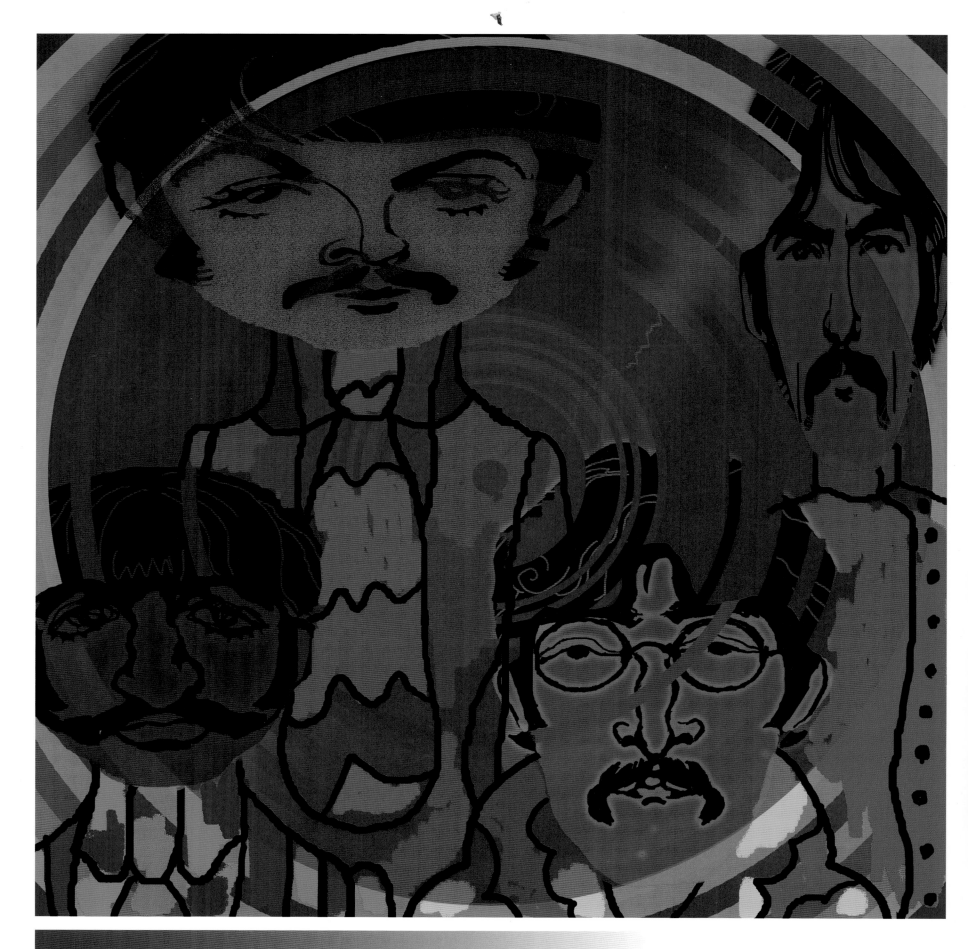

*Artist:* HARVEY CHAN    *Title:* BEATLES LP

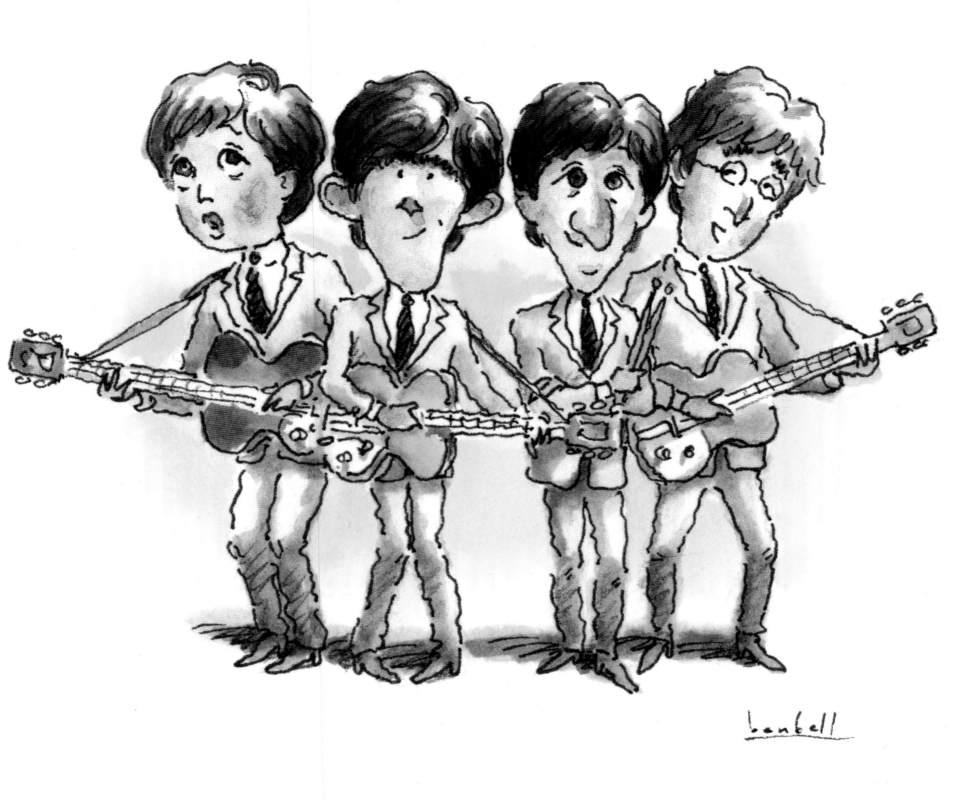

Artist: NORMAN BENDELL    Title: BEATLES CARTOON

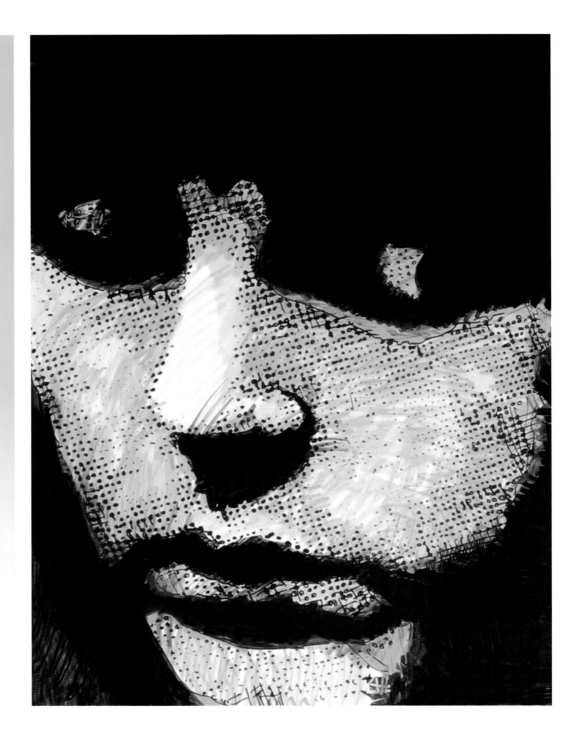

*Artist:* Gᴇᴏʀɢᴇ Fʀᴀʏɴᴇ    *Title:* Yᴏᴜɴɢ Pᴀᴜʟ

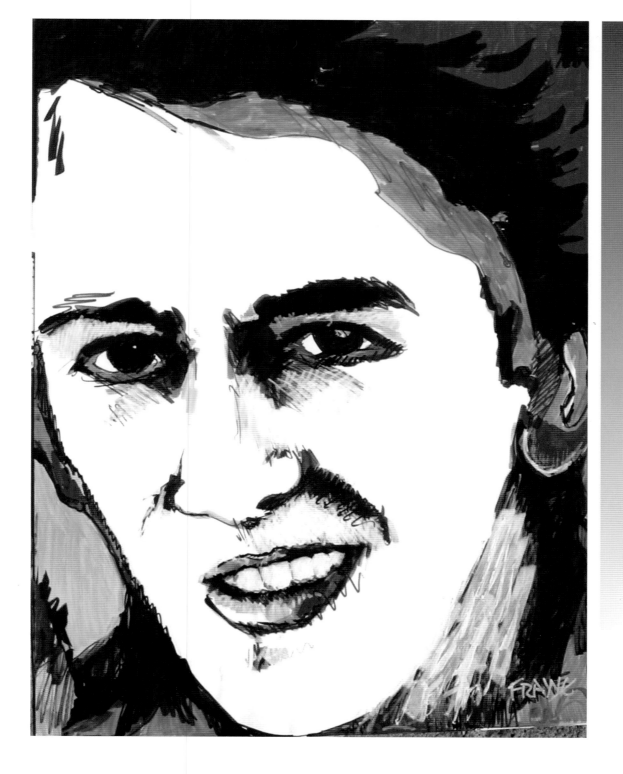

Artist: GEORGE FRAYNE     Title: YOUNG GEORGE

23

*Artist:* Apolonio S. Herrera

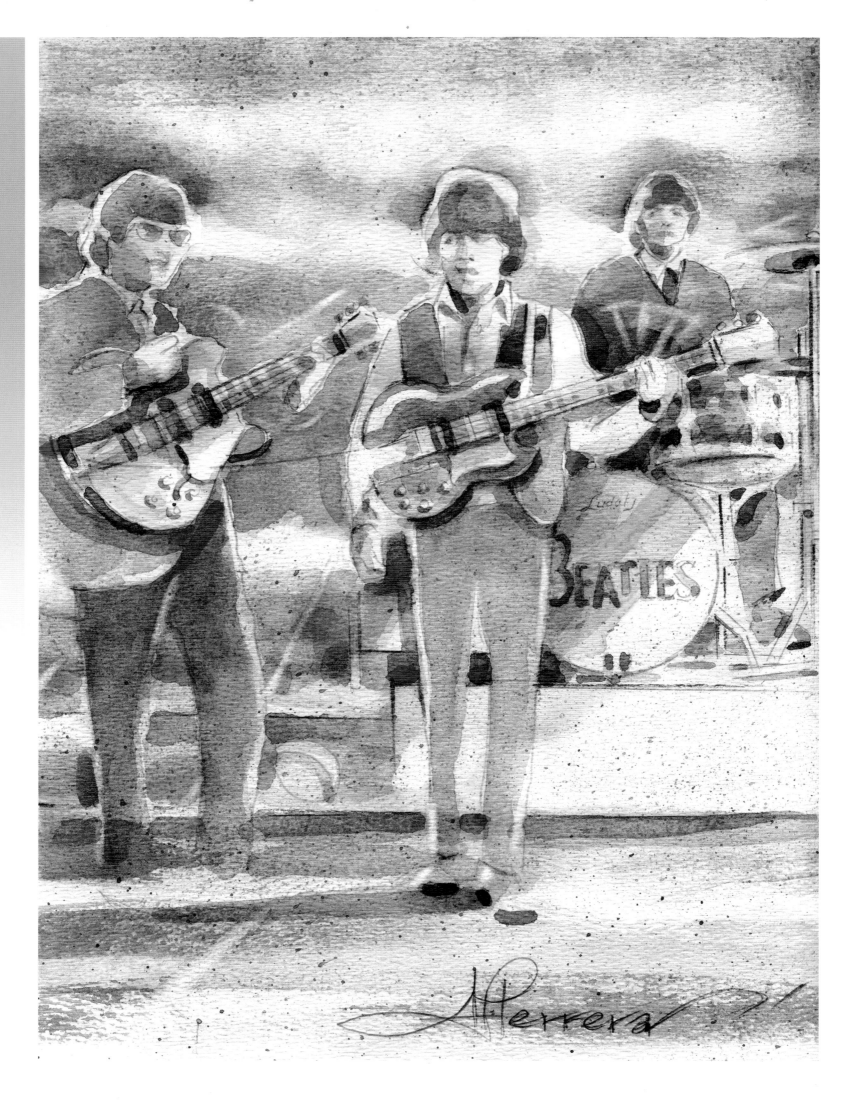

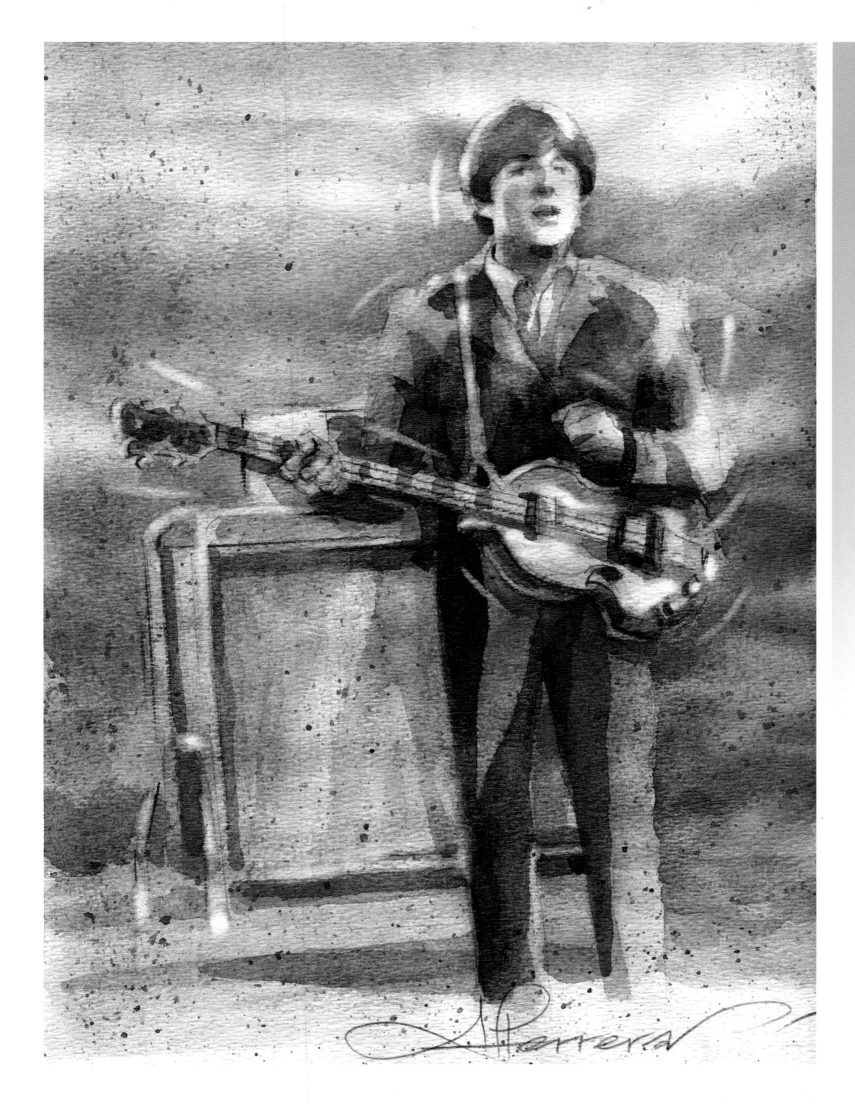

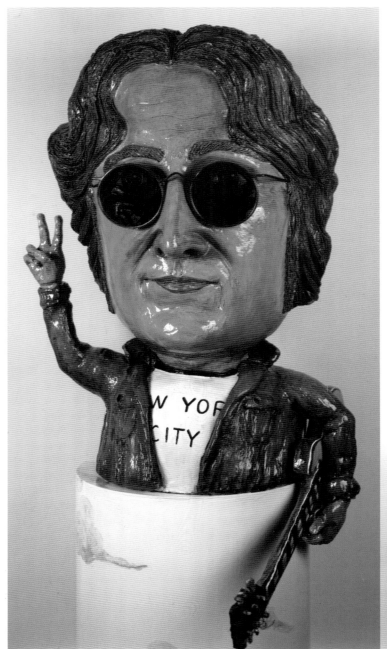

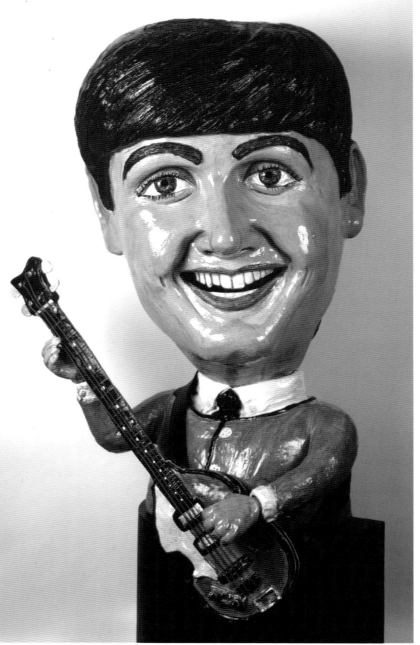

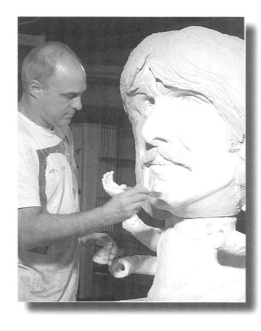

*Artist Tony Natsoulas in his studio putting the first of many coats on his ceramic sculpture of George Harrison.*

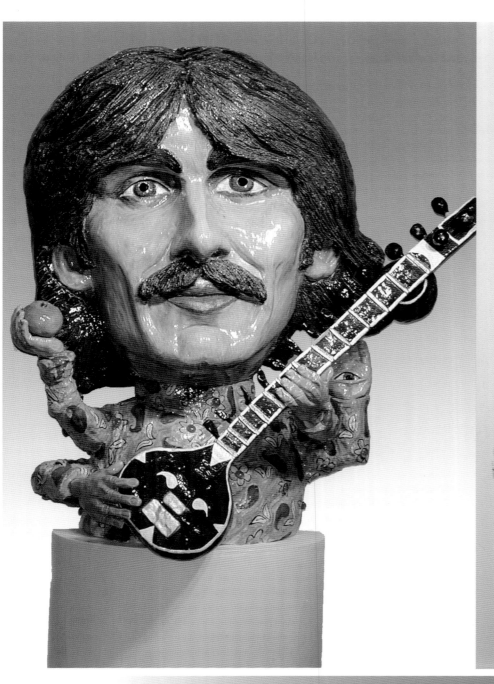

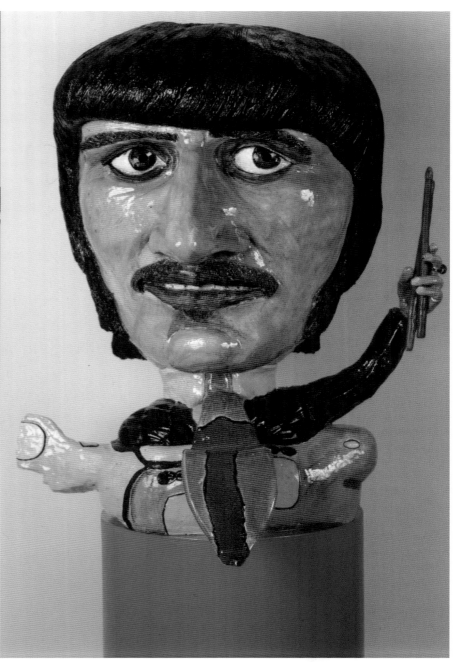

*Artist:* TONY NATSOULAS          *Title:* I Me Mine, Sea Of Green

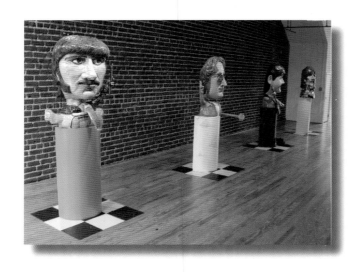

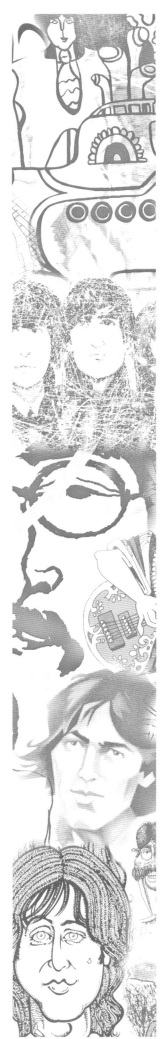

"I will always remember a particular day way back in 1970. I was at a friend's house, and we were listening to the radio and heard the news that The Beatles had broken up. I was only 11 years old, but the story had a big effect on me. I couldn't believe it could happen. Our whole world changed so fundamentally that it was like California had just dropped into the ocean.

"Many years later I was watching a TV special about either John Lennon or The Beatles. One of the interviewed guest stars gave this quote when asked what The Beatles had meant to him: 'The Beatles were the background to our lives!' Even the British Prime Minister has voiced this same sentiment. I felt and feel the same way, as though they were a part of my life, like having two arms.

"I remember my parents taking me to see the Beatles' animated movie, The Yellow Submarine, at a drive-in in 1968. What an incredible film! It blew me away and am sure it had something to do with me becoming an artist.

"Years later, I remember not being able to listen to Beatles music because it reminded me of my childhood too much. I felt like time was slipping away. It was too sad to listen to them through my college years. But, after my wife and I were married, we went on a nostalgia binge, buying all the toys and music of our childhood. Now, for some reason, thinking of my youth and listening to the music from back then is very exhilarating.

"Before this time in my art-making, I was making large ceramic sculptures of people who were not specific. I then decided to make a whole series of sculptures dedicated to the nostalgic figures from my past. As part of this nostalgic series, I also included The Beatles. With these portraits, I did extensive research on each person. I viewed dozens of videos and looked at hundreds of photos. In The Beatles' case, I listened to all of their music for the months I worked on their sculptures.

"I had decided to make each one of these pieces represent a different moment in The Beatles' career. Paul is represented in the style of their first appearance on the scene with his brown suit and 'Beatle' haircut. Ringo is portrayed in the style of their psychedelic period, emerging from his Yellow Submarine. George is in the style of their Indian 'spiritual quest' phase with his four Shiva arms and sitar. John is represented in a post-Beatles separation style.

"All and all, I am so very glad The Beatles—John, Paul, George and Ringo—were around making the music they did when they did it. I will always feel young listening to their songs and looking at the sculptures I made of them."

Tony Natsoulas

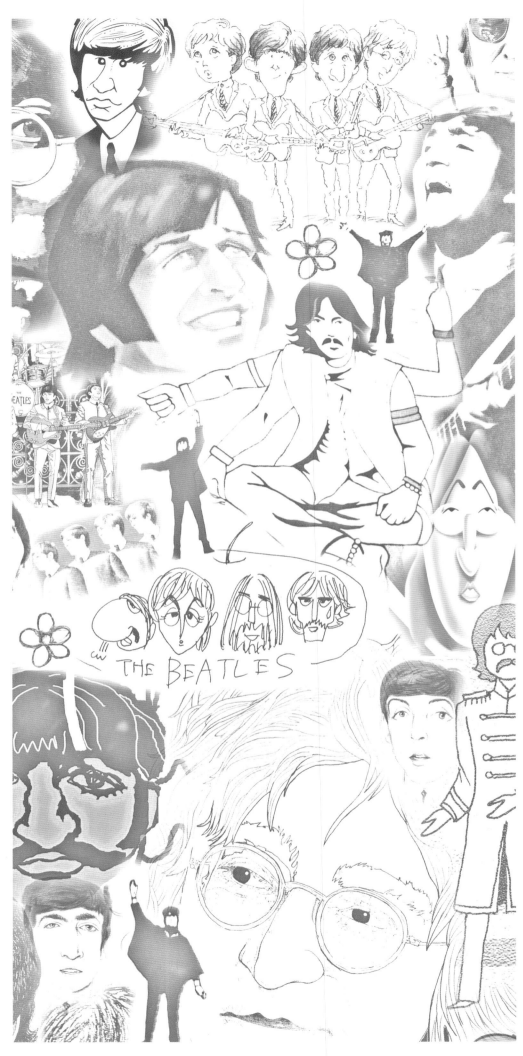

"I WAS FORTUNATE TO BE A TEENAGER IN THE 60's. I WAS INTRODUCED TO Beatle music IN 1965 AT THE AGE OF 15. I KIND OF liked THE EARLY STUFF like 'ANNA,' 'CHAINS,' AND 'Please Please Me.'

"I WAS BORN AND RAISED IN NORTHERN New Mexico. My ANCESTORS CAME TO THE AREA 400 YEARS AGO AND lived IN HARMONY WITH NATIVE AMERICANS DURING THAT TIME. THE 'ANGLO' INFLUENCE ARRIVED ABOUT 1850 with THE OPENING OF THE SANTA Fe TRAIL. When New Mexico BECAME A STATE IN 1912, THE U.S. GOVERNMENT STOLE by MANY MEANS SPANISH LAND GRANTS THAT WERE SUPPOSED TO BE HONORED WHEN WE BECAME A STATE— BACKGROUND FOR MY RADICAL PERIOD.

"AT THIS TIME, I GOT INTO Rubber Soul, Revolver, AND THE White Album, which WERE A MAJOR INFLUENCE IN MY NEWLY DISCOVERED TRAIN OF THOUGHT. DURING MY COLLEGE DAYS, I WAS A FOUNDING member OF 'A la RASA UNIDA,' A HISPANIC ORGANIZATION THAT WAS TO GET OUR land GRANTS BACK FROM THE U.S. GOVERNMENT. IN PROTEST WE OVERTOOK OUR college ADMINISTRATION BUILDING, BOOED THE GOVERNOR OF THE STATE, TRAVELED TO Denver, TOOK DOWN THE U.S. FLAG AND REPLACED IT WITH THE Mexican FLAG AND Chicano FLAG AT THE STATE CAPITOL. All OF THIS WAS DONE WHILE LISTENING TO Beatle music. OUR ANTHEM WAS THE SONG 'Revolution.'

"AS TIME GOES ON, I LEARNED TO love AND listen TO Beatle music ON A DAILY basis. Their music CONTINUES TO INFLUENCE me IN MY DAILY LIFE. GEORGE HARRISON IS MY FAVORITE SOLO ARTIST, AND I DRAW INSPIRATION FROM his music AS well."

RICHARD MONTOYA

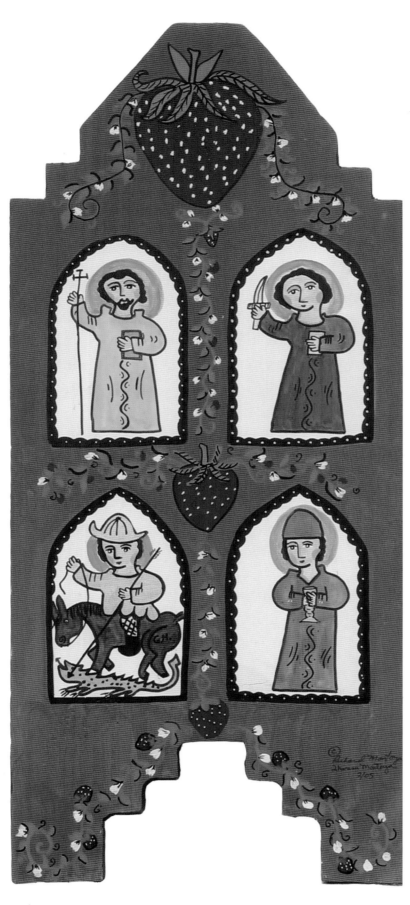

Strawberry Fields

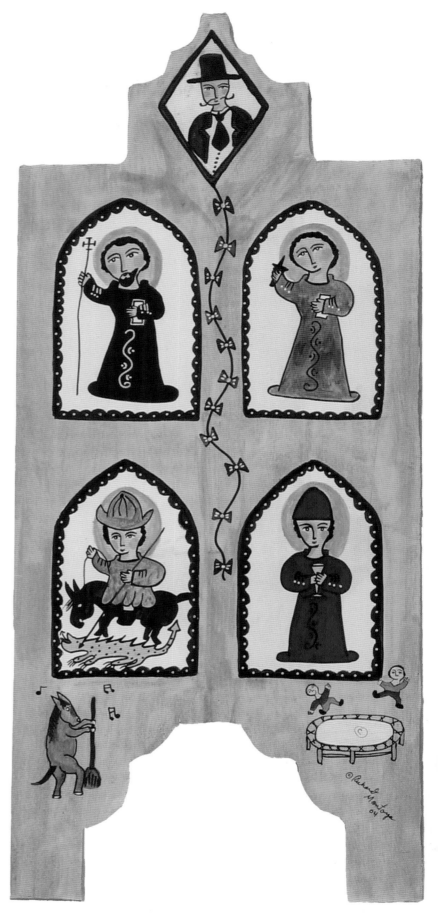

For the Benefit of Mr. Kite

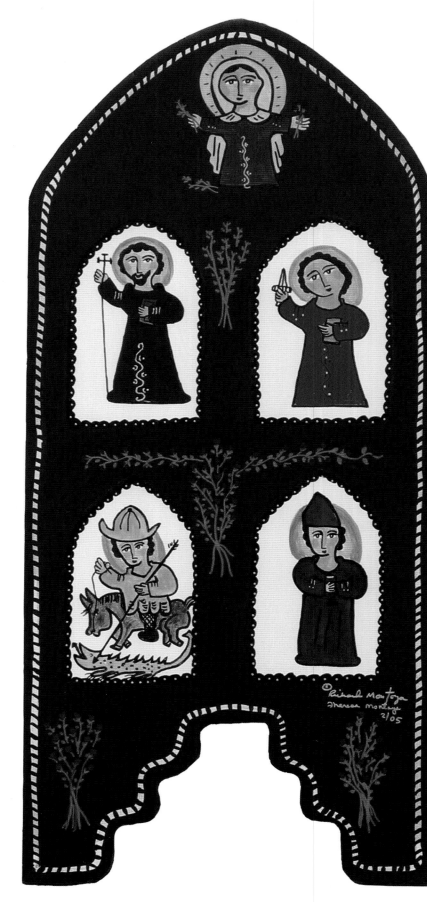

Let It Be. Let Mother
Mary Come to Me

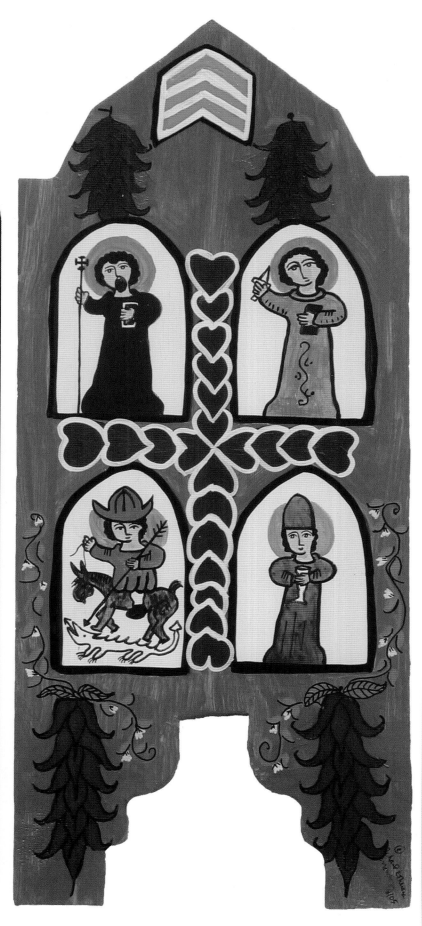

Sgt. Pepper's Lonely
Hearts Club Band

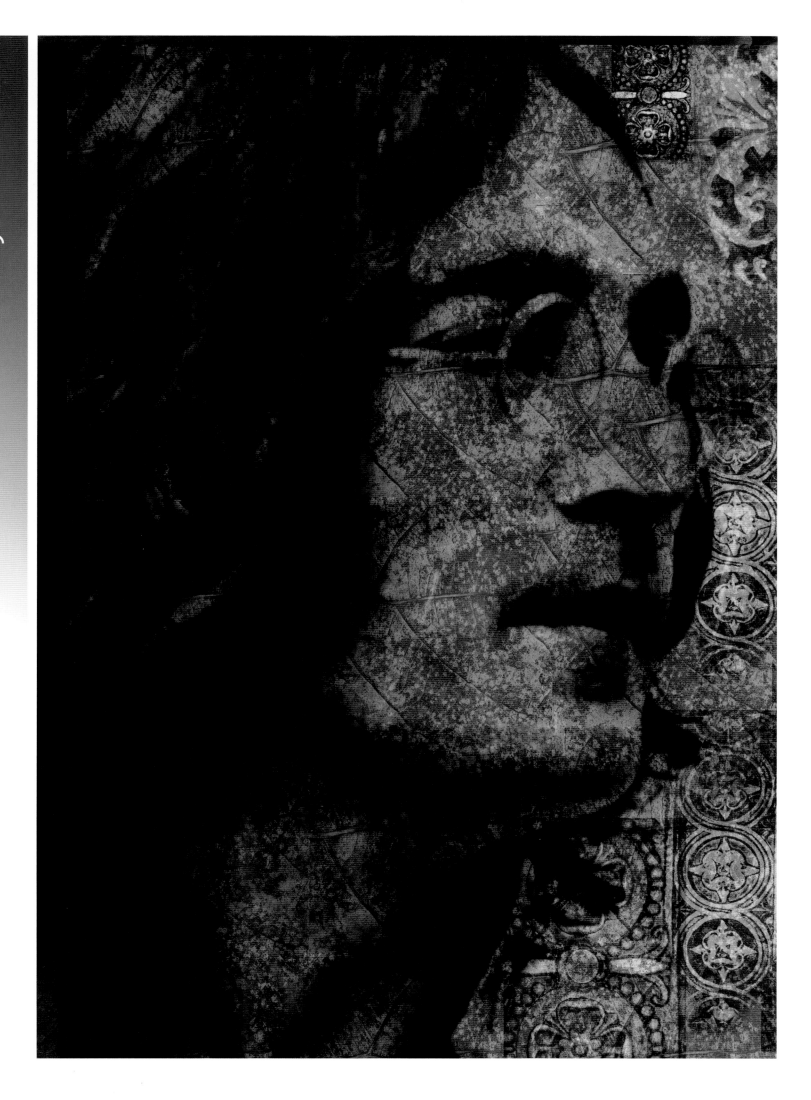

"Who can resist the appeal of all the early Beatle songs that caught on immediately with each new single: 'I Wanna Hold Your Hand', 'She Loves You', 'Please Please Me', etc... I could go on and on, of course! The world loves these songs: They are catchy, fun, and what most first think of when you think of The Beatles.

"But then, whether it was due to a songwriting competition with Paul, trying to gain respect from the folk crowd due to the popularity of Bob Dylan, or the strange, artsy influence of Yoko, the lyrics of John Lennon evolved into a type of surrealistic art. You first saw a glimpse of it in 'Nowhere Man' and 'Norwegian Wood', but then a giant, experimental, and creative leap was taken over the next few years.

"On their own, the lyrics of 'I Am The Walrus', 'Lucy In The Sky With Diamonds', and 'Strawberry Fields Forever' are nonsensical. But when they are combined with the layered musical bed that George Martin and the rest of the group created, they become magical! Art! They put pictures in your head— unique to each listener—and every now and then one of these pictures gets the one-in-a-million chance to spill onto canvas and be shared with the world. Regardless of the medium, art inspires art, and the music of The Beatles did just that."

Linda Webb

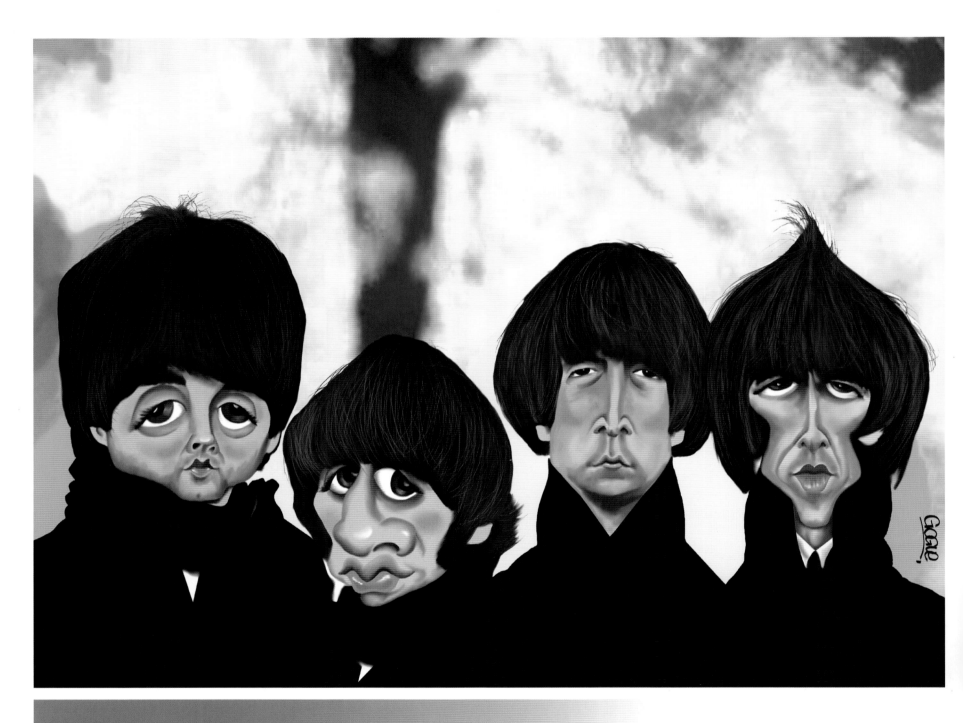

*Artist:* Gogue     *Title:* Beatles

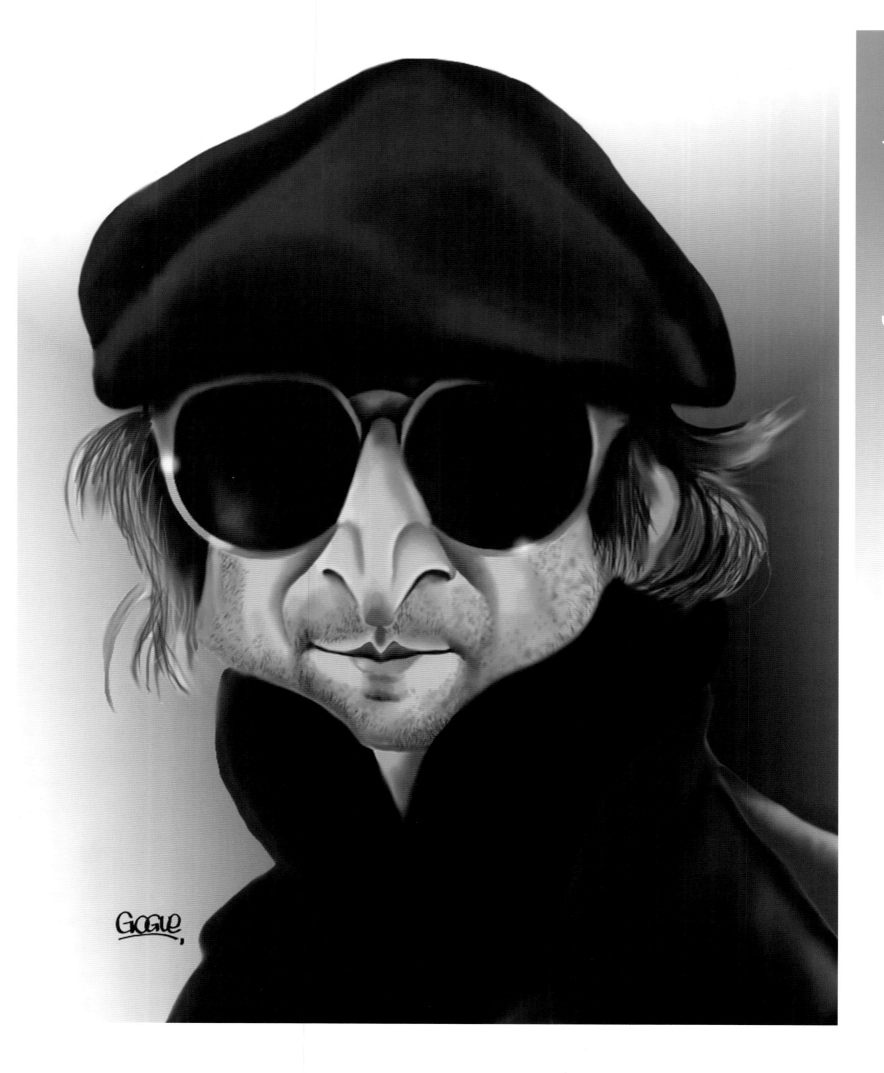

"Throughout the years, I have often thought about creating an art piece as a lasting tribute and salute to The Beatles. Upon first learning about George Harrison's failing health, several months before he passed away on 12/1/01, I began work on my Beatles sculpture.

"I reminisced about all of the great music and vibrant color that The Beatles brought to the world and just really how fast the years have gone by. It then struck me that February of 2004 would mark forty years since The Beatles first hit song, 'I Want To Hold Your Hand', arrived on the shores of America. Realizing this, I knew the time had come to begin my project and give something back straight from my heart. This sculpture is my expression of gratitude for all that The Beatles have given me growing up.

"Anyone who can remember the consuming hanging gloom of the months following President Kennedy's assassination will also certainly never forget the reprieve found, several months later, in the excitement that the Beatles brought to America. I remember so well that electrifying evening of February 9, 1964, when the Beatles made their first televised appearance on the 'Ed Sullivan Show'.

"It was as if The Beatles brought color back into a black and white world and emanated some kind of hope throughout the Vietnam War years. Beatles music and memories are so deeply forever forged in my mind that I wouldn't be surprised if it would show up in my DNA.

"I took up the drums and my siblings' other musical instruments and creative art forms, all largely inspired by the creativity and passion of these four talented young men from Liverpool. My wonderful parents supplied the encouragement and provided all they could. I will always treasure my many good memories of performing in bands and of all the friends I've made over the years, having been very much positively and creatively affected by The Beatles. And, of course, I'll simply never forget seeing The Beatles live, Pittsburgh performance at the Civic Arena in September of 1964. I was just a young boy of 14 when it all began... it was the time of my life! You can bet that I'm a Beatles fan!

"Posters, T-shirts and lunch boxes are all exciting, great fun, but now it's time to honor The Beatles with the kind of dignity that they so deserve in a classic way."

Kris Atkinson

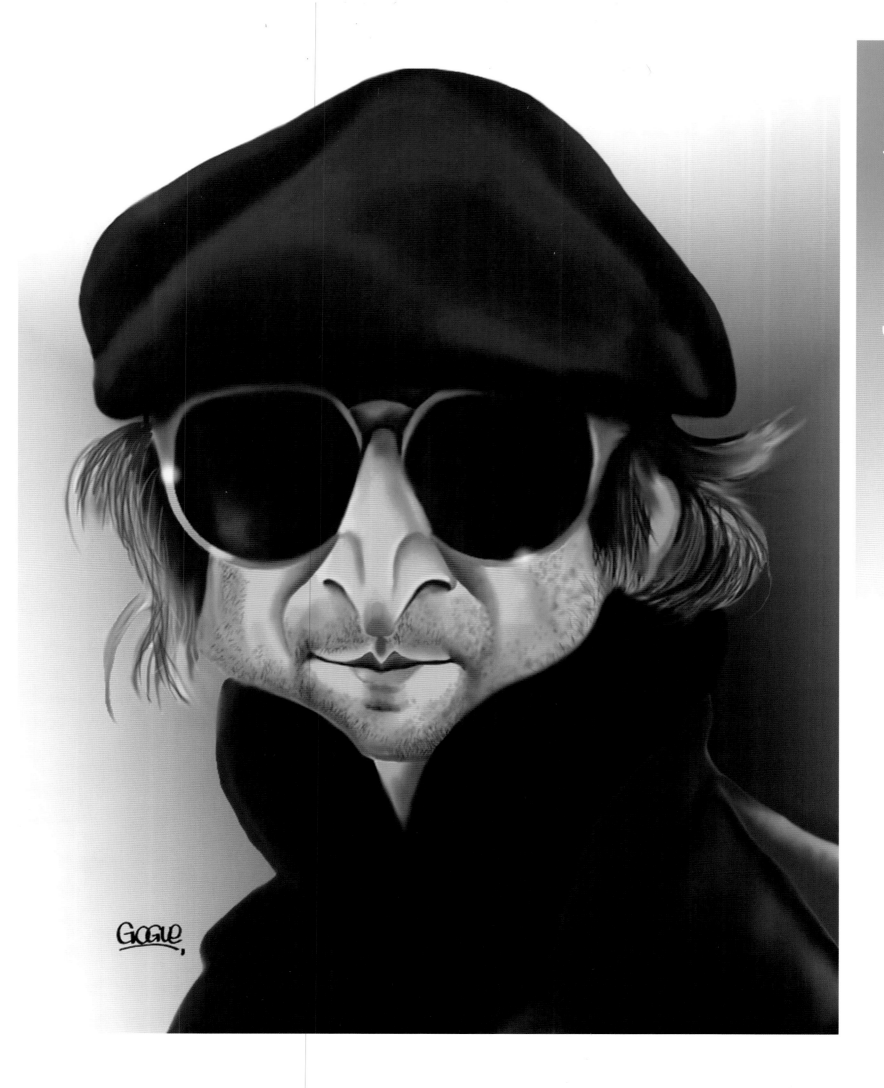

"Throughout the years, I have often thought about creating an art piece as a lasting tribute and salute to The Beatles. Upon first learning about George Harrison's failing health, several months before he passed away on 12/1/01, I began work on my Beatles sculpture.

"I reminisced about all of the great music and vibrant color that The Beatles brought to the world and just really how fast the years have gone by. It then struck me that February of 2004 would mark forty years since The Beatles first hit song, 'I Want To Hold Your Hand', arrived on the shores of America. Realizing this, I knew the time had come to begin my project and give something back straight from my heart. This sculpture is my expression of gratitude for all that The Beatles have given me growing up.

"Anyone who can remember the consuming hanging gloom of the months following President Kennedy's assassination will also certainly never forget the reprieve found, several months later, in the excitement that the Beatles brought to America. I remember so well that electrifying evening of February 9, 1964, when the Beatles made their first televised appearance on the 'Ed Sullivan Show'.

"It was as if The Beatles brought color back into a black and white world and emanated some kind of hope throughout the Vietnam War years. Beatles music and memories are so deeply forever forged in my mind that I wouldn't be surprised if it would show up in my DNA.

"I took up the drums and my siblings' other musical instruments and creative art forms, all largely inspired by the creativity and passion of these four talented young men from Liverpool. My wonderful parents supplied the encouragement and provided all they could. I will always treasure my many good memories of performing in bands and of all the friends I've made over the years, having been very much positively and creatively affected by The Beatles. And, of course, I'll simply never forget seeing The Beatles live, Pittsburgh performance at the Civic Arena in September of 1964. I was just a young boy of 14 when it all began... it was the time of my life! You can bet that I'm a Beatles fan!

"Posters, T-shirts and lunch boxes are all exciting, great fun, but now it's time to honor The Beatles with the kind of dignity that they so deserve in a classic way."

Kris Atkinson

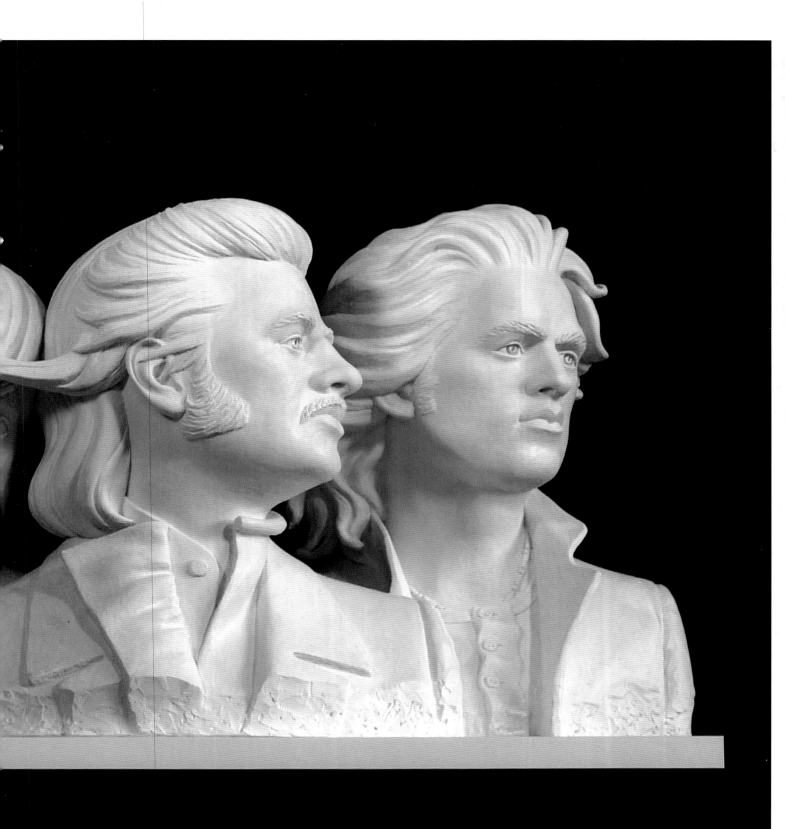

Plastalina modeling clay (non-hardening clay that cannot be baked or fired) was applied over a hardware and wood armature. A signed and numbered Classic Limited Edition Series of "Spirit of The Beatles" sculpture is planned for Fall of 2006.

*"Sculpture is unlike two-dimensional art in that the artist must imagine, visualize and create not a single viewing angle but a full 360 degrees of viewing compositions. The creation of this art piece required nearly all of my available time over the past four years, and I can say that it was time well spent. I hope it brings as much great pleasure to Beatle fans the world over as creating it has brought me."*

**39" Wide X 17" Tall X 18" Deep**

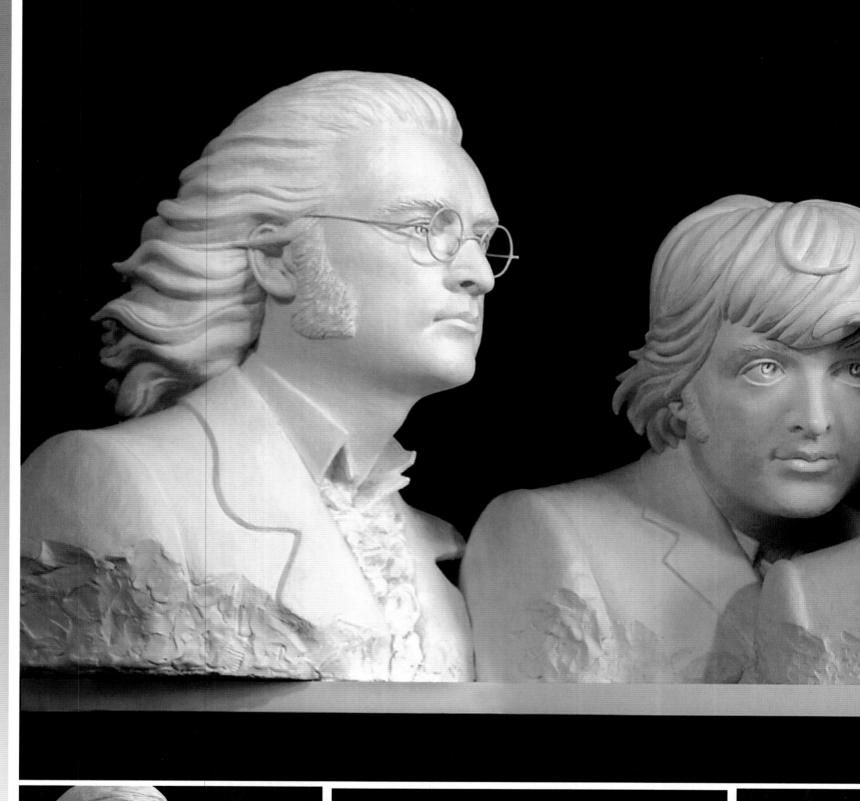

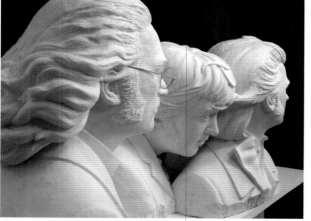

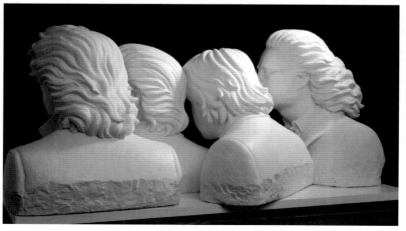

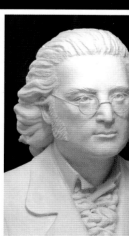

*Artist:* George Frayne          *Title:* John

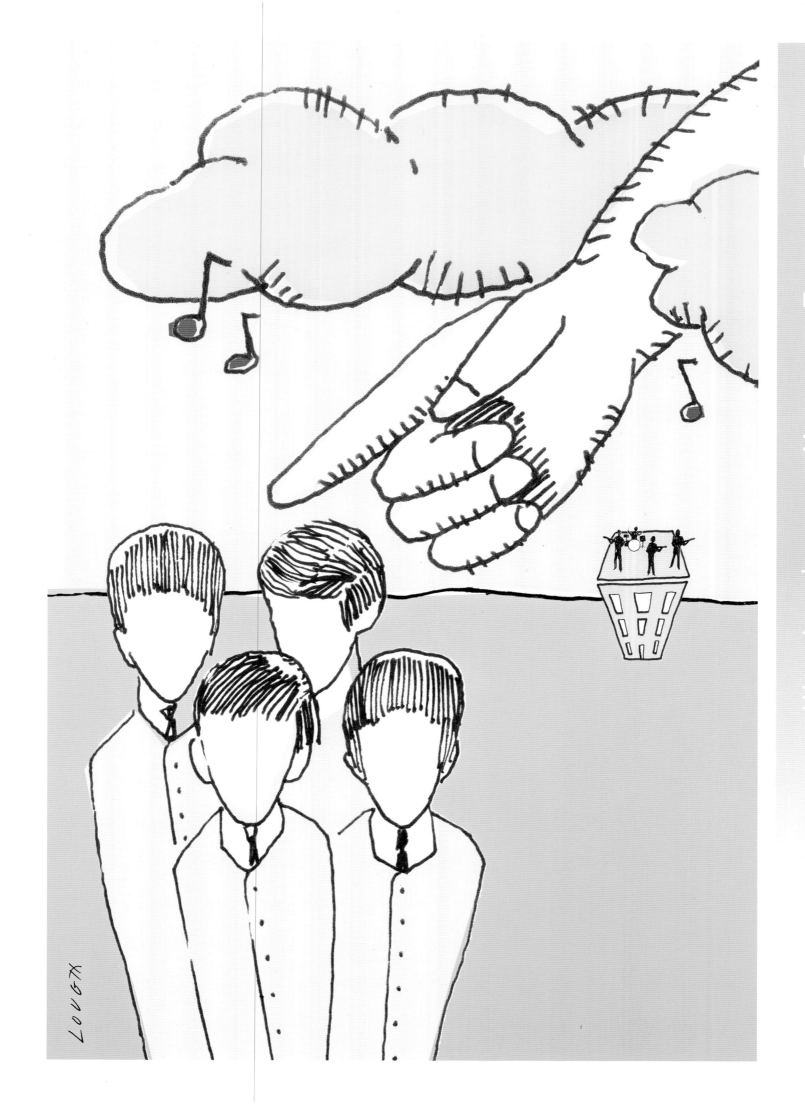

*Artist:* Wade Lough    *Title:* Yesterday, Today, and Forever

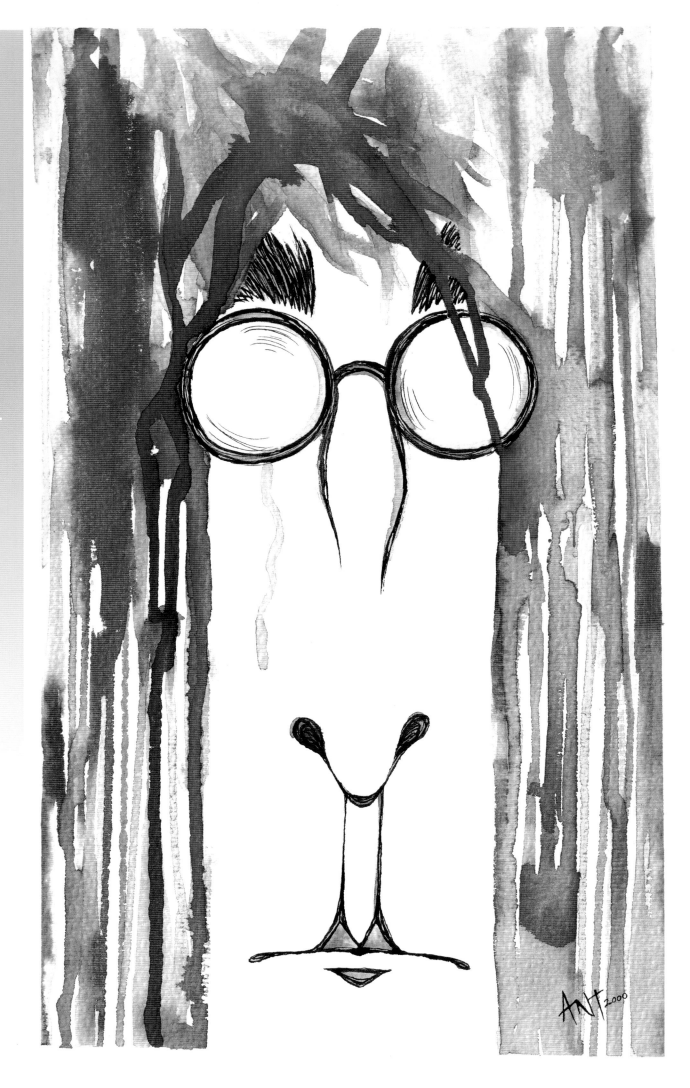

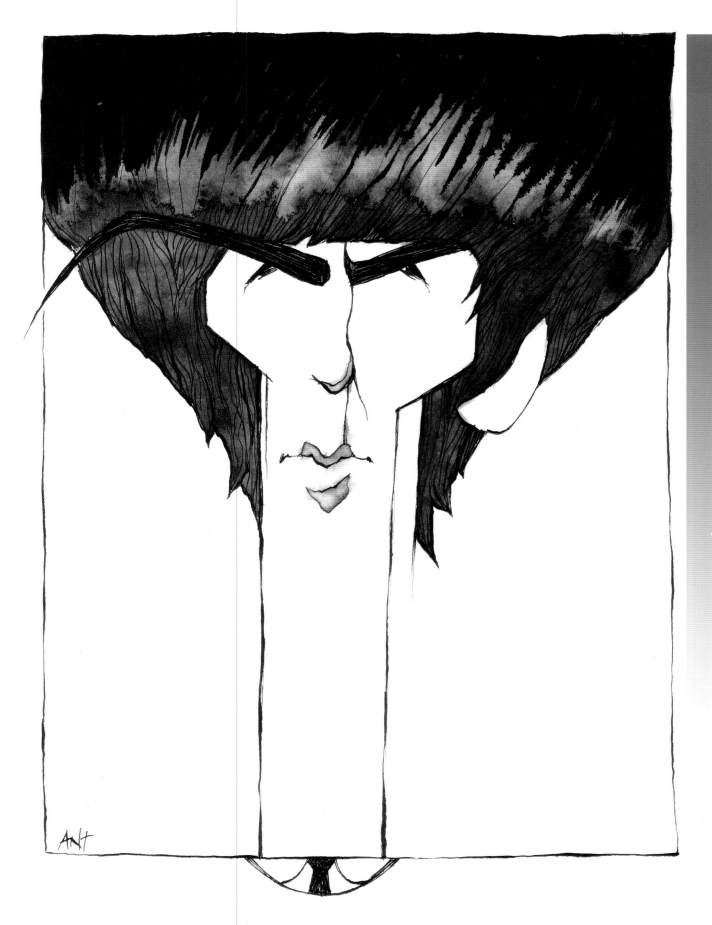

*Artist:* Anthony Garner    *Title:* George Harrison

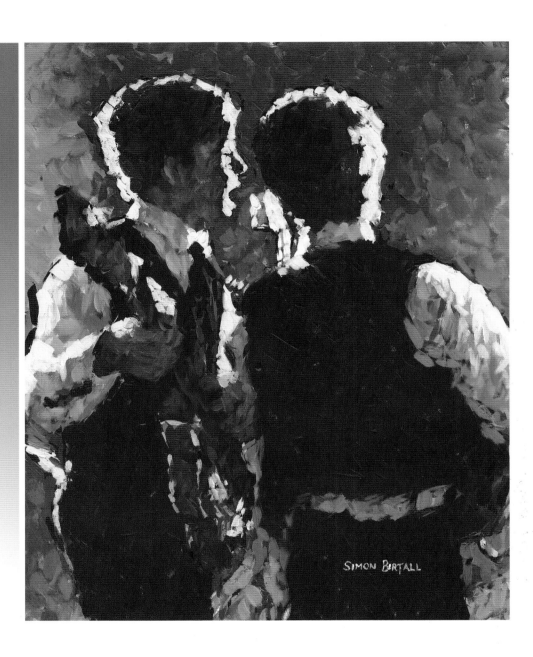

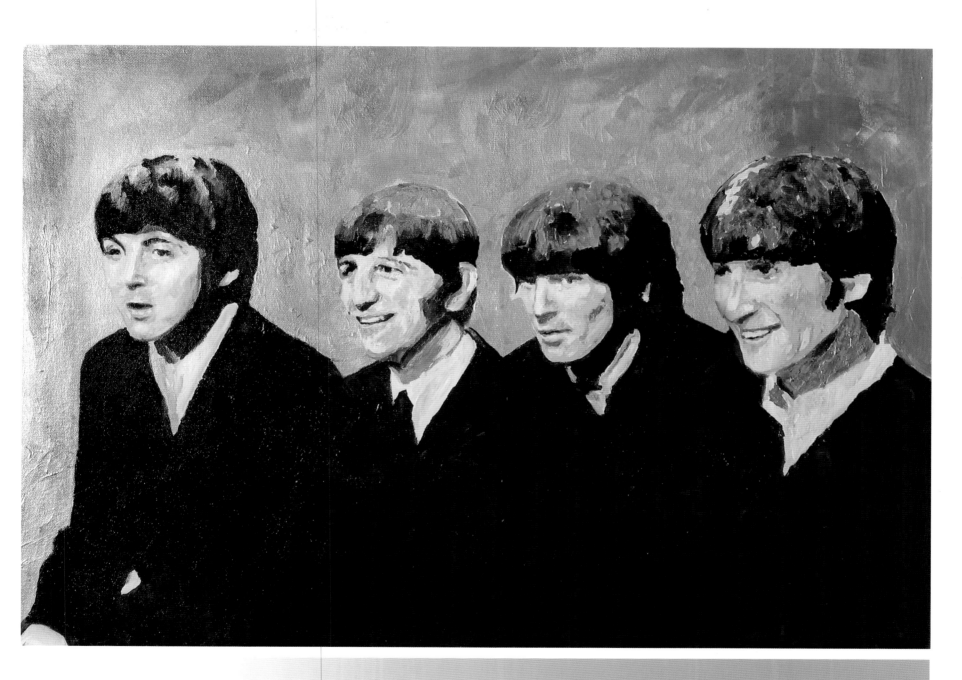

*Artist:* HOWARD MATHURINE    *Title:* BEATLES BLUES

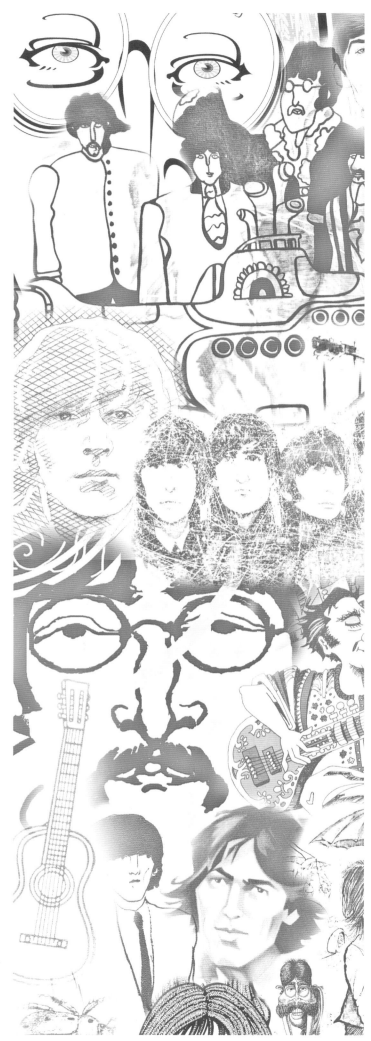

"The Beatles represent art to me in all forms. Whether musical, political or media related, The Beatles strove for perfection and, as a result, created art.

"I have grown up with The Beatles on the radio and in the family car. They represent all kinds of emotion and events of my past and now my future. The Beatles have created not only some of the best-ever influential music, but political advocacy that has helped bring around change in the world. The Beatles, in many ways, have influenced my work.

"First and foremost I listen to The Beatles when painting, and I am able to pull images based on the lyrics and emotion of the music.

"They represent a part of priceless history for the world."

Lucy in the Sky with Diamonds (right)
"When creating my 'Lucy in the Sky with Diamonds' piece, I wanted to incorporate several aspects of the song. First and foremost to me is the depiction of the sky with its whites and blues, which I represented in a three-dimensional manner. Second, I represented the name Lucy. That seems to be the subject of the song and placed it in the sky. Finally, I represented four diamonds to represent each of the Beatles as the 'diamonds' that Lucy is striving for."

Beatles Collaboration By: Terry & Brenda Womble
(following page)
"My wife Brenda Womble and I collaborated on this piece over dinner one night on a cocktail napkin at one of our favorite restaurants. I liked the idea so much that I told her we would work on the painting together. We have represented all of the most commonly known instruments as well as The Beatles' names with vibrant psychedelic colors."

Terry Womble

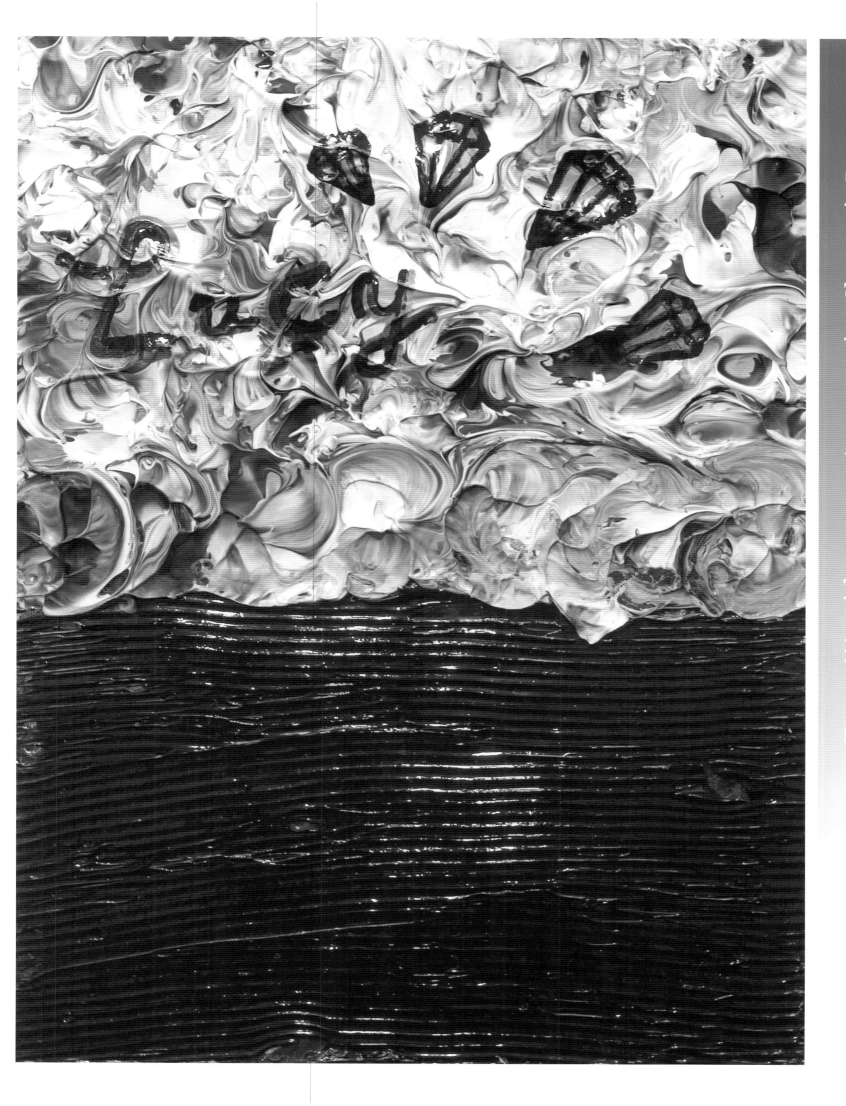

*Artist:* Terry Womble    *Title:* Lucy in the Sky with Diamonds

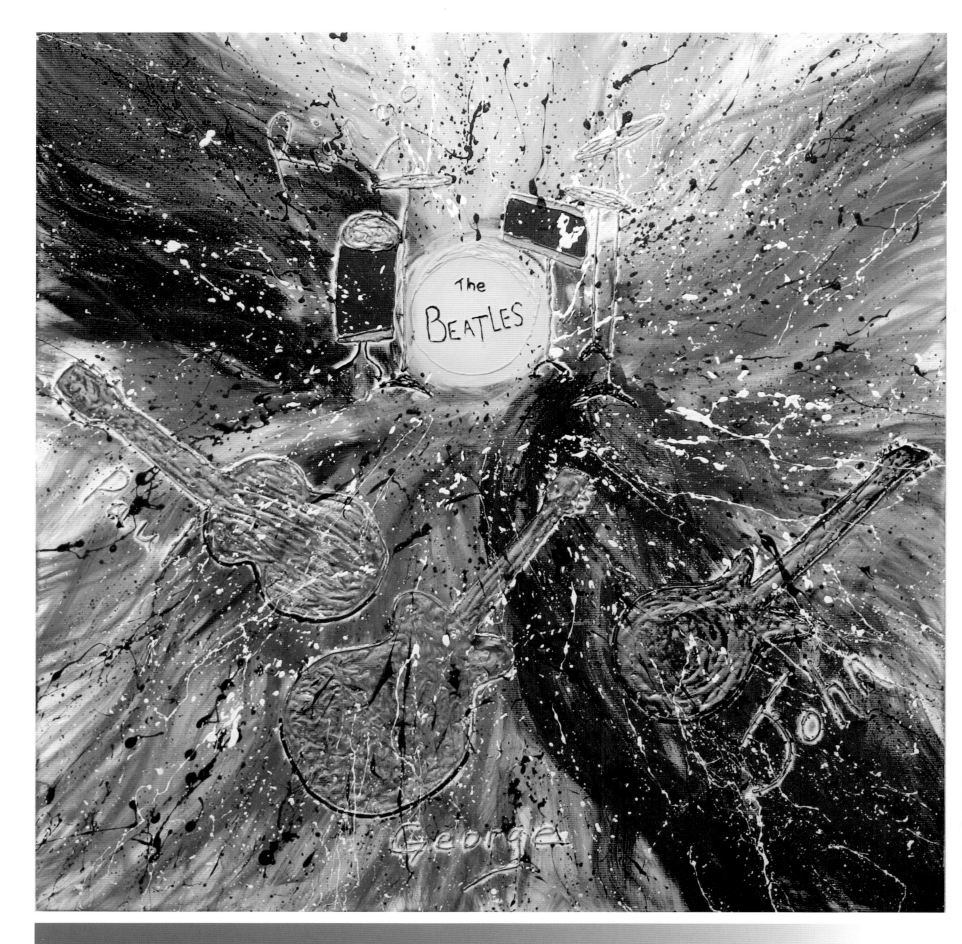

*Artist:* Terry & Brenda Womble     *Title:* Beatles Collaboration

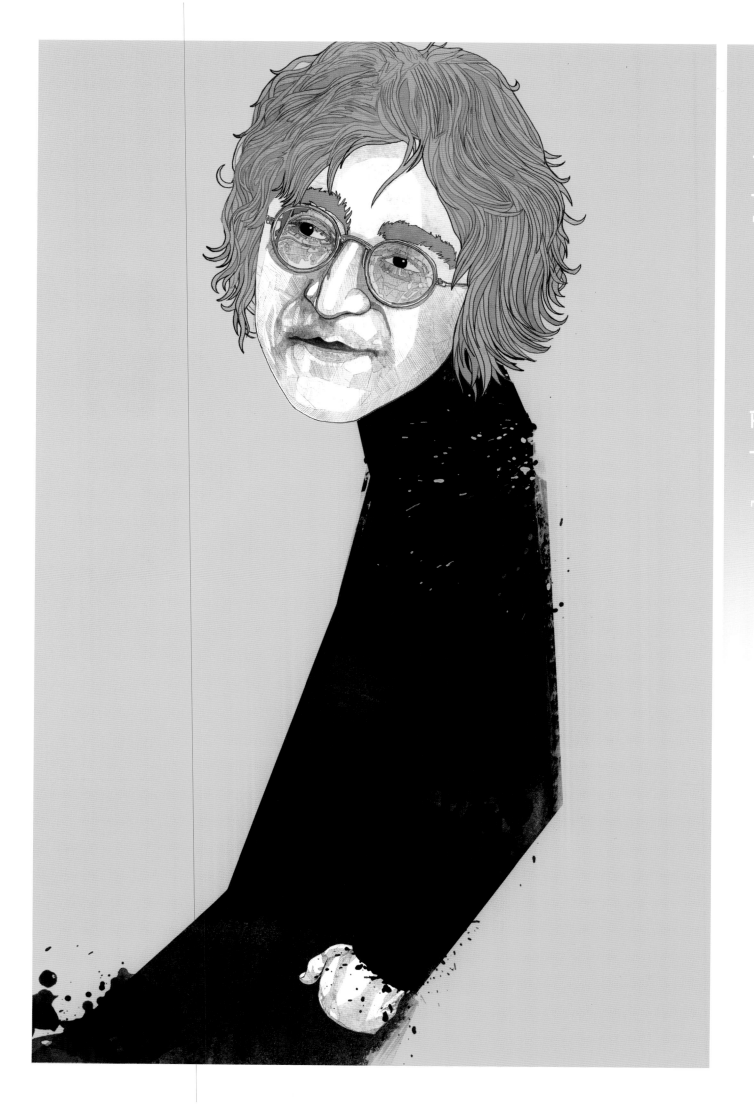

Artist: Jacob Thomas    Title: John Lennon

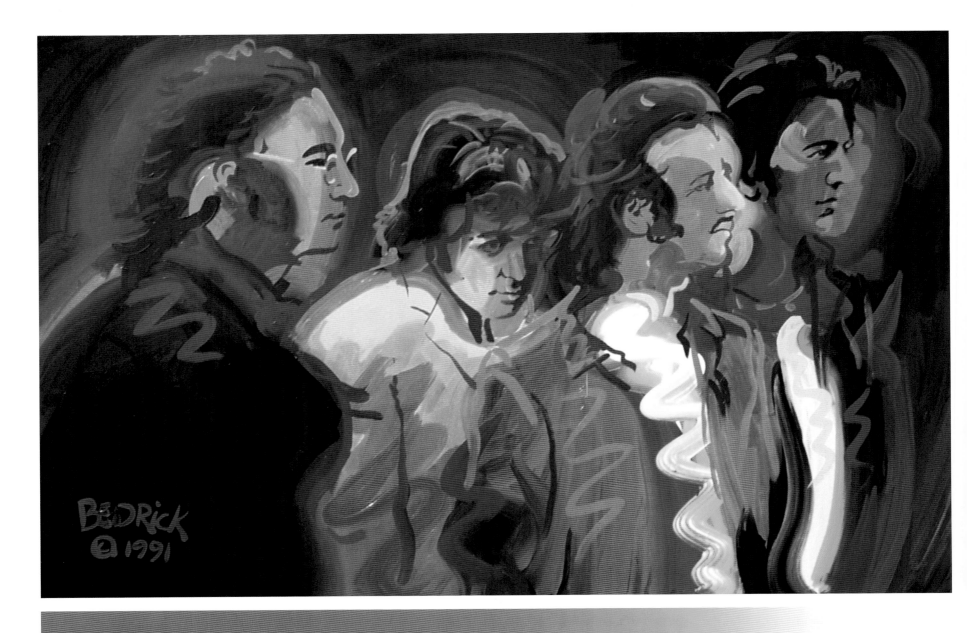

*Artist:* Jeffrey Bedrick    *Title:* Fab Four In Fauve

"One of my earliest memories is singing along to 'I Wanna Hold Your Hand' on the car radio while being driven home from kindergarten in 1965. Even then, I knew that this music was something very special if I could enjoy it along with my parents. Coincidentally, my aunt was married briefly to Roger McGuinn of the Byrds around that same time. So, we had a little more proximity and awareness of the pop music world than most middle-class families in those early days.

"However, I was always most drawn to The Beatles because their imagery was as appealing as their music. Their lyrics contained unusually evocative visual descriptions of people and places, especially on 'Sgt. Pepper's Lonely Hearts Club Band', 'Yellow Submarine', and 'Magical Mystery Tour'. They were storytellers. They were handsome and likable. The art on their albums was always intriguing and filled with hidden meanings. Their literary and visual imagery was anachronistic, eclectic, nostalgic, optimistic, childlike, romantic, revolutionary, and hallucinogenic, all at the same time. In this explosion of compelling, colorful imagery was their message of love, self-awareness, and spirituality, which had already begun to influence my personal views and artistic sensibility. As an aspiring young artist, my own creativity matured in this fertile era of psychedelia.

"In 1991, I met the artist Peter Max at a gallery in San Francisco. His style combined influences from French comic book art, Warhol-esque pop culture subjects, and the bold line and color of Matisse and the Fauves. The Beatles' animated film 'Yellow Submarine' was strongly influenced by his psychedelic poster style. As a lifelong fan of his work, I was inspired by this meeting to embark on a distinct departure from my established artistic style with my own bold paintings of icons from pop culture."

Jeff Bedrick

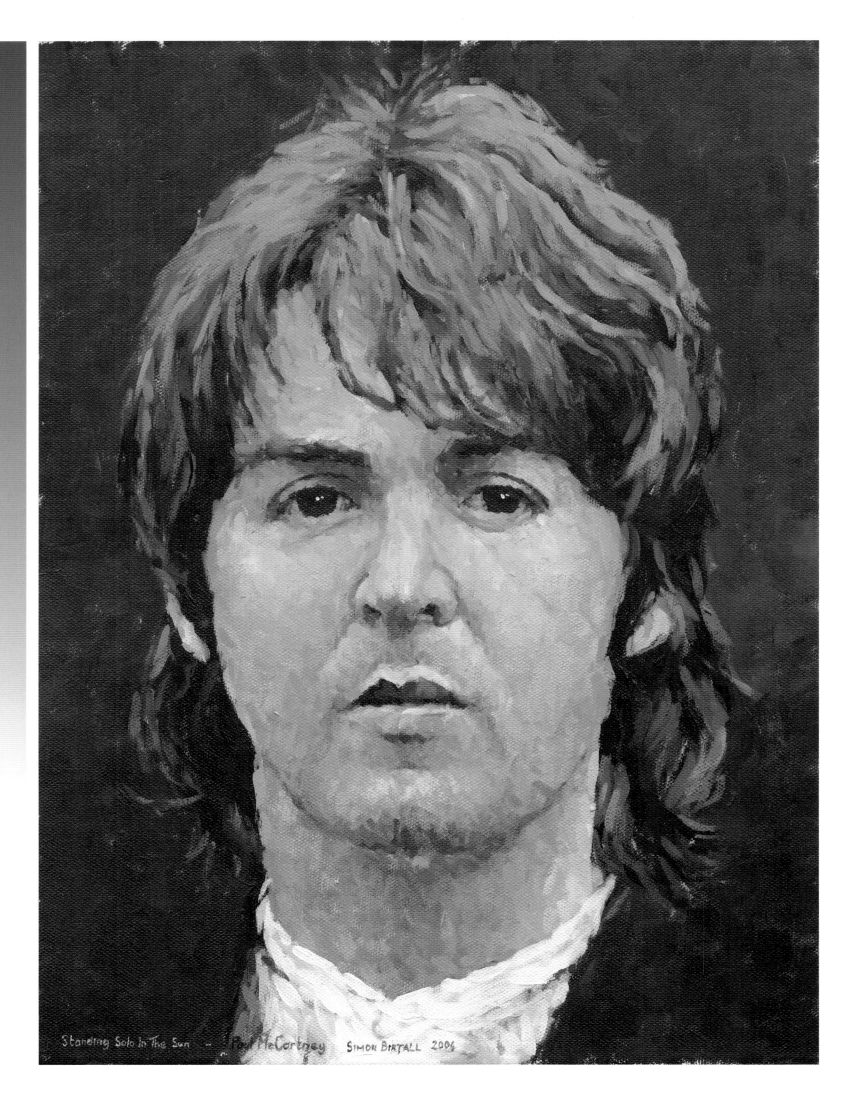

Standing Solo In The Sun — Paul McCartney    Simon Birtall 2004

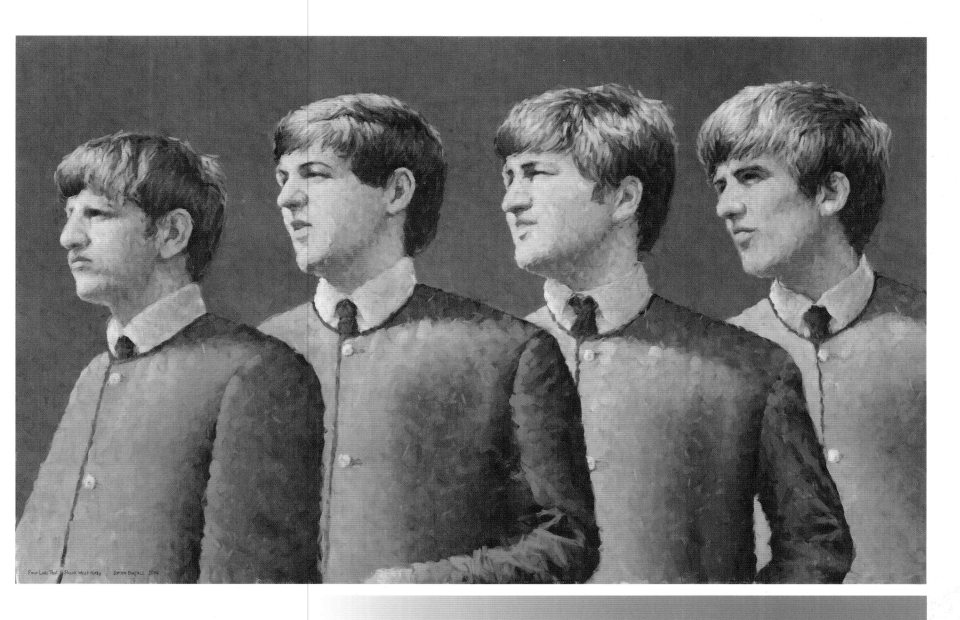

Four Lads That Shook West Kirby    Simon Birtall 2006

*Artist:* Simon Birtall          *Title:* Beatles

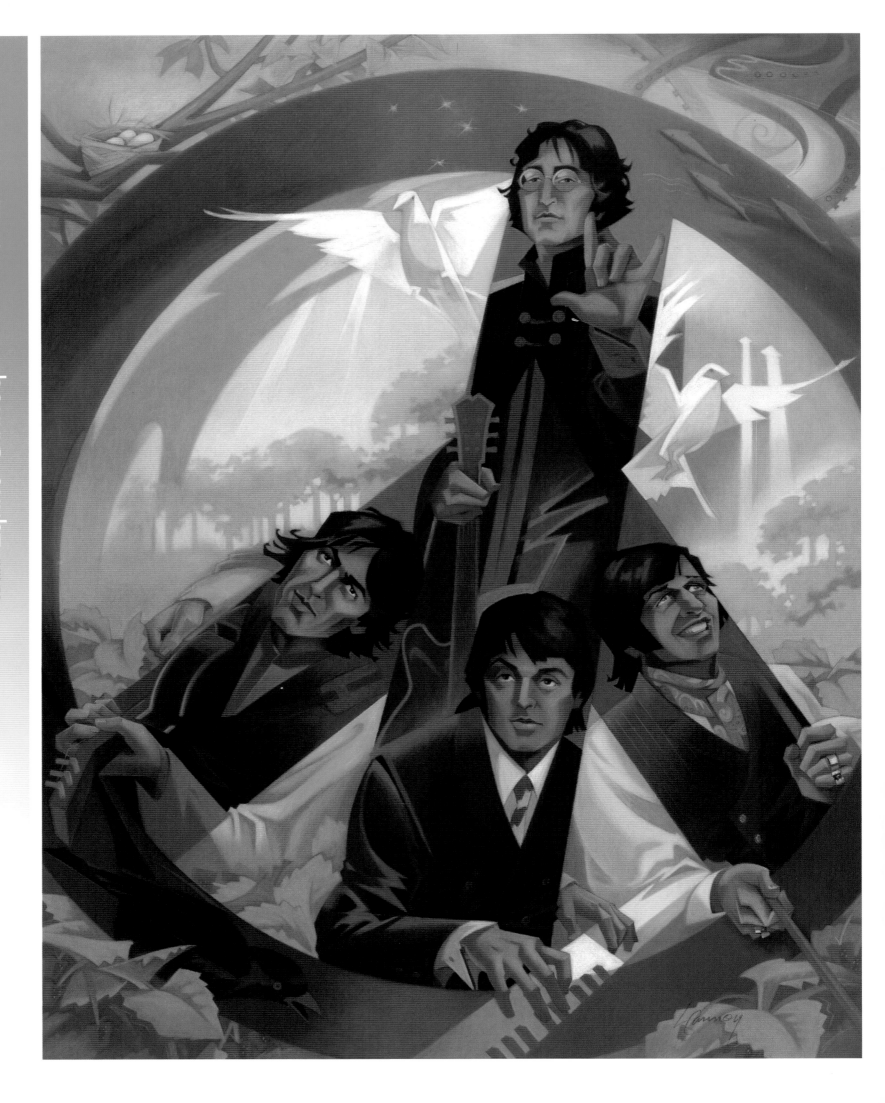

"'Peace. Let It Be' was originally painted for the Pittsburgh Society of Illustrators 'Beatles Generation: An Illustrated Journey' 2005 group show. The theme emerged as a personal proclamation against pointless wars, the use of fear and paranoia to sell them, and the destructive stance toward social and environmental issues. The painting was intended to give voice to the seemingly forgotten notion that peace is rarely attained through aggression, and that patience and wisdom are inextricably linked. It was as much a political statement as an artistic one, which is a tradition with a long history among artists of every stripe.

"The Beatles' contribution to music and the larger culture indelibly etched my memories and my experiences; it reinforced the value of the peaceful soul. Their metamorphosis from lads in a hardscrabble landscape to a force permanently shifting the musical and cultural paradigm strikes a resonant chord, reassuring me that it is possible to make a difference through artistic expression. And throughout a decade of tremendous pressure from stardom and expectation, The Beatles always delivered, never losing their sense of humor and irony in the process. English balladeer Donovan is quoted as saying, 'The Beatles were, and still are, the best friends this planet ever had.'"

Lynne Cannoy

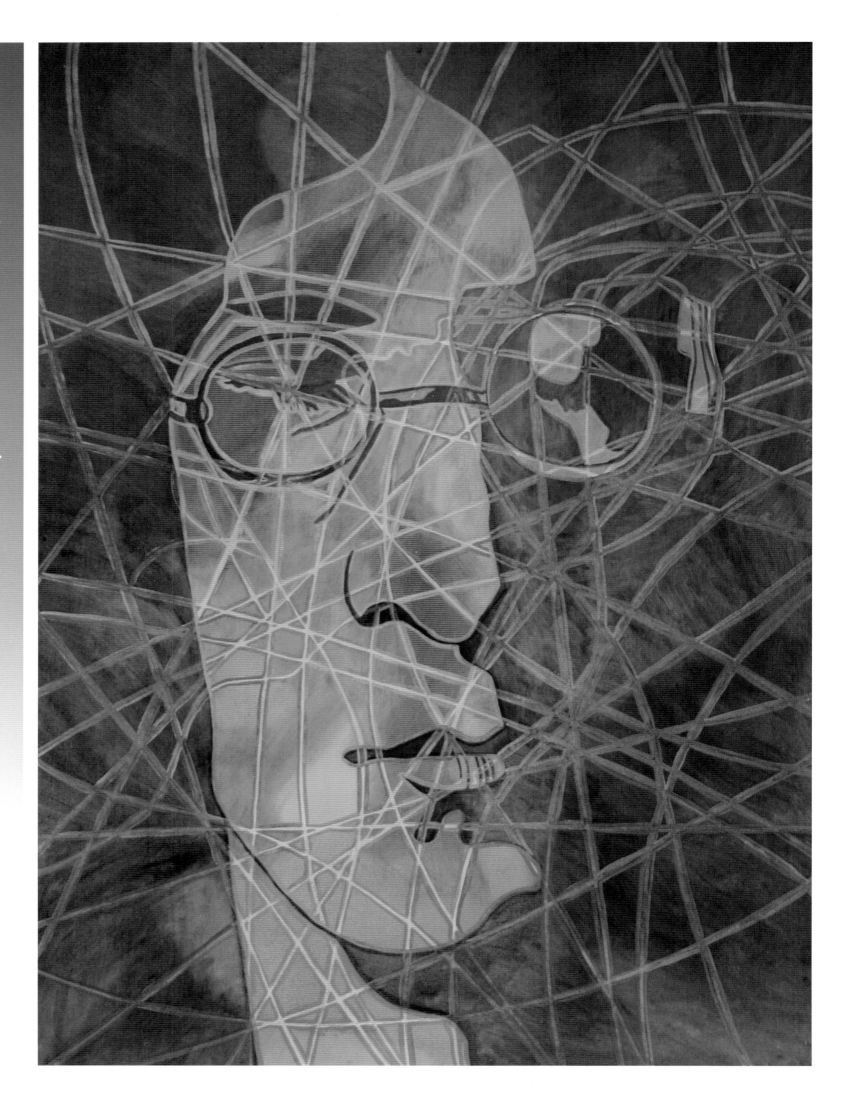

Artist: SERGEY PARFENUK    Title: JOHN LENNON

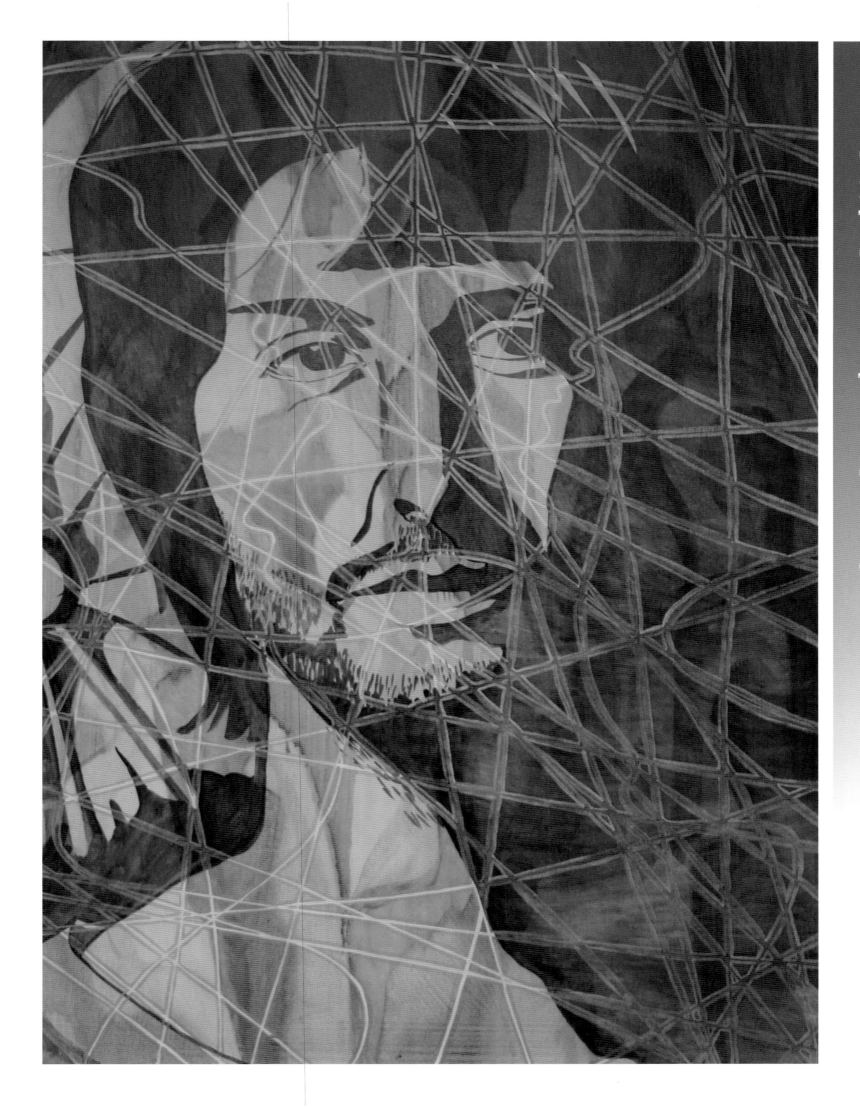

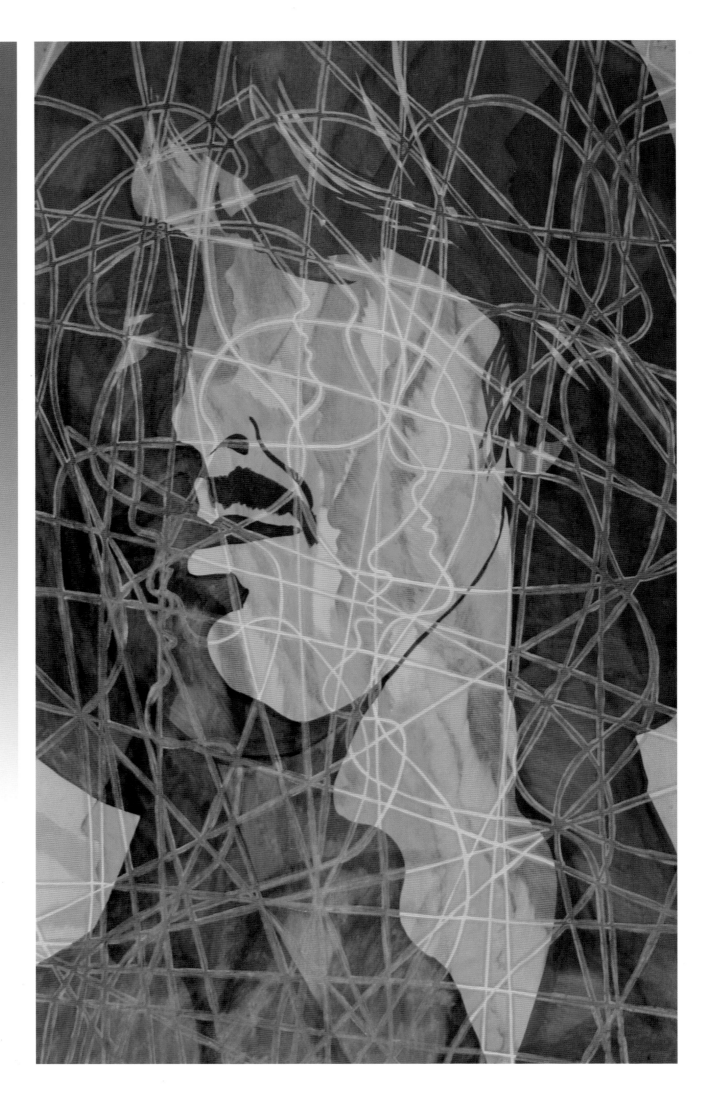

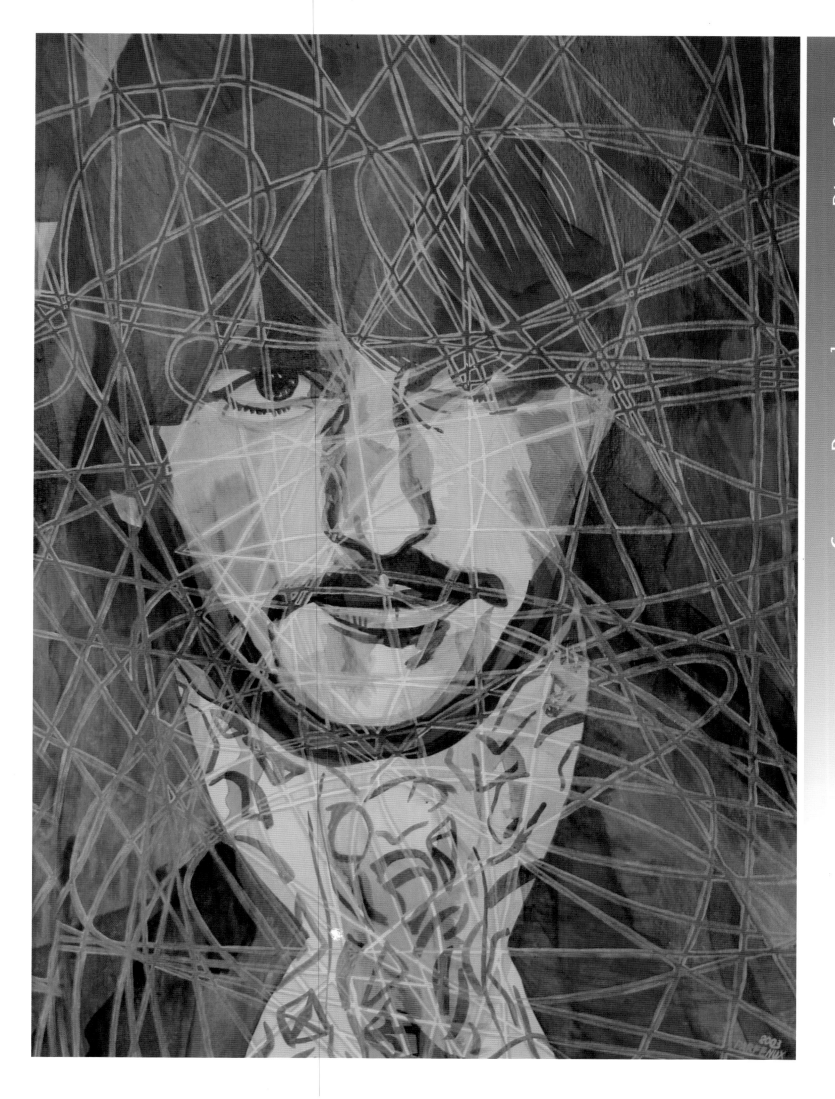

59

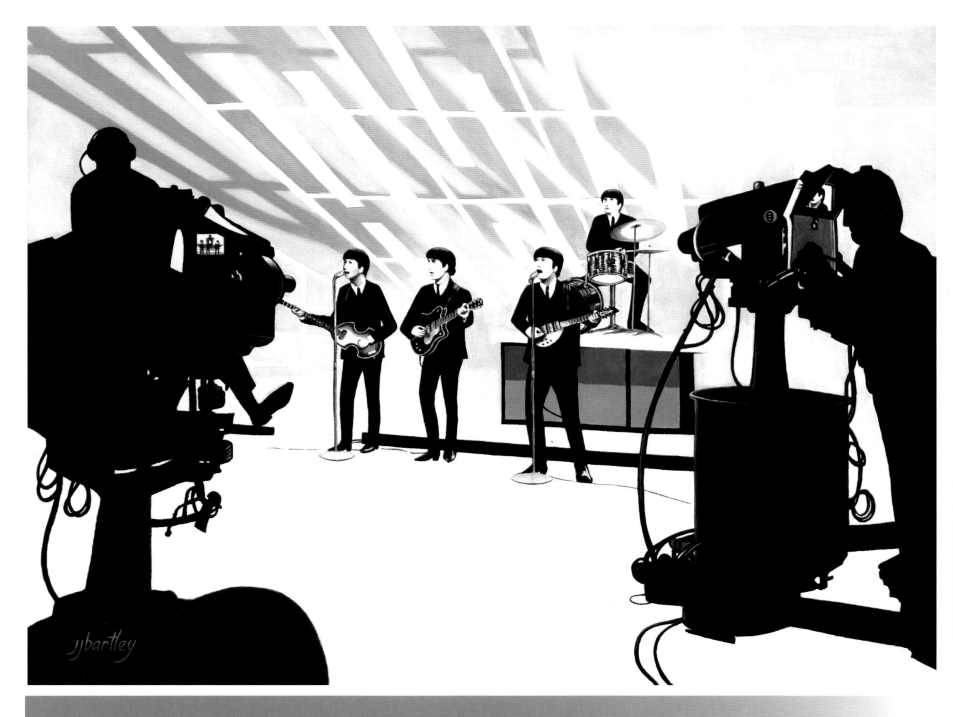

*Artist:* Jock Bartley          *Title:* The Night The World Changed

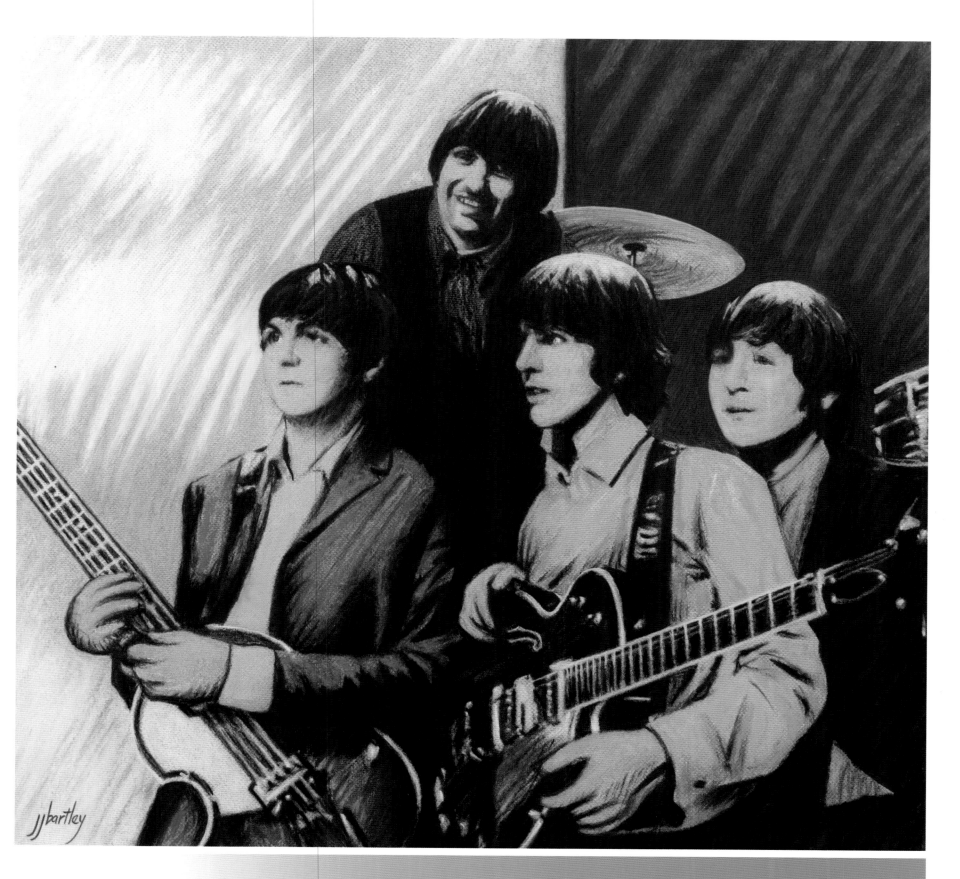

*Artist:* Jock Bartley  *Title:* Between Takes

"The Beatles' influence on my life started at an early age, though the year I was born, unfortunately, coincided with the year of their separation. Knee-high to a grasshopper, I remember listening over and over to a sleeveless 'Hard Day's Night' LP what was supposed to belong to my mum, an original 'Cavernite'. It transpired later that the missing sleeve for the LP belonged to my auntie, who unfortunately reclaimed her record to go with her sleeve. As a nice auntie, though, she let me continue to listen to it, along with her copy of 'With The Beatles'. I finally got around to buying my own copies of all the Beatles original British LPs when I was around 10 or 11 and pretty much wore them all out. I loved the Beatle TV cartoons and eagerly anticipated the next BBC screening of Beatles' films.

"I don't like to analyze things too much, so I've never questioned why The Beatles have meant so much to me throughout my life. I just know that their records make me happy and that I both like and admire them as people. That seems enough. They seemed like a fun, down-to-earth bunch. Their achievements, fitting in so much into such a short space of time and pushing themselves to their creative limits is an inspiration to anyone seeking to achieve something with their lives.

"The Beatles provide a fascination that only continues to grow. Though I don't like to think of myself as an obsessive fan, as an owner of four or five copies of the same albums in various formats, shelves full of Beatles books, and countless other paraphernalia—such as the Yellow Submarine die-cut jotter which I'm currently sadly making notes on—I do accept that I have some Beatle 'issues'.

"At school I filled sketchbooks full of Beatles images when I should have been out in the open air making studies of trees, passing cloud formations and such. Although I've branched out since in a professional career (in which I thought it more commercially viable and creatively fulfilling to become a painter of family portraits and landscapes), I still enjoy going back to produce some Beatles imagery.

"The image of The Beatles as a group in their collarless jackets was commissioned for display in the 'What's Cutting' hair salon in my hometown of West Kirby, about 10 miles from Liverpool. Back in February 1962, it was a dance instruction hall above a quiet cafe, but for one night only, under the name of the 'Beatles Club', it became the site of The Beatles' first booking arranged by their new manager Brian Epstein."

Simon Birtall

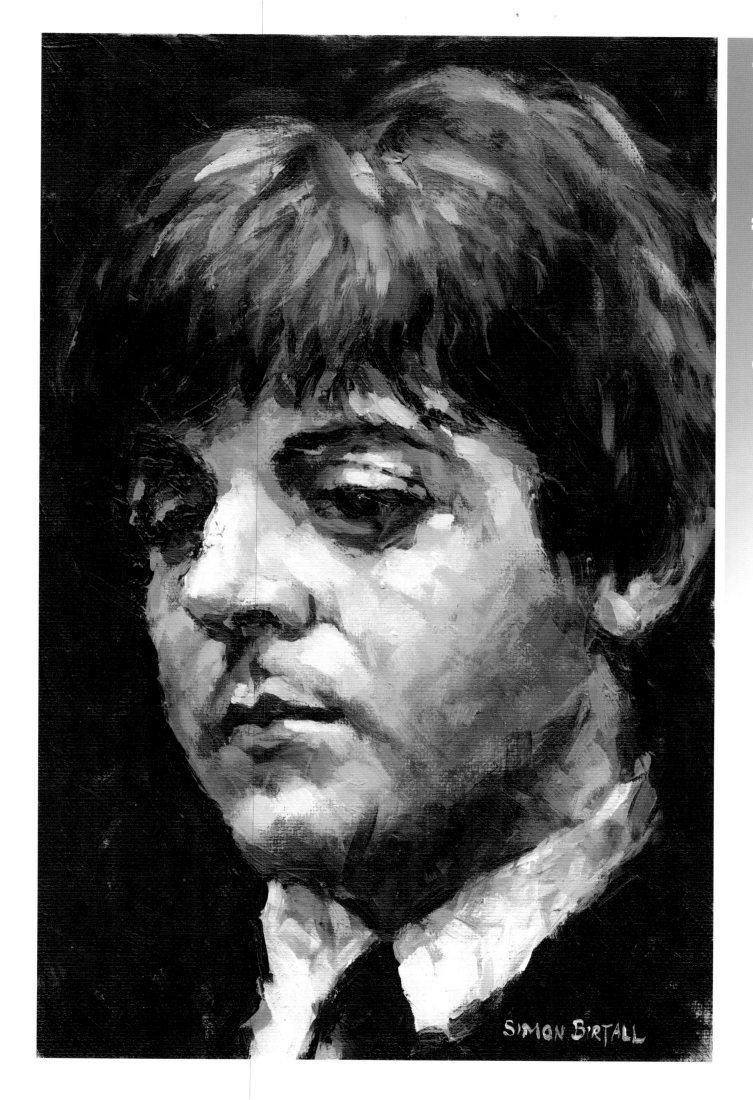

SIMON BIRTALL

Artist: Simon Birtall   Title: Paul

63

Artist: Greg Webb    Title: The Fabs

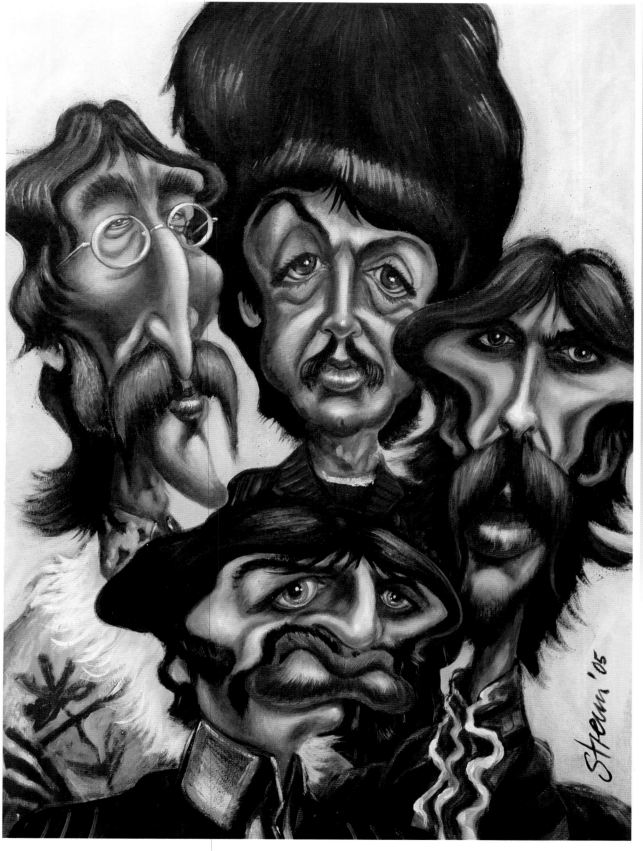

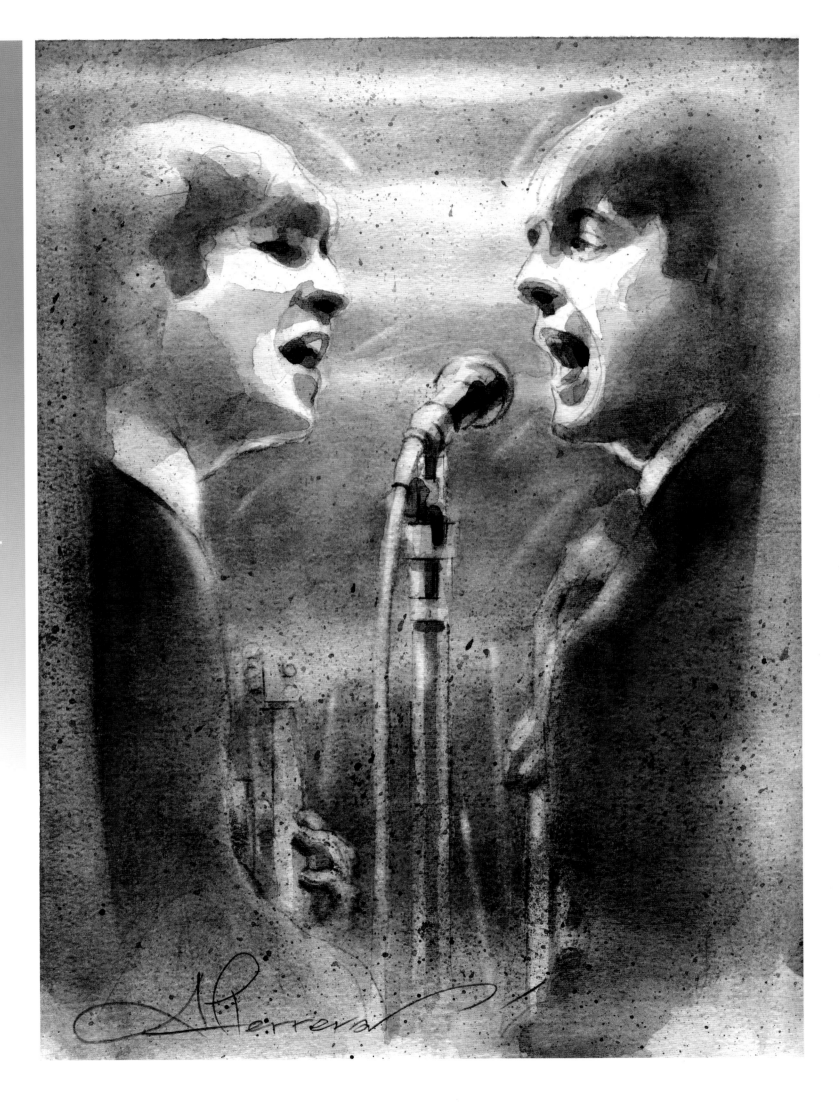

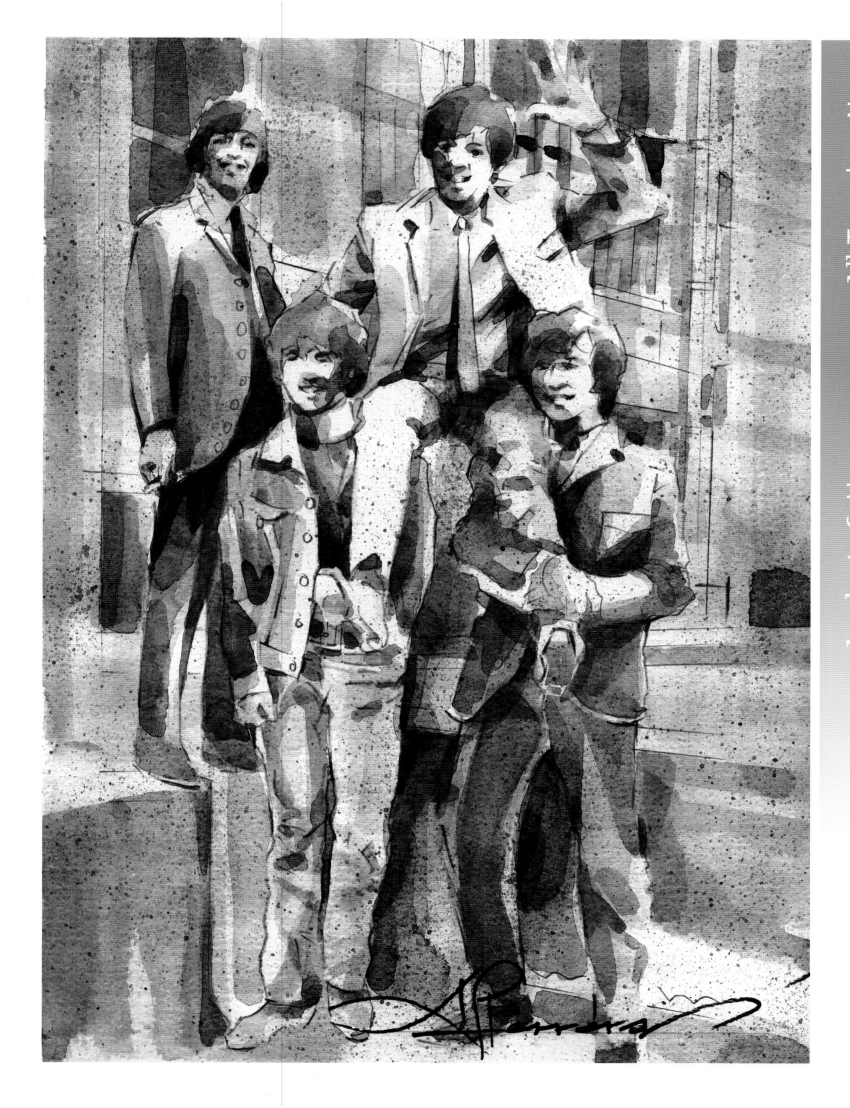

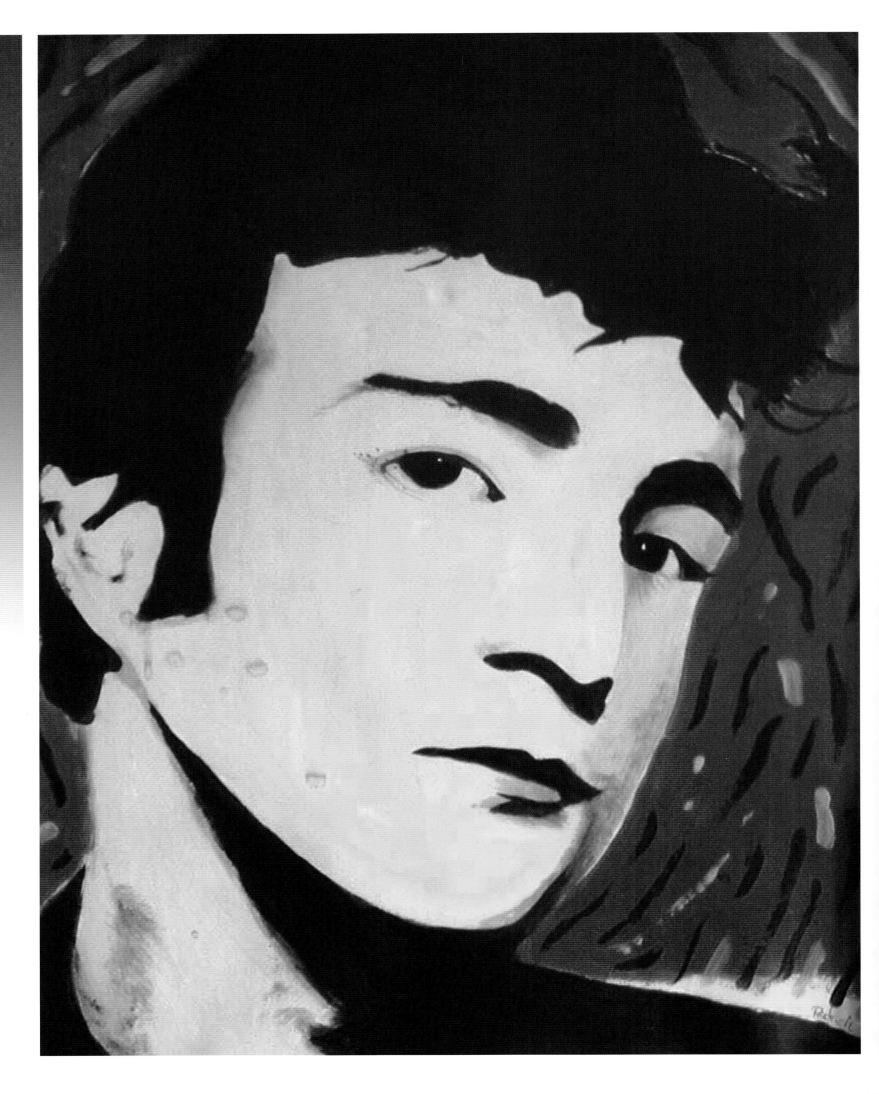

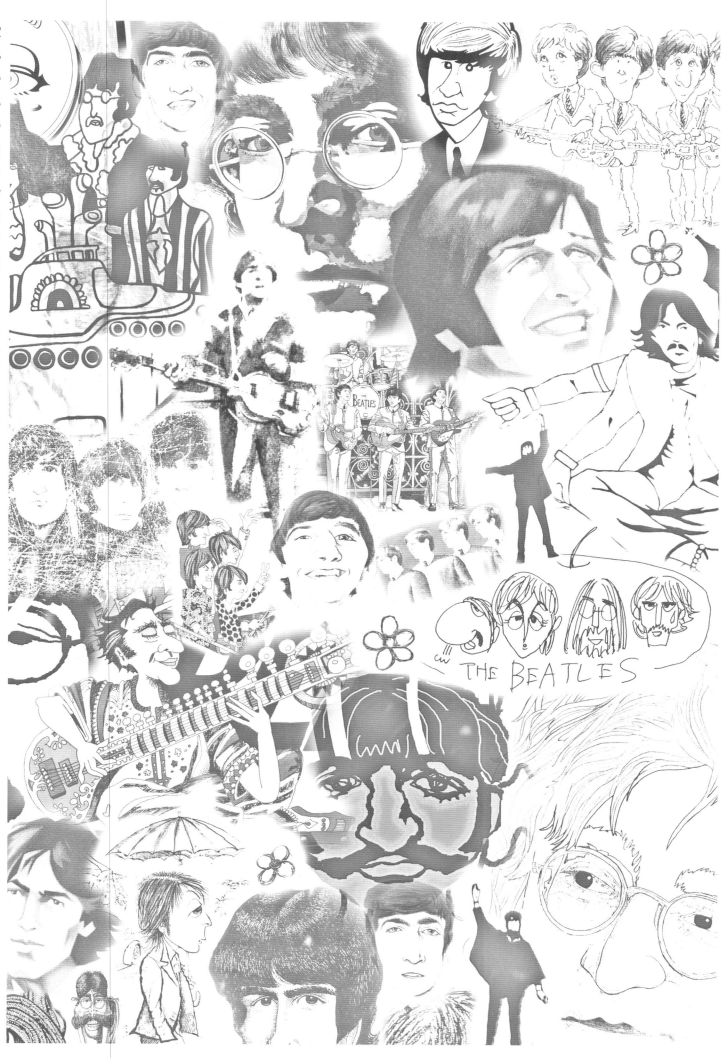

"The Beatles' music speaks for itself; it's timeless. I love the album 'Sgt. Pepper's Lonely Hearts Club Band'. The song 'Lucy in the Sky with Diamonds' is one of my favorite songs: It is cool to paint to. This song has everything for me.

"When I paint or draw my subject, I use the face, but I also use the music. Then I put this inspiration inside my art. I have been drawing for most of my life and will never stop—it's cool. I always have my art, and no one can take that from me.

"When I listen to The Beatles, I get a sense of freedom, just like when I paint."

Patrick Burke

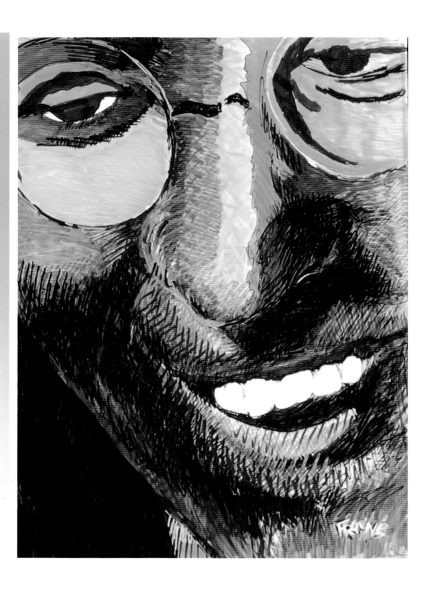

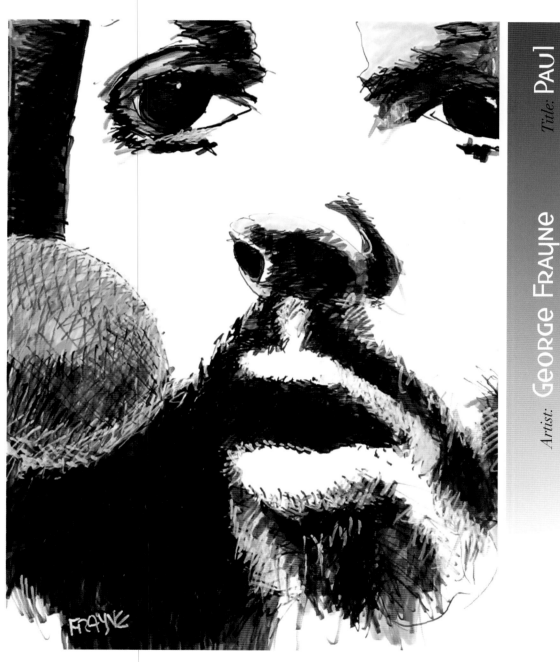

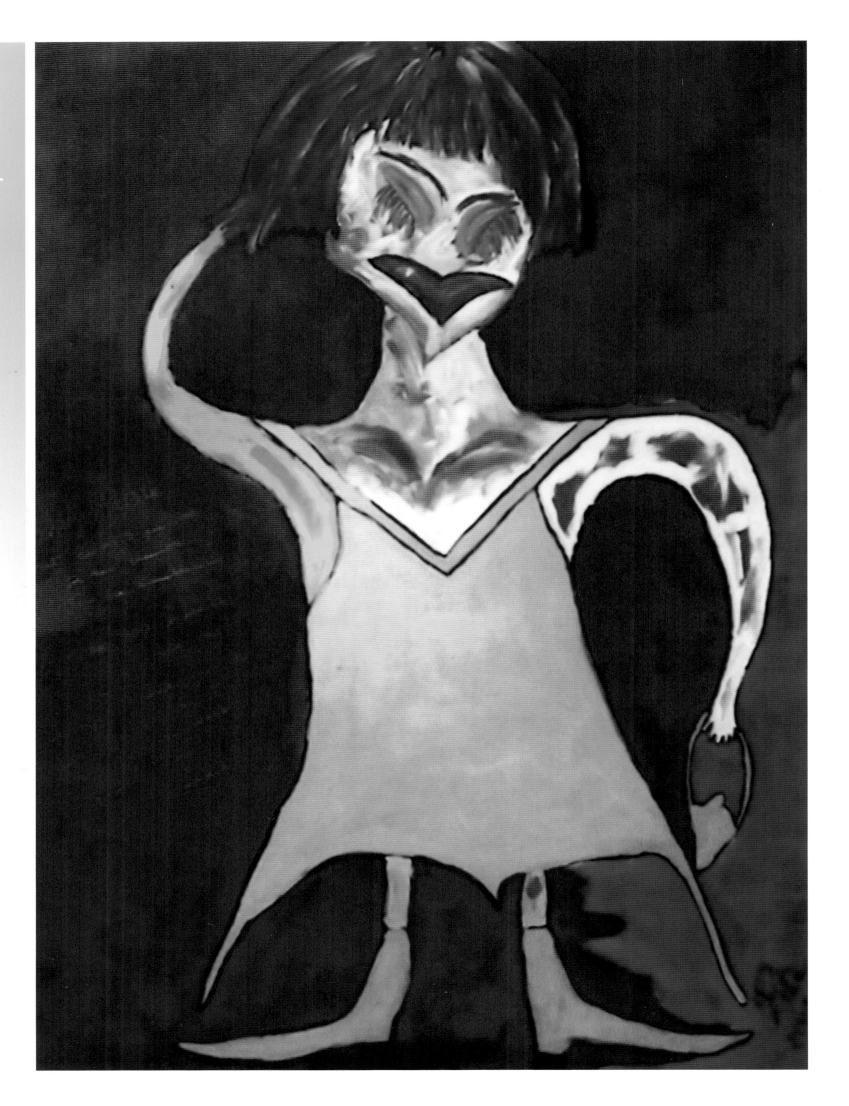

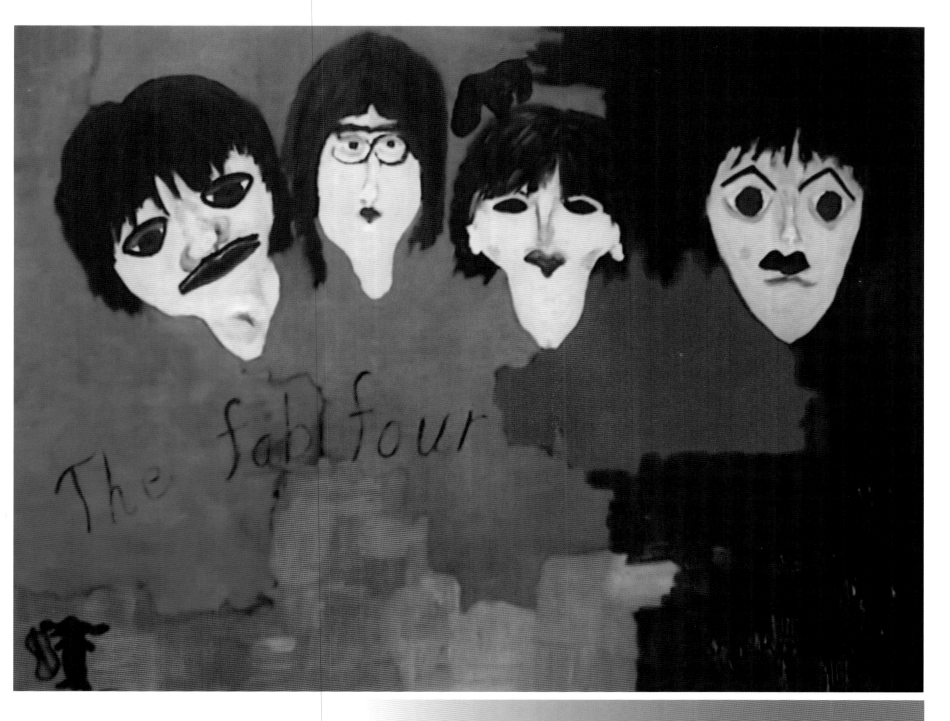

*Artist:* Peta Wright          *Title:* The Fab Four

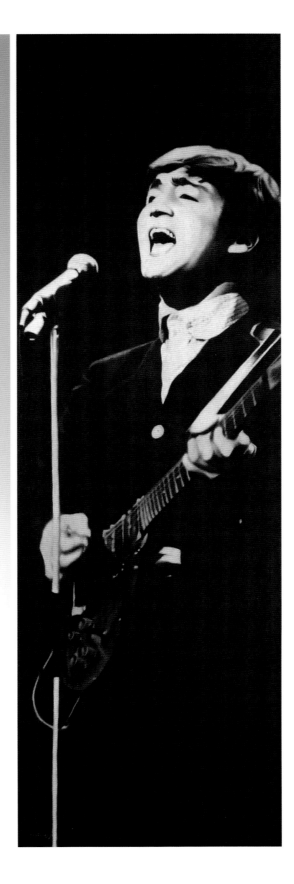

*Artist:* Dave Scott  *Title:* John Lennon

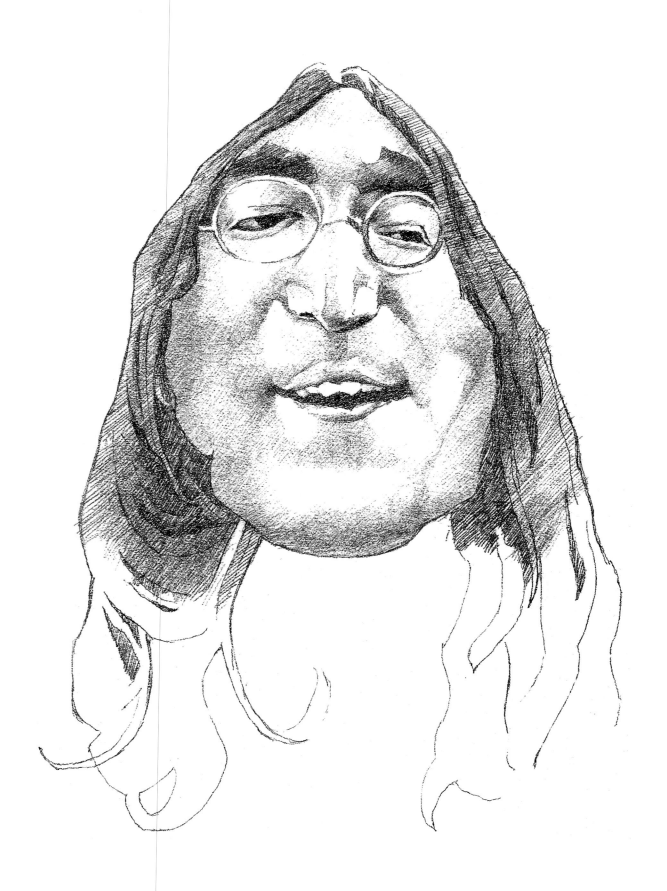

Artist: Dave Scott          Title: Lennon Sketch

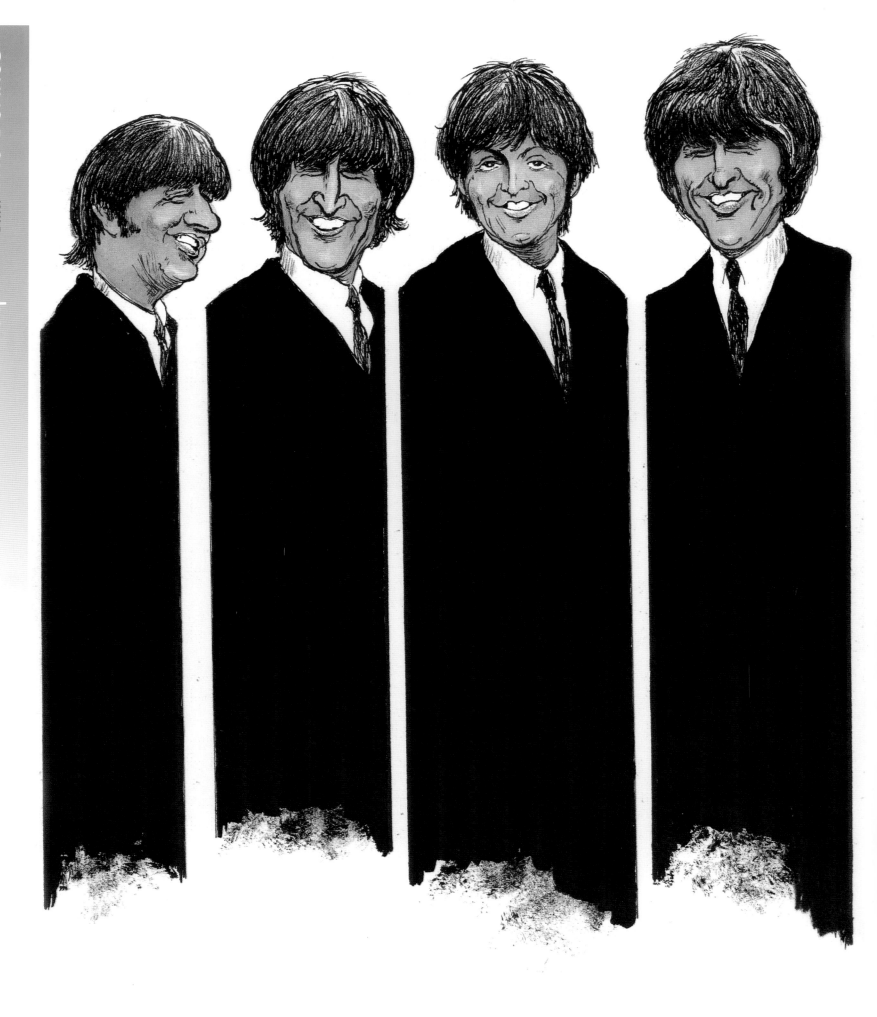

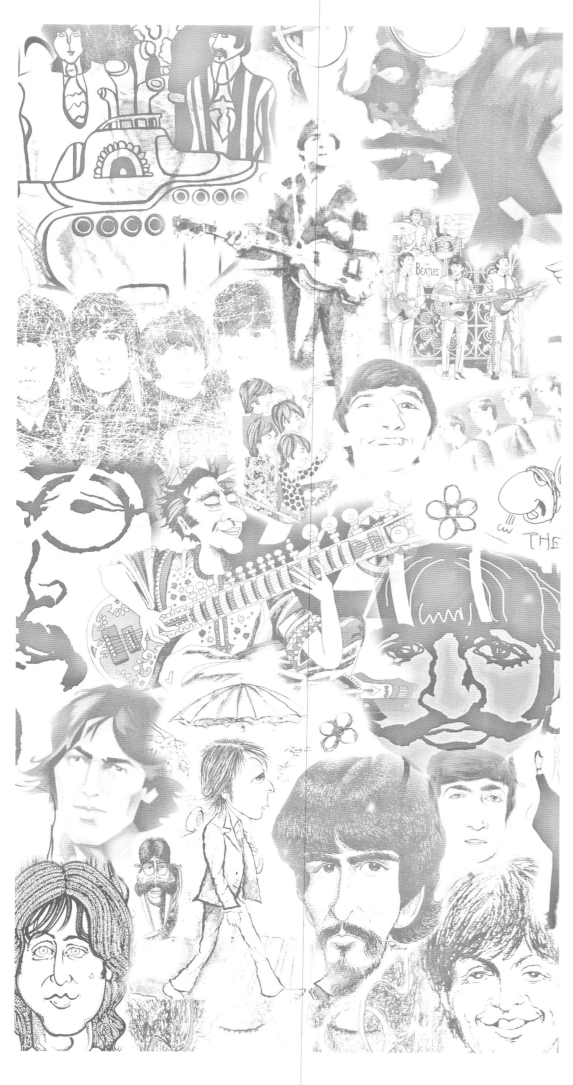

"As a young person I was inspired by The Beatles' continual work toward perfecting their art. As I began my own art career, I saw the similarities in every artistic outlet: drawing, filmmaking, writing, music composition.

"Creating something is an act of faith. An artist in any medium begins at the same place and must believe in his or her skills to bring life to the creation, whether it's a cartoon, a movie, literature, or 'Love Me Do.'"

George Danby

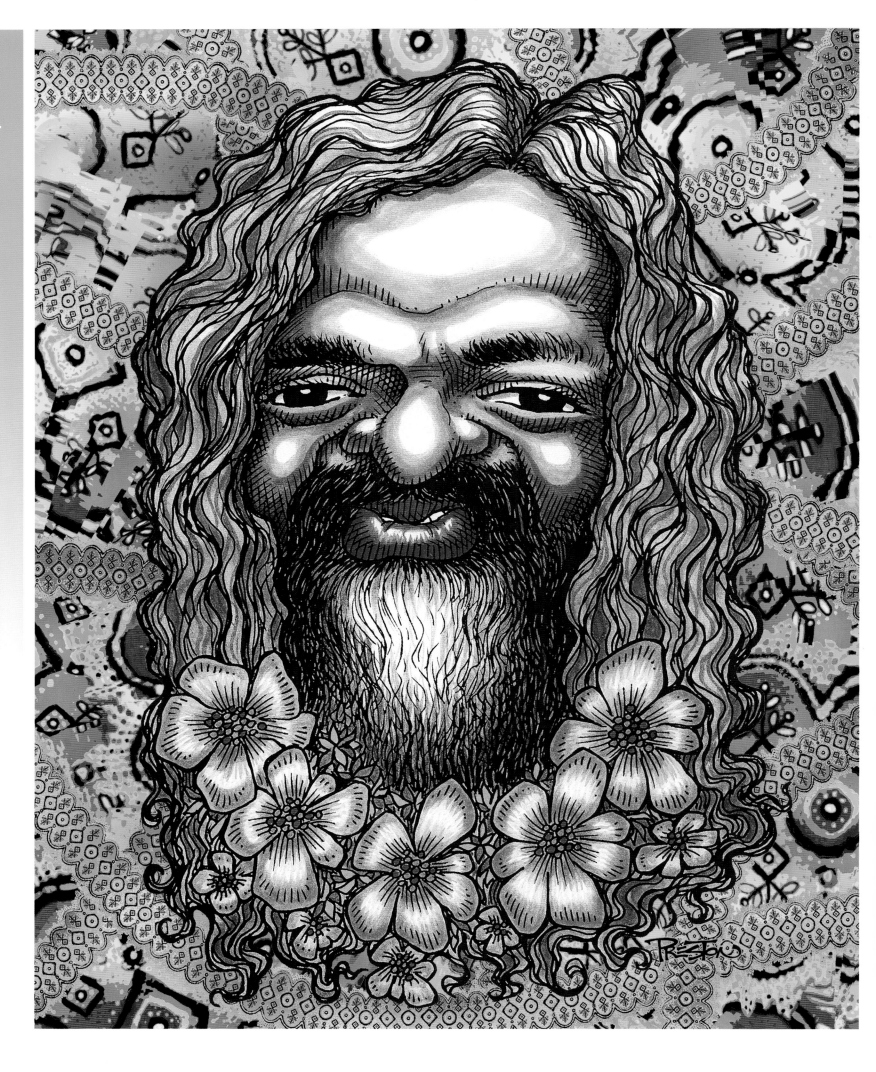

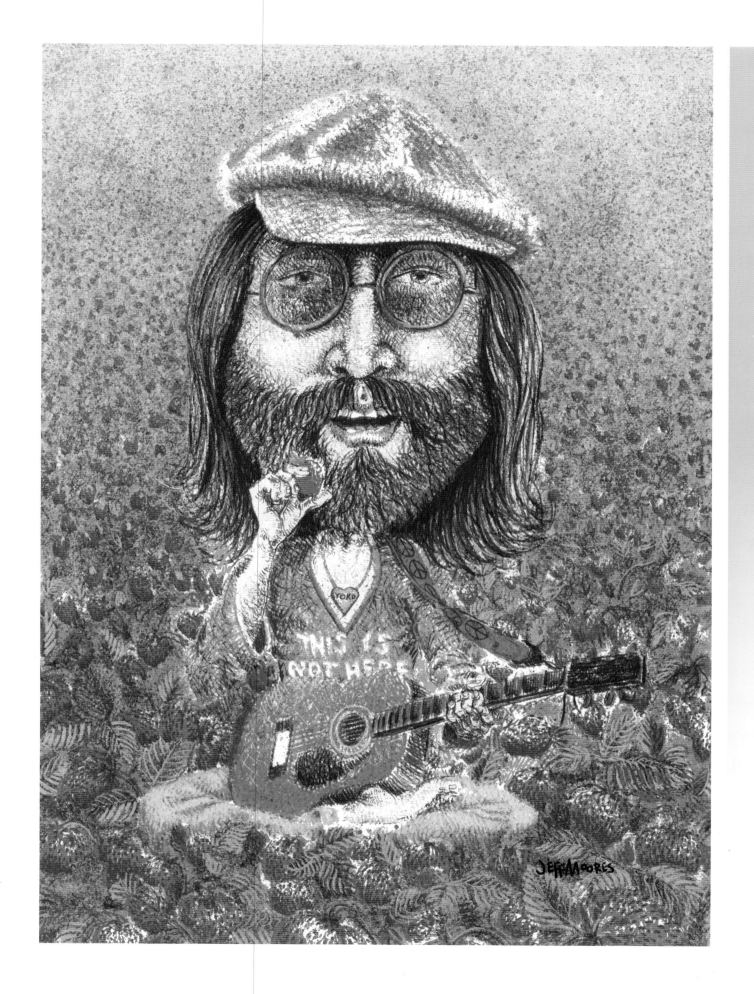

To/A:

From/De:

5-10

*Artist:* ANDREA FUHRMAN        *Title:* TICKET TO RIDE

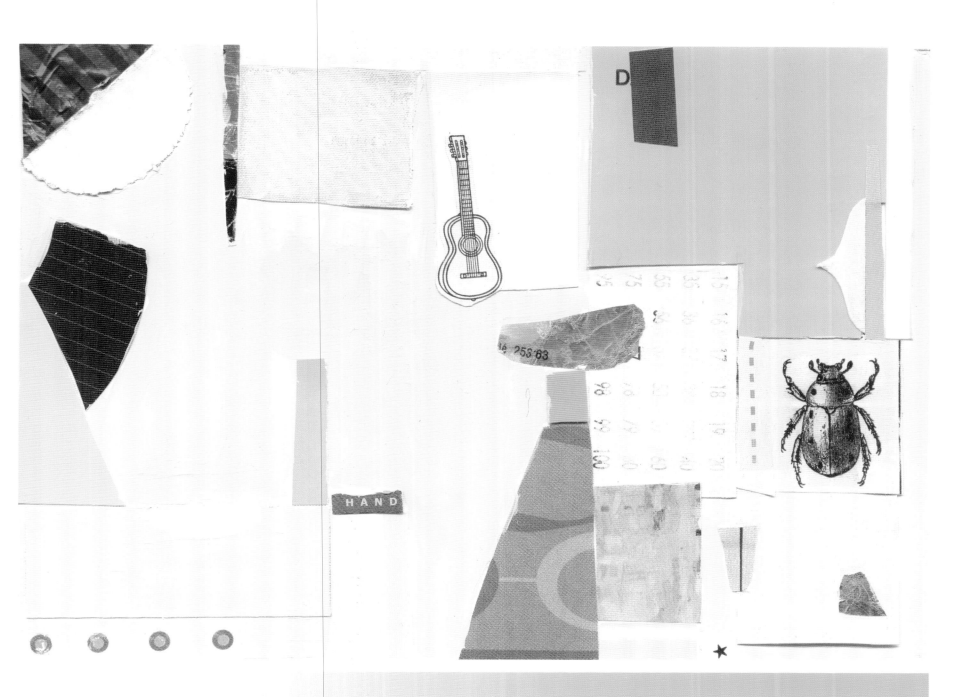

Artist: ANDREA FUHRMAN          Title: BEATLES MEMORIES

Artist: ANNE PROVOST    Title: GEORGE HARRISON AND & THE BEATLES

Artist: ANNE PROVOST     Title: Give Peace A Chance

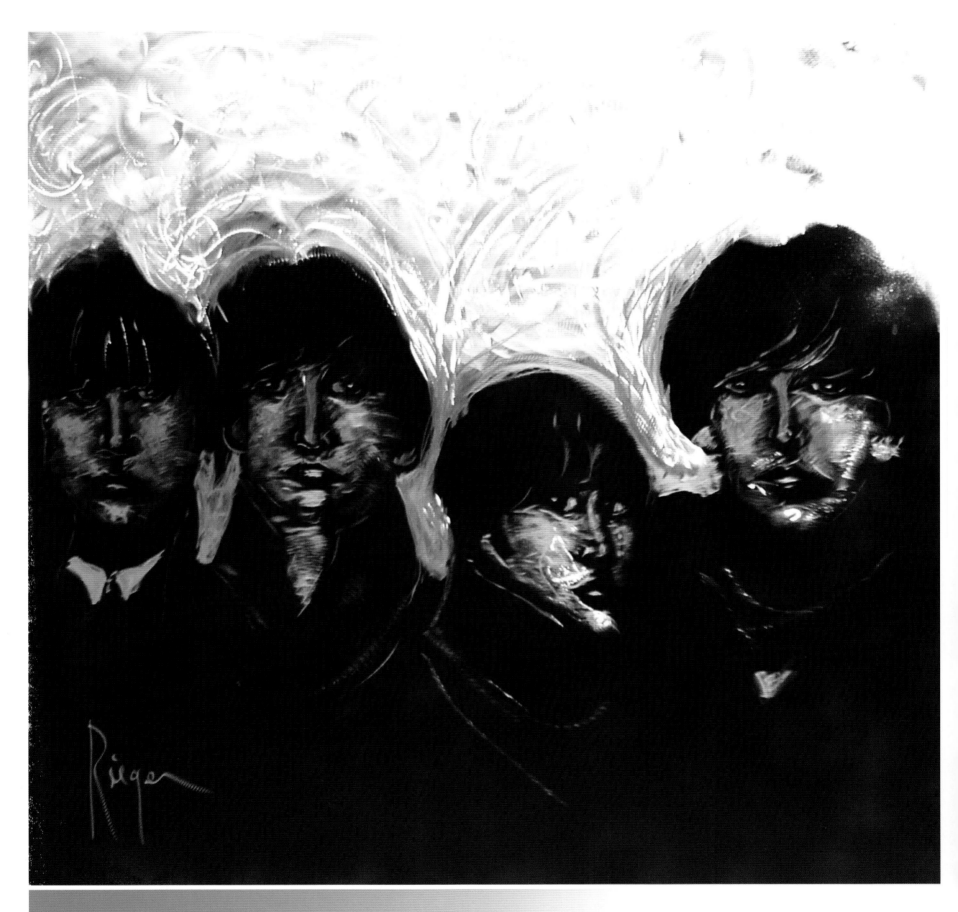

Artist: **Erik Rieger**    Title: **Beatles**

*Beatles metal etching (16 grade steel – 48"X 48") created live at an art street festival in Denver, Colorado in September 2005.*

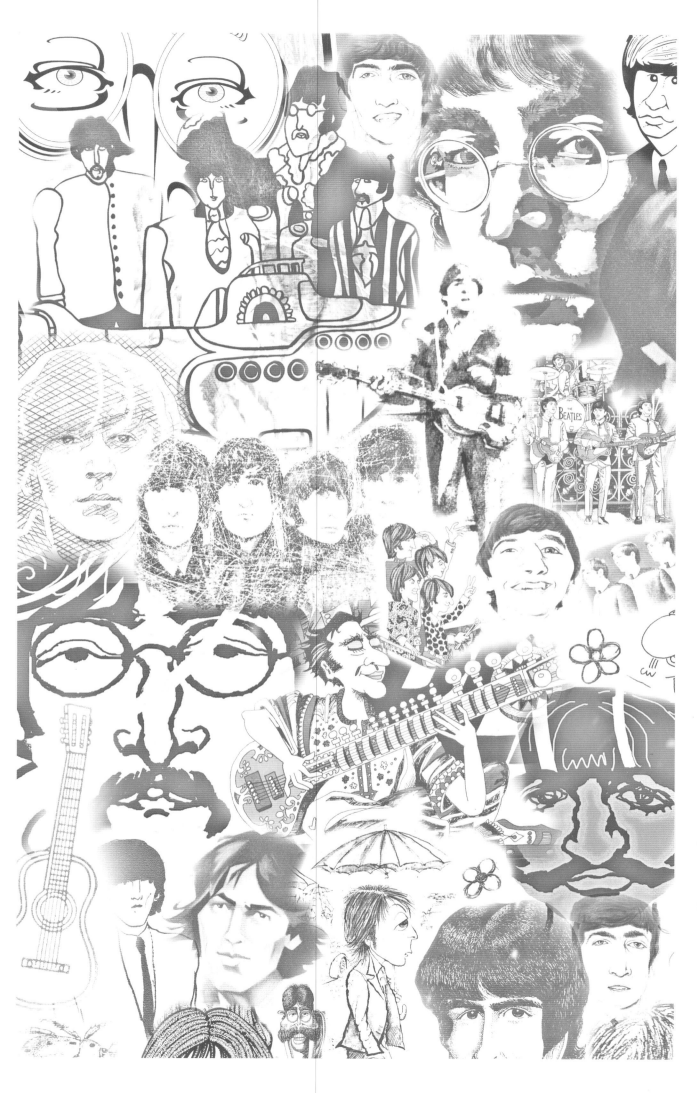

"How have The Beatles influenced my art?

"A simple question, but as complex as asking a plant how has the sun influenced you.

"As an artist and a musician, The Beatles were my introduction to music. The first 45 I owned was 'Love Me Do'. Someone once said all art should strive to emulate music. For me it is the siphon that every idea is filtered through. I could write pages on the fusion of art, music and philosophy of The Beatles, but what impresses me most is their unique appeal. For not only did they speak to my generation, but my parents enjoyed them equally, and even my grand parents found some of their songs appealing.

"Like great works of art there is no limit to their audience."

Erik Rieger

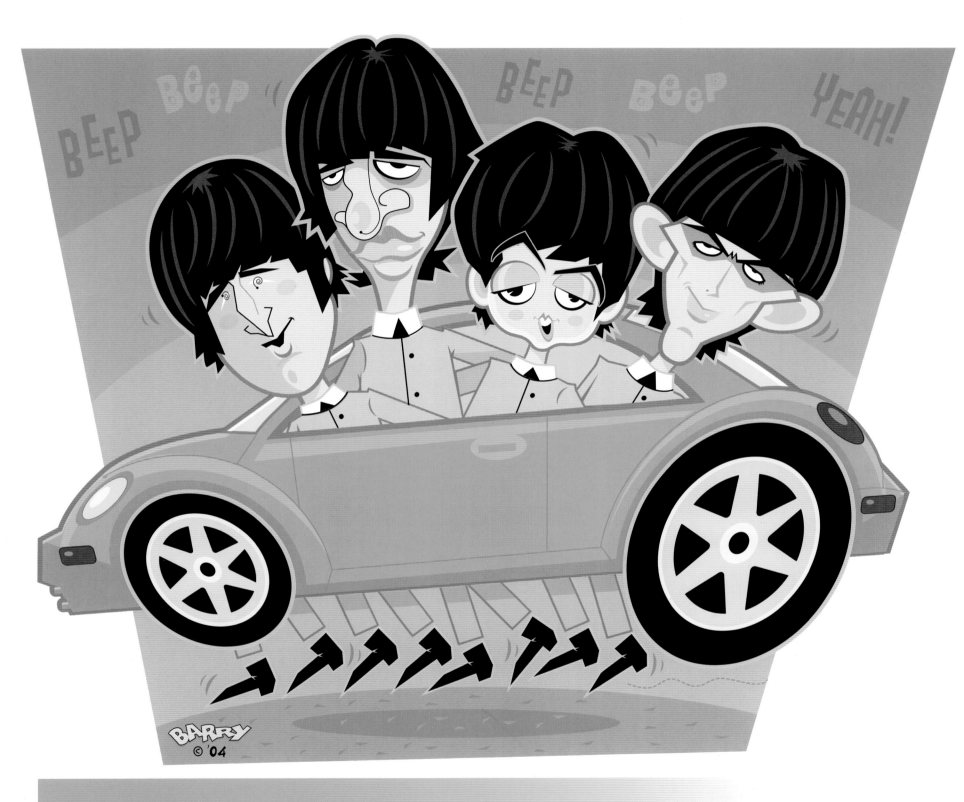

Artist: Rich Barry    Title: Beatle Beetle

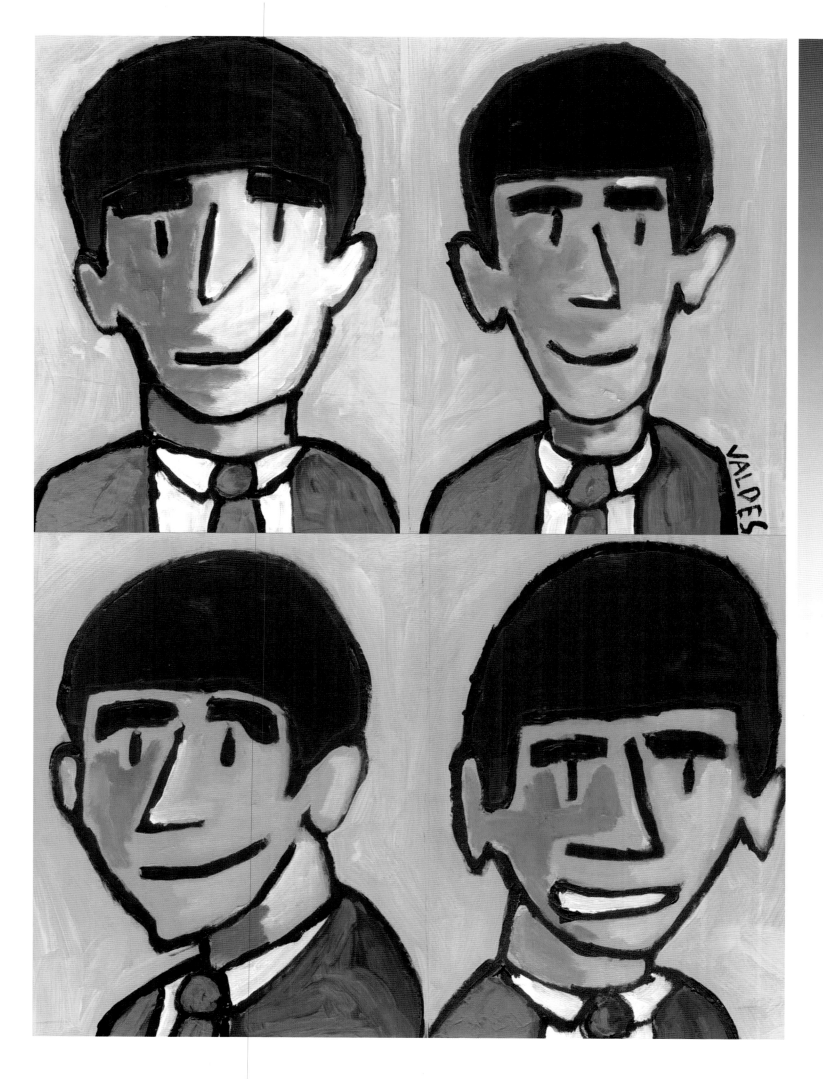

"Whether one is aware of it or not, everyone has their own soundtrack. Like in a movie or television show, a musical piece will appear, carefully selected to compliment the scene to help convey the mood and tone. Everyone has one. An appropriate song will appear in one's mind during the most mundane task like cutting the grass or taking out the trash. Sometimes the soundtrack will come out to play in the form of a whistle, humming or sometimes a louder solo performance — in the shower.

"My soundtrack is also my inspiration and my passion behind my art. For me it's always been the Beatles. Whether it's their compositions as a band or their extensive solo work, the Beatles' creations have been the music 'in my life' from the beginning.

"When I was an infant, my mother would place me in my playpen with my toys during the day while she took care of things around the house. One fall day, my mom placed me on my back in my playpen so she could play her new record 'A Hard Day's Night'. Shortly after I heard that distinctive G chord ringing out on that Rickenbacker 12-string, I grabbed the bars on the side of my crib, pulled myself up to my feet, and started dancing! My mother was amazed! Her baby was standing for the first time. Of course, when the song was over I crashed to the floor of my playpen, but that's a whole other story. From that point on, I was sold on those four guys with the cool haircuts.

"I grew up in an artistic and musical home. I watched my father paint and create caricatures with a passion that you could feel coming off of the paper. At the time, I often wondered what his soundtrack was. I learned the art of caricature from watching my father, who even had Al Hirschfeld sit to have one done.

"I consider myself a 'face specialist' while stylizing the human form to give one-dimensional figures the fluidity and illusion of motion. I try to capture not only their likeness, but their personality. For that you have to get the eyes just right—even if I draw them with just two dots. I feel that the eyes are the window to the soul.

"That is why I love creating illustrations and caricatures of The Beatles: four distinctly different, strong personalities for me to capture and interpret on paper. I have never met any of them, yet, like any true Beatle fan, I feel as if I have. Their lyrics are their thoughts, confessions, fears, and dreams written down for all of the world to see. And their music has been written, performed and recorded to become the world's soundtrack. At least it has been for me."

Anthony Parisi

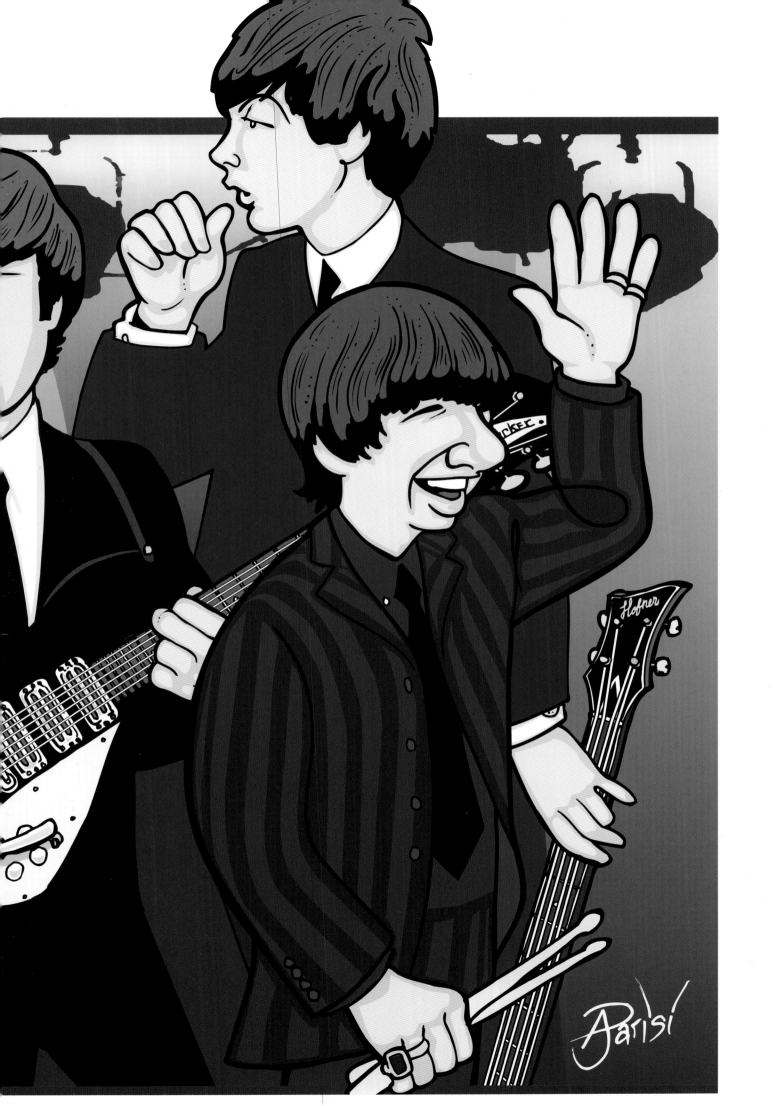

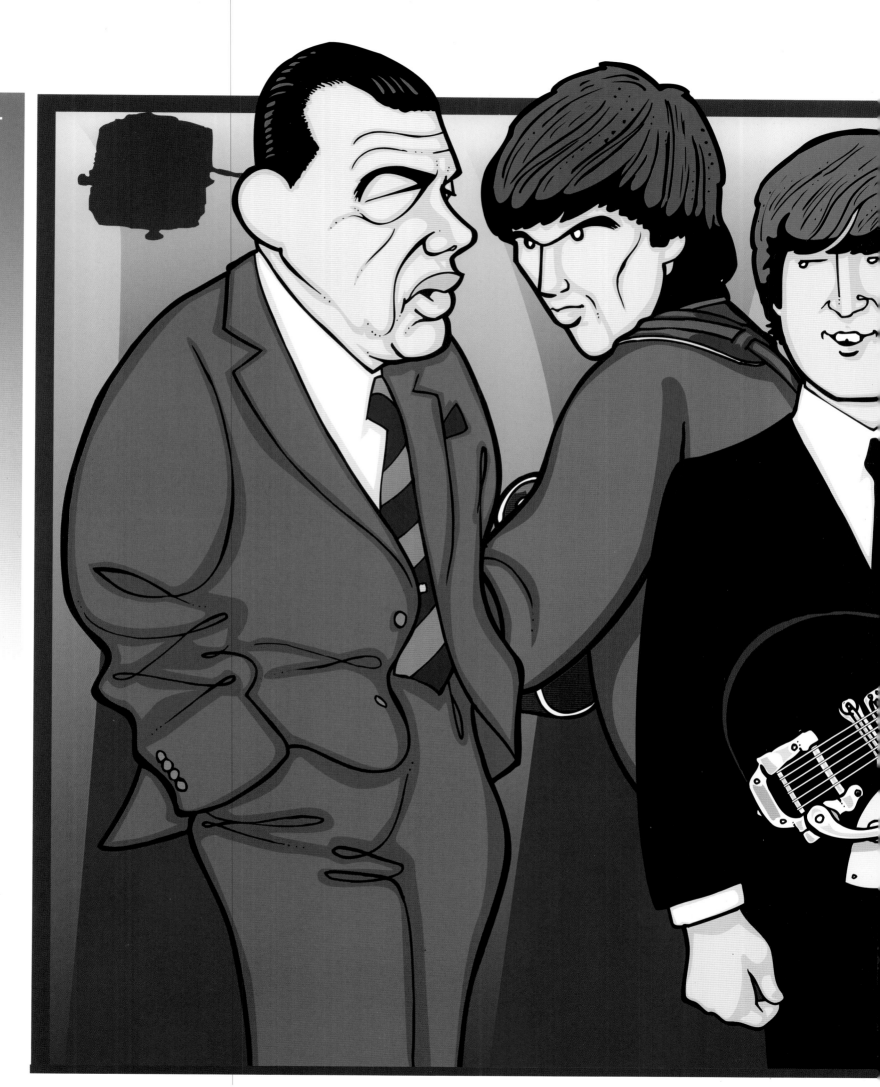

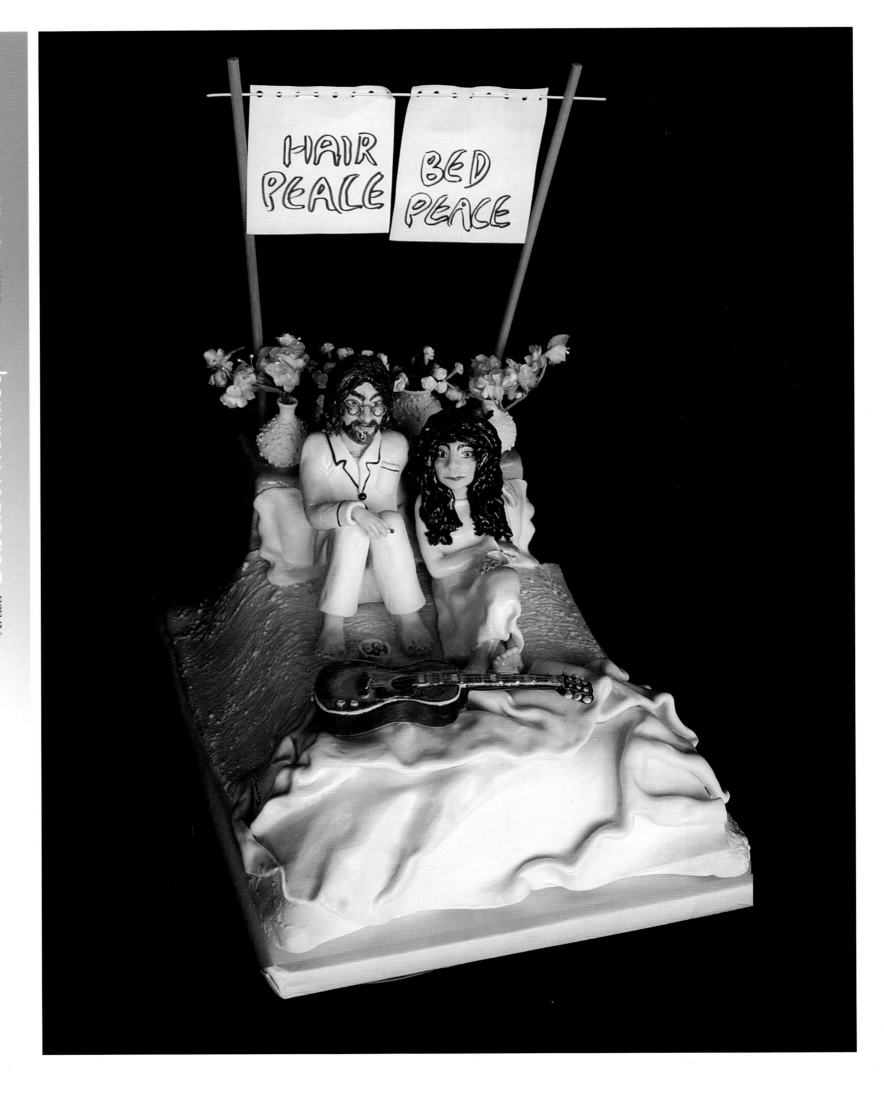

*Artist:* Deborah Parmley    *Title:* Peace Politicians

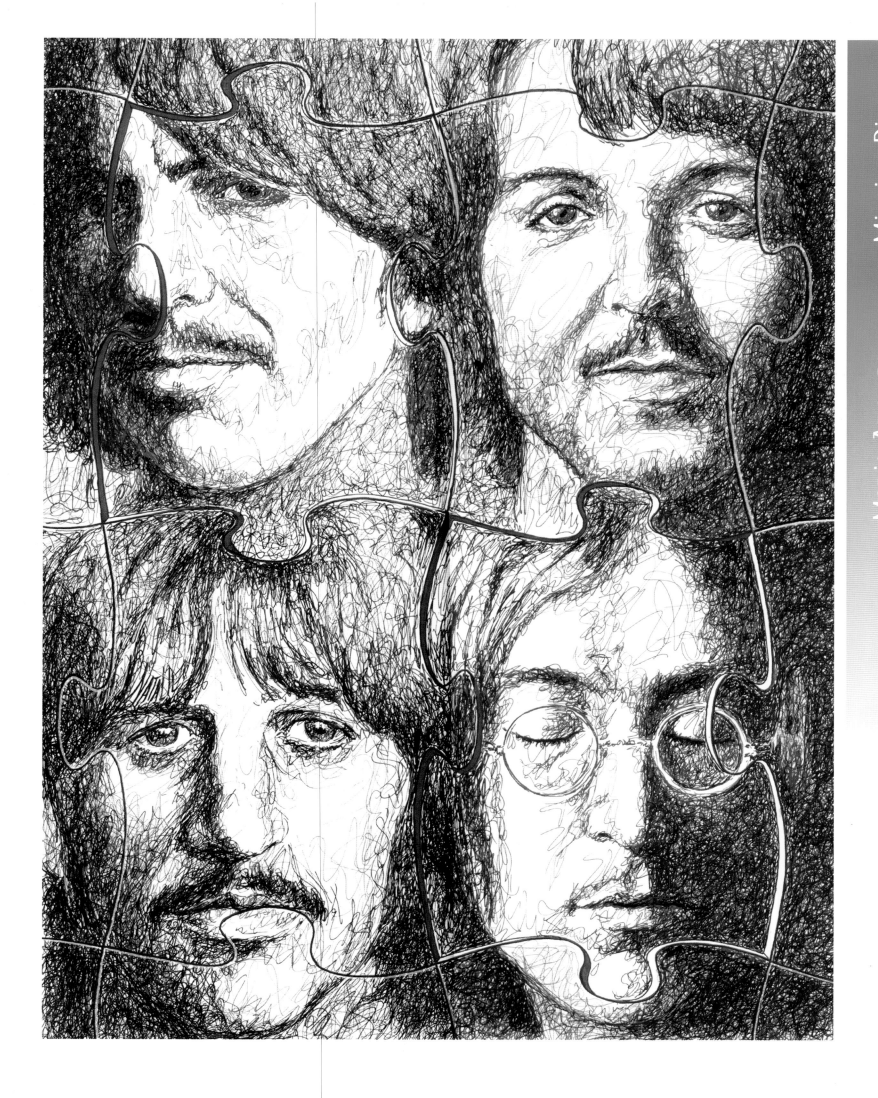

*Artist:* Maria Arango      *Title:* Missing Pieces

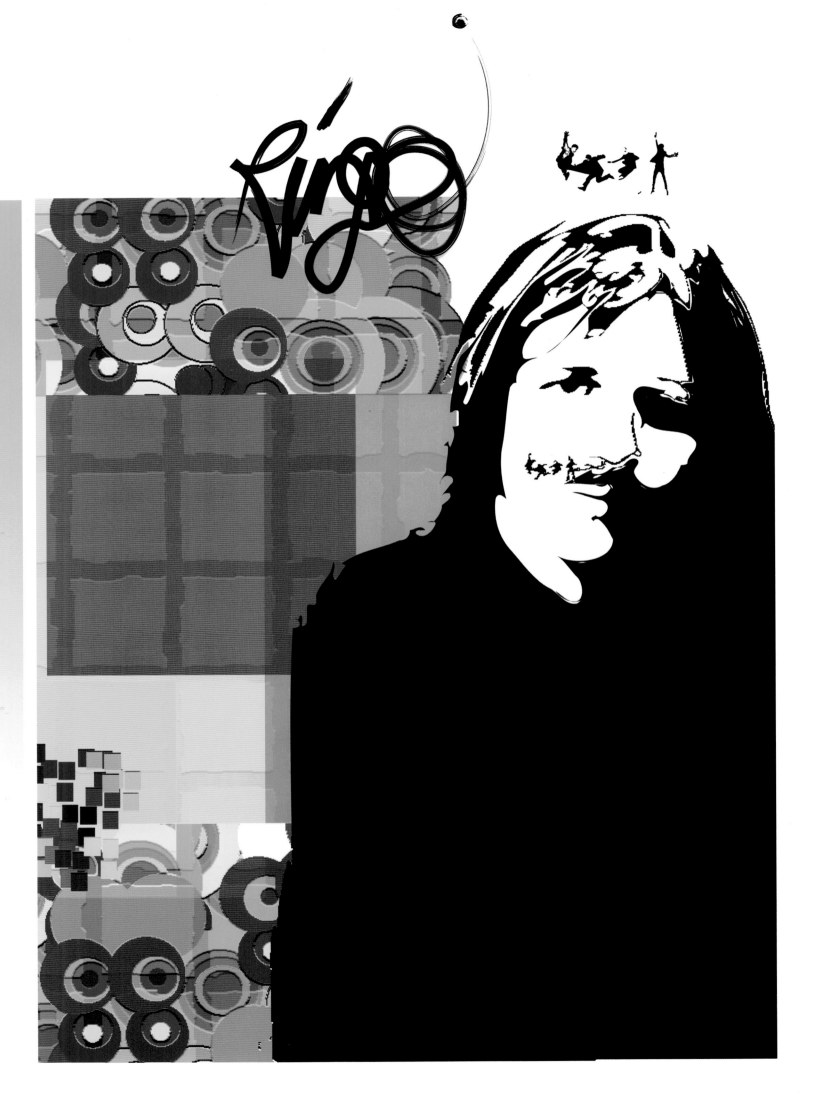

*Artist:* Emma Hicks

*Title:* RiNGO

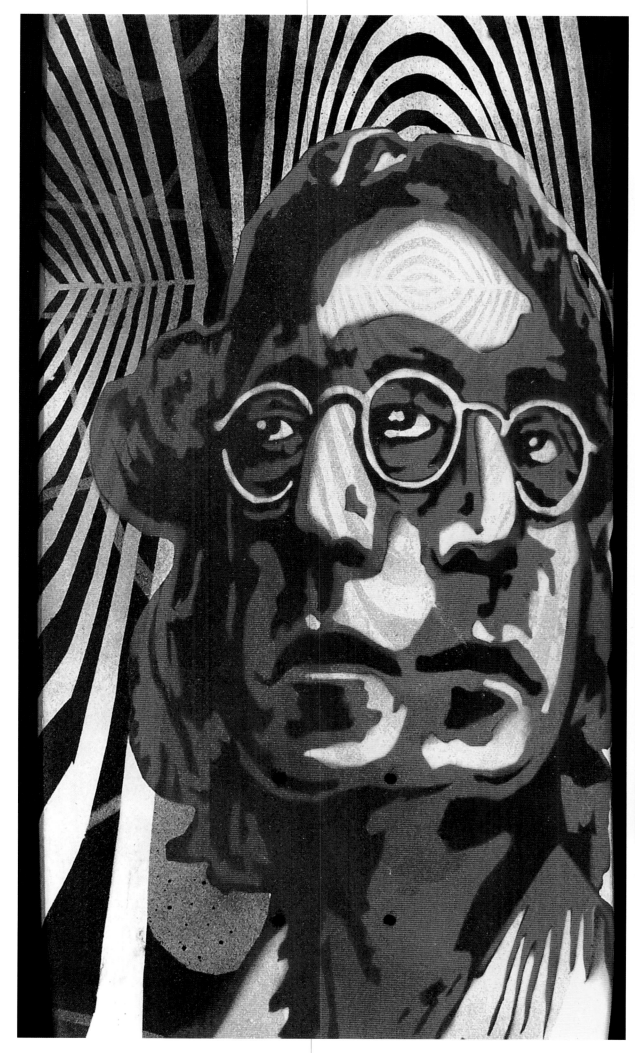

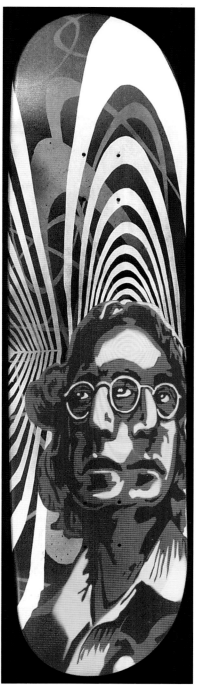

Artist: Eric Pitt

Enamel and polyurethane
on wood (Skateboard)

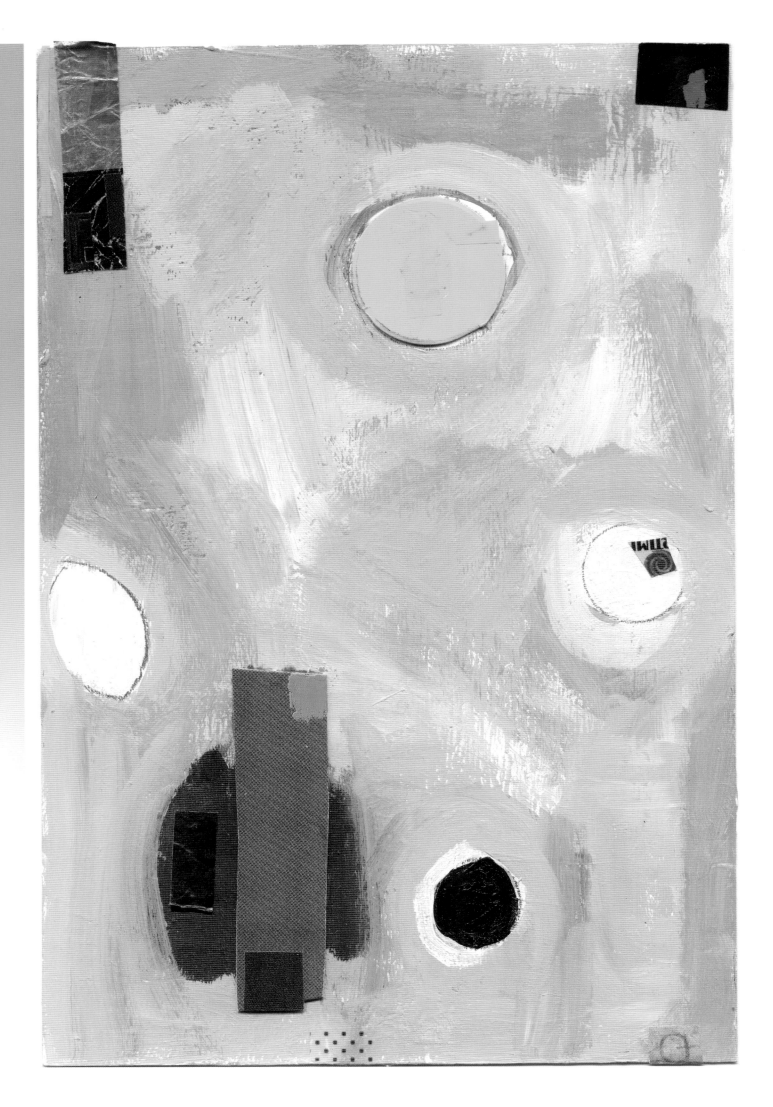

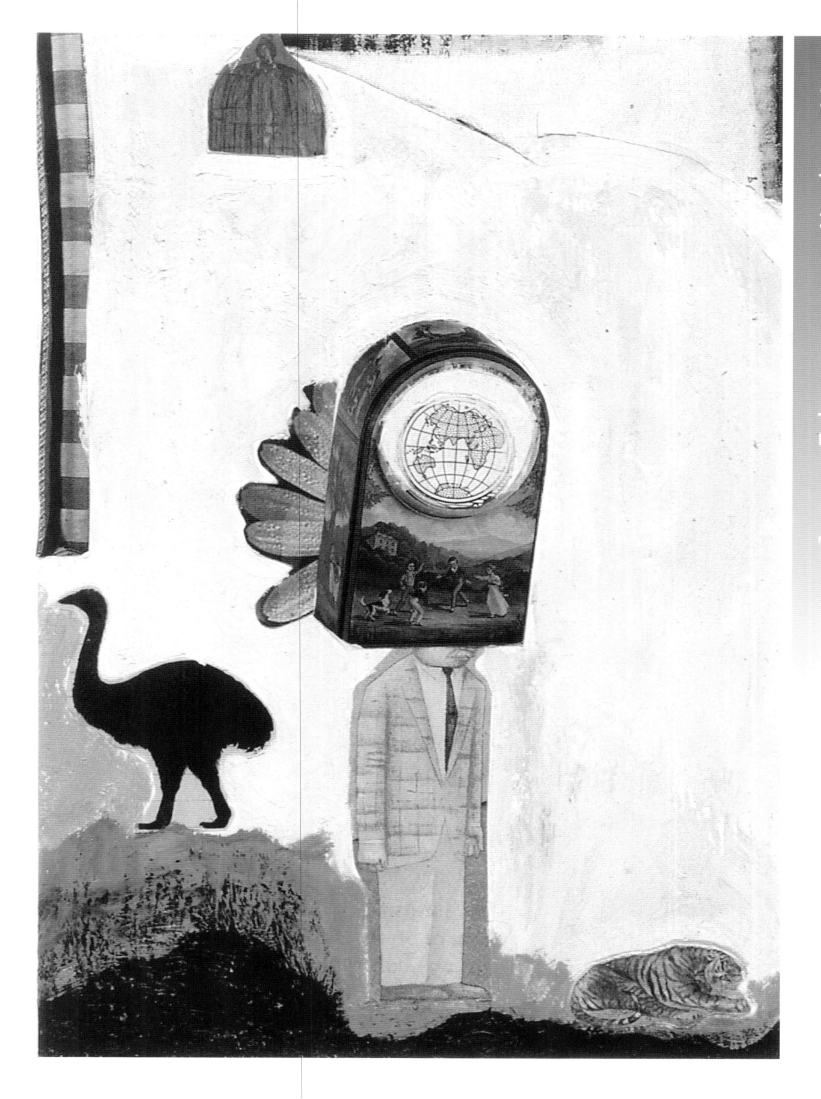

*Artist:* ANDREA FUHRMAN    *Title:* NOWHERE MAN

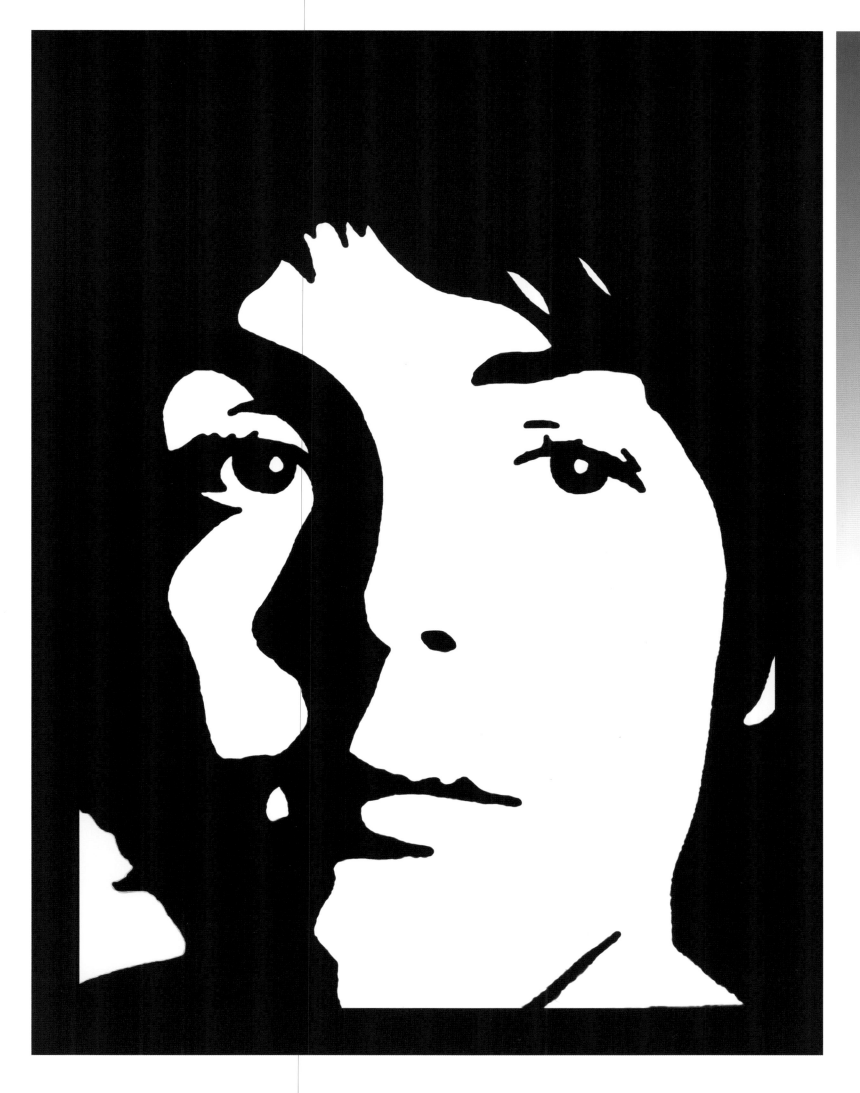

*Artist:* Ken White
*Title:* PAUL

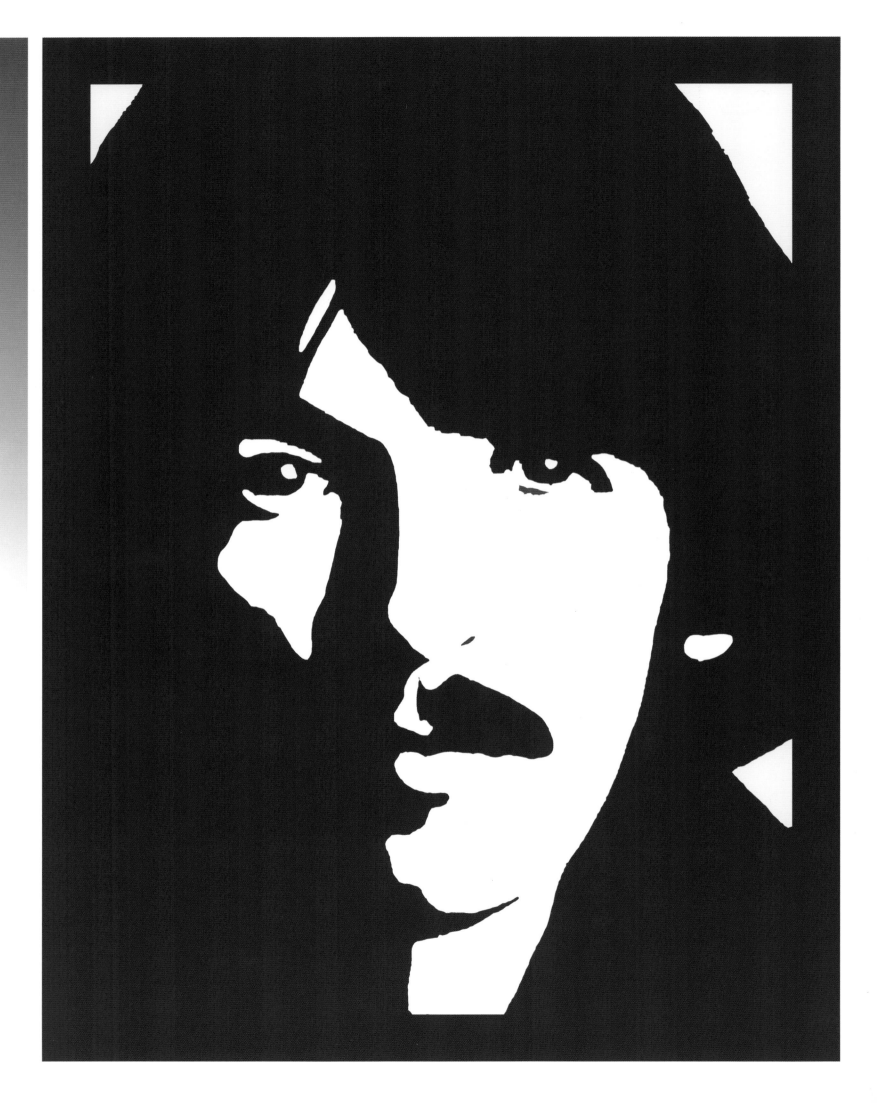

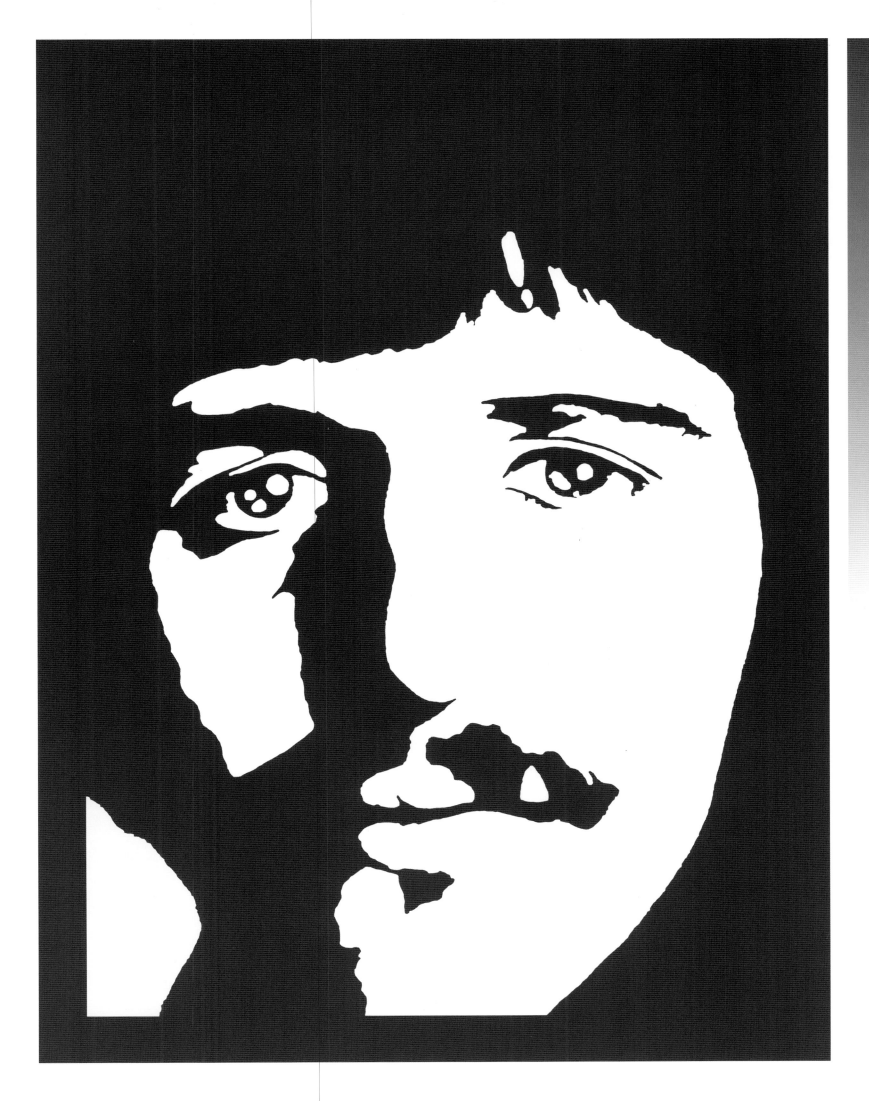

*Artist:* Ken White

*Title:* RiNGO

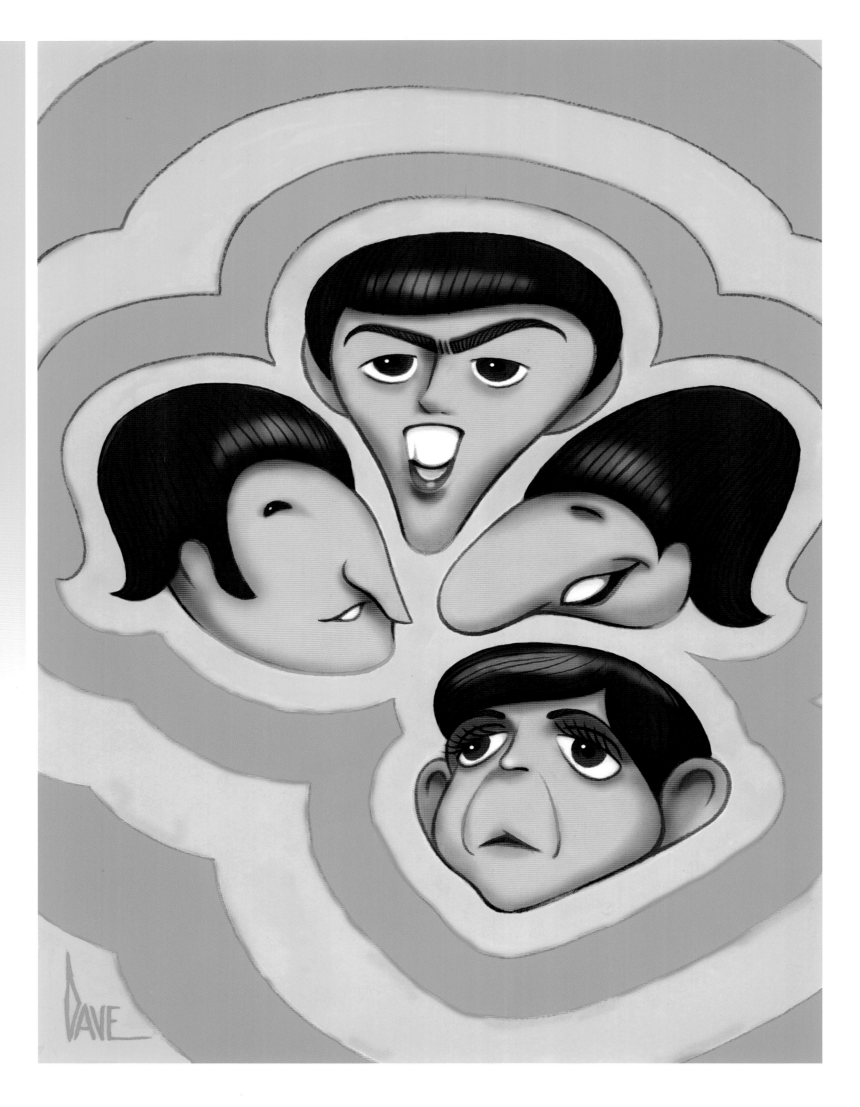

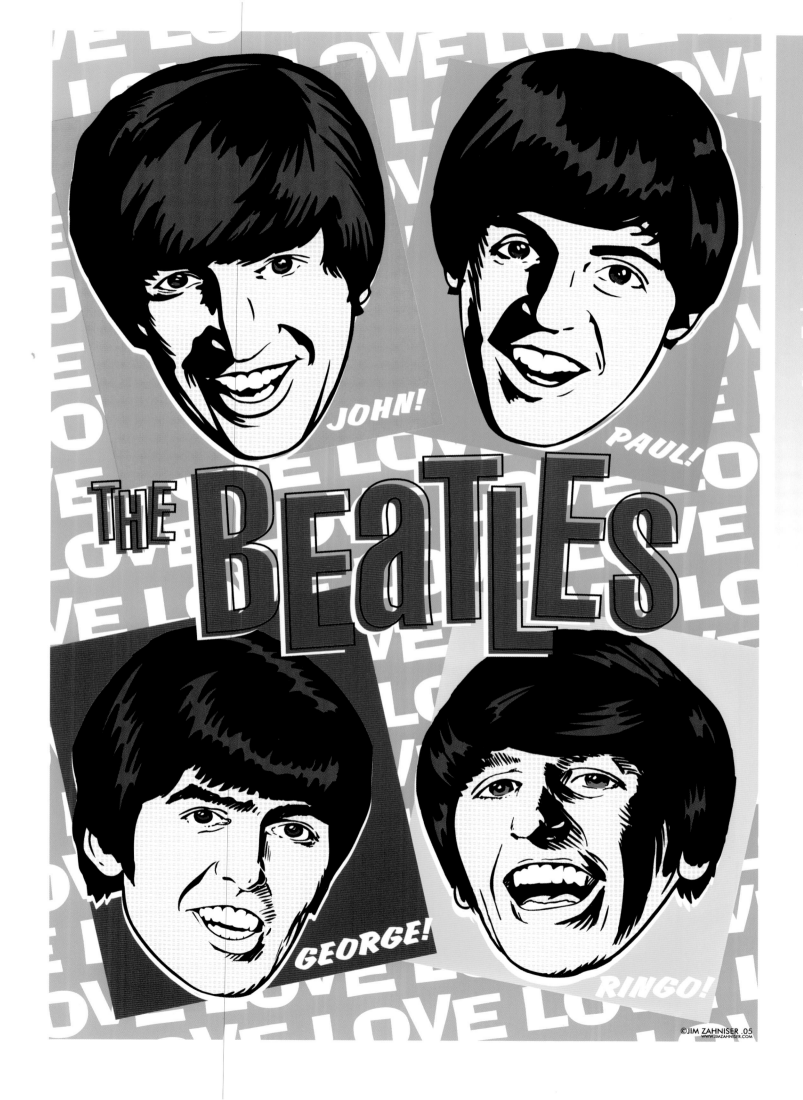

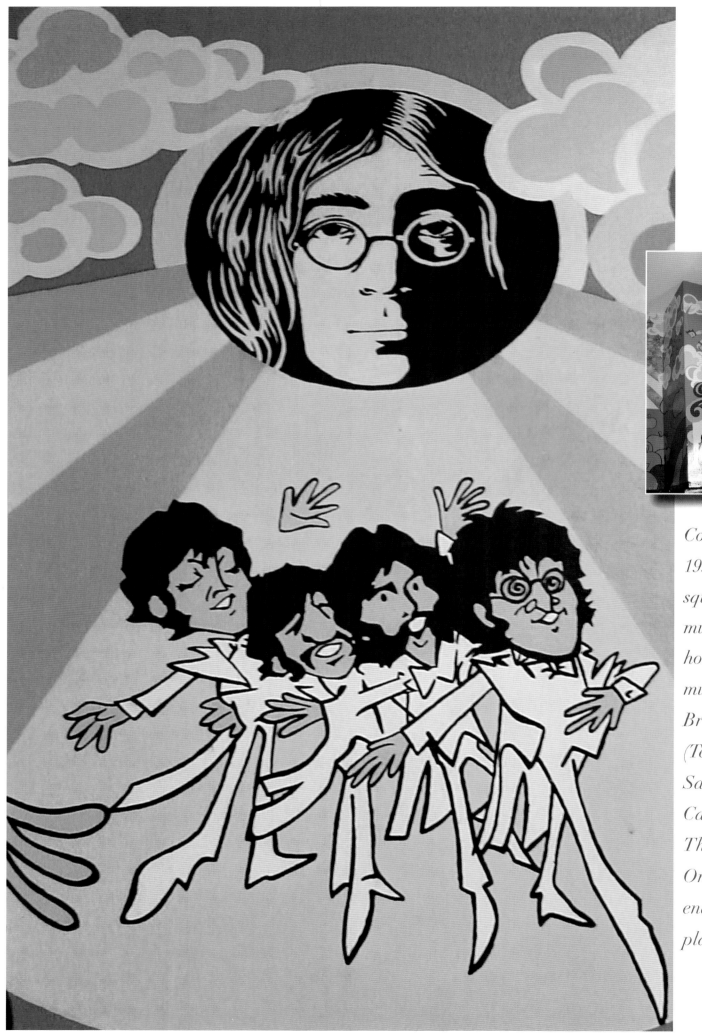

Completed in 1998, this 250 square-foot mural is in the home of musician Brian Wheat (Tesla) in Sacramento, California. The medium is One-Shot enamel on plaster walls.

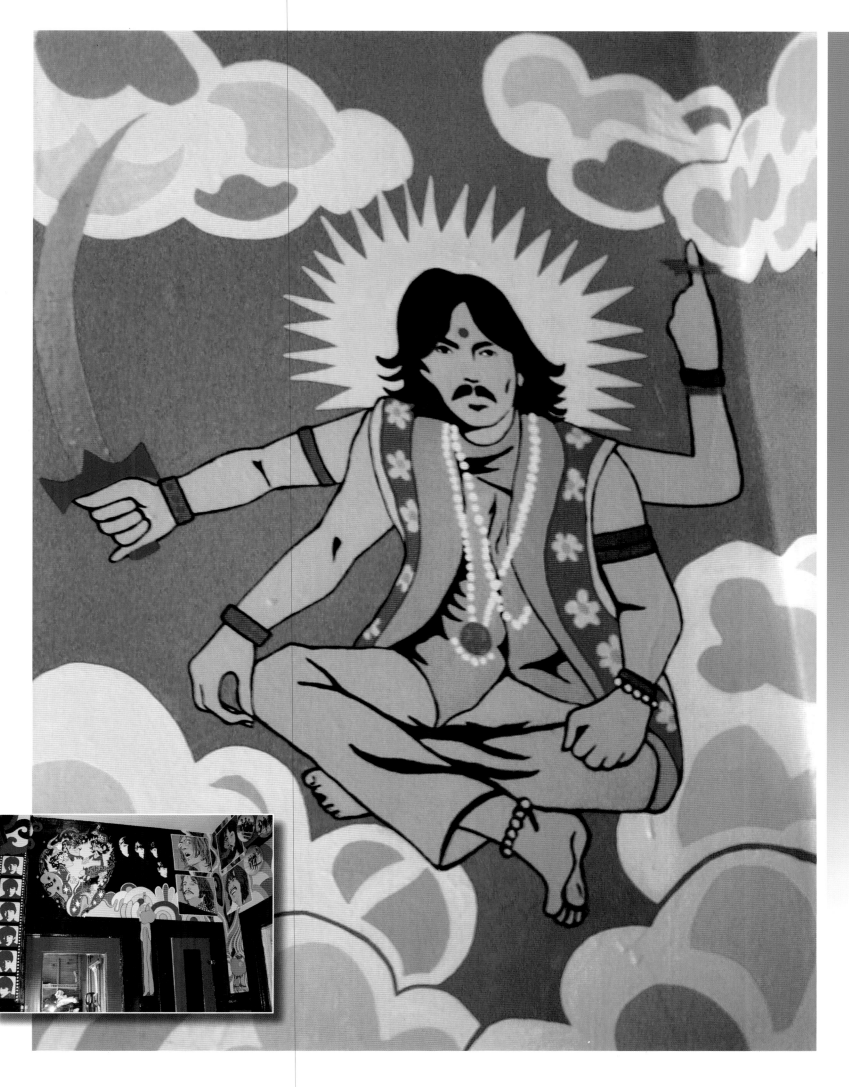

Artist: Christy Savage & Darin Wood    Title: Beatles Mural

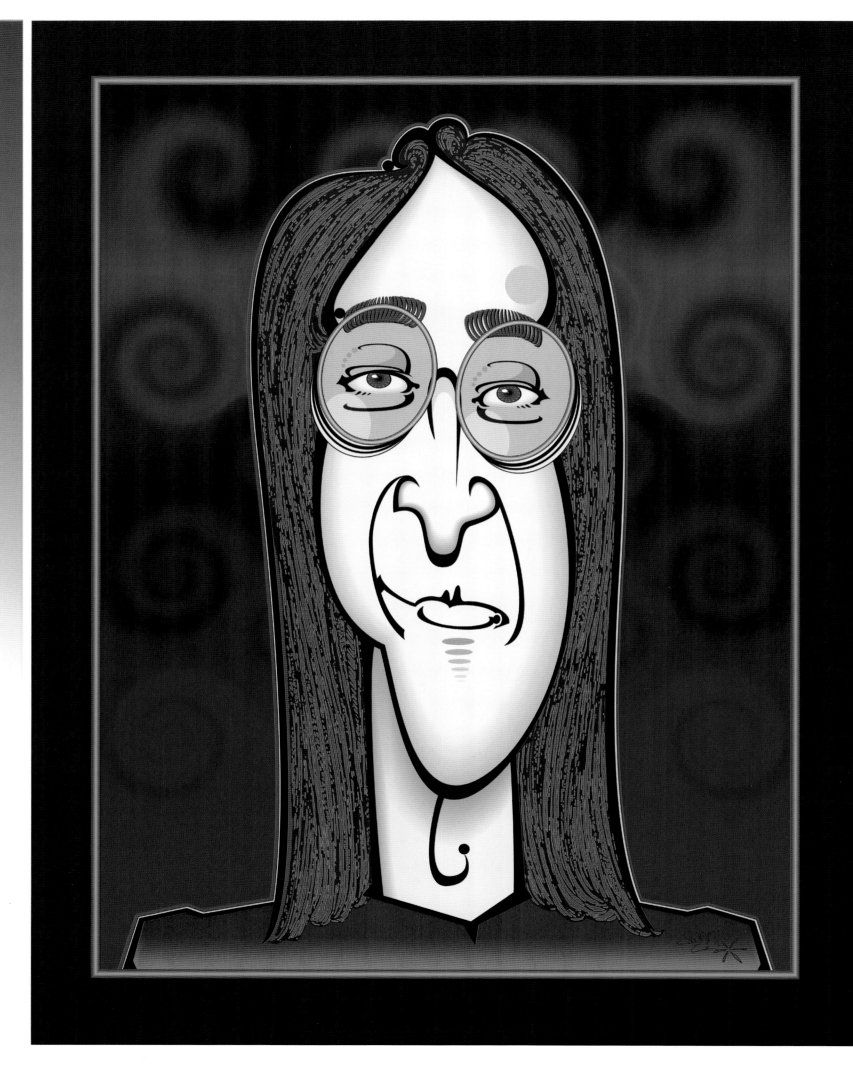

Artist: Jim (Swami) Wombacher    Title: John

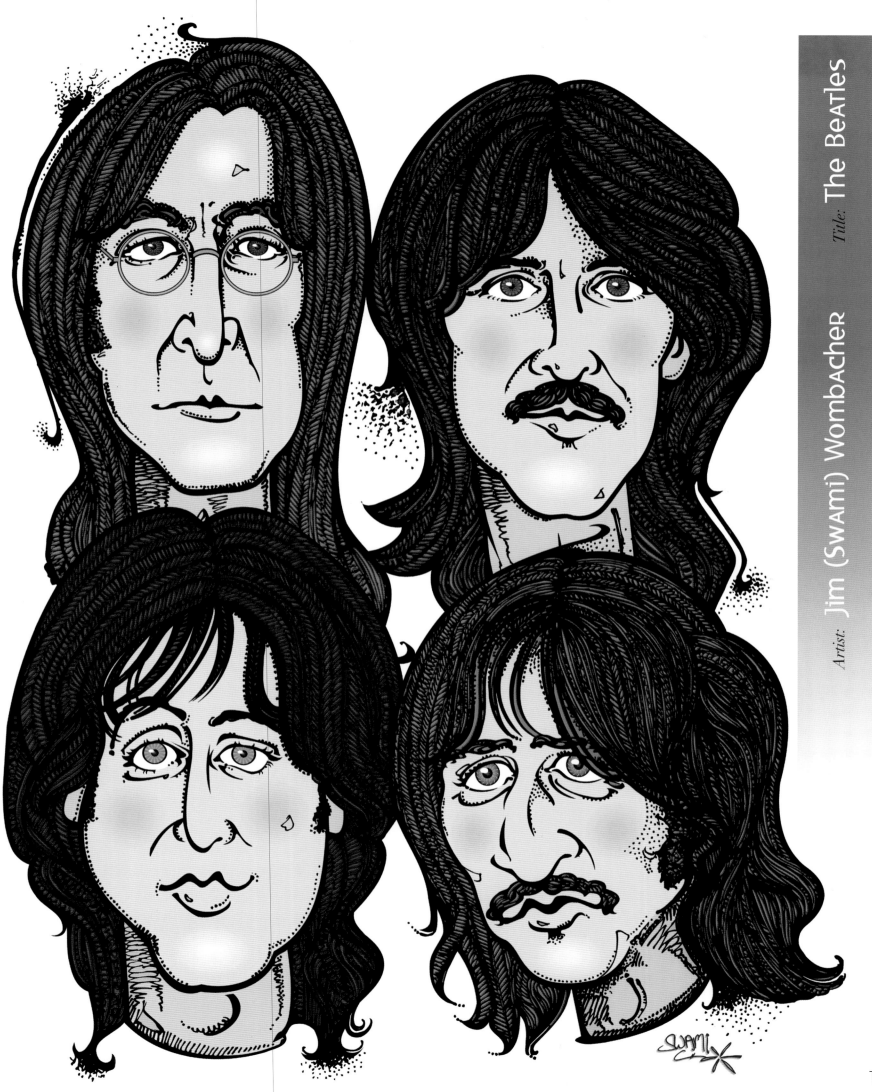

*Artist:* Jim (Swami) Wombacher    *Title:* The Beatles

107

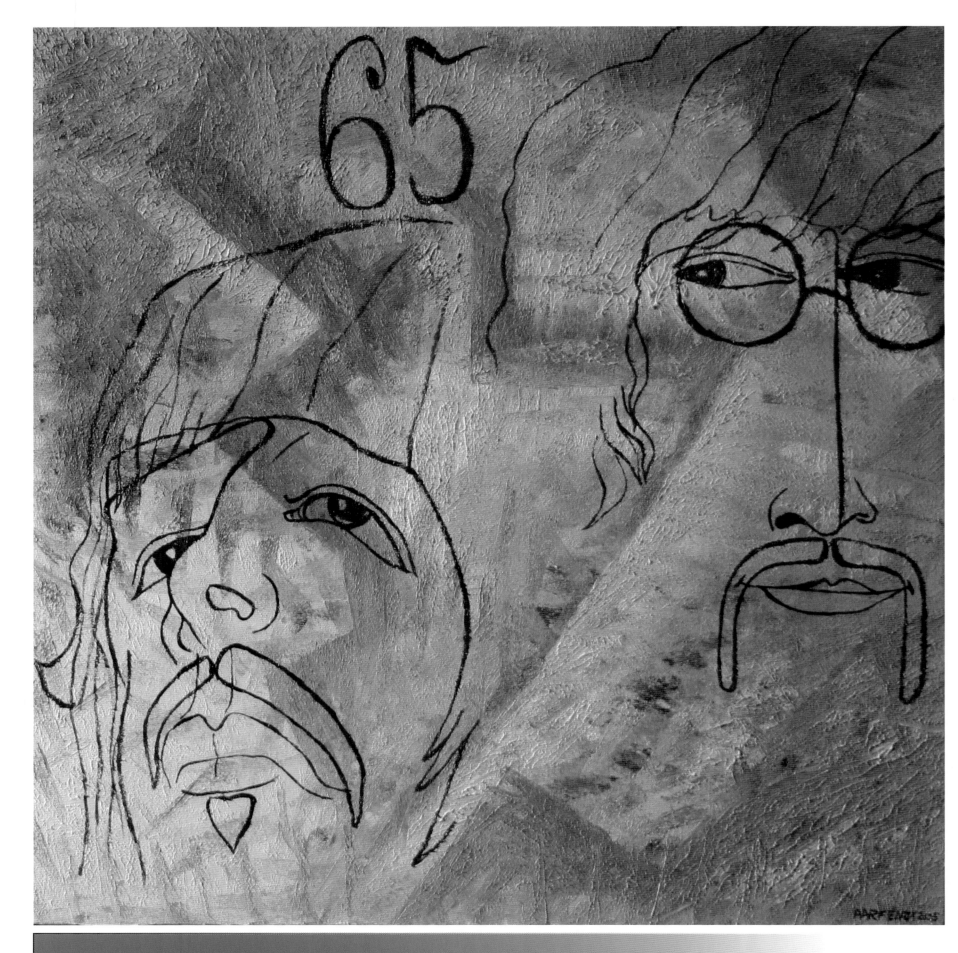

Artist: *Sergey Parfenuk*  Title: John & Ringo are 65

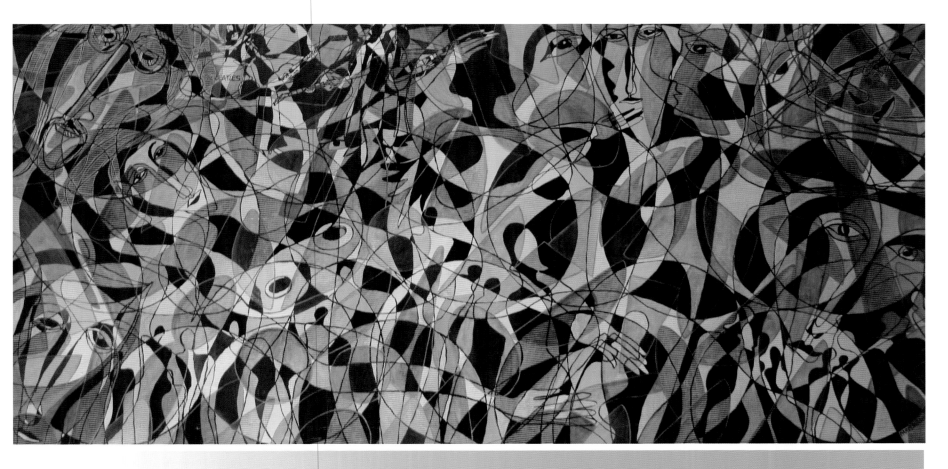

*Artist:* Sergey Parfenuk     *Title:* At The The Beatles Concert

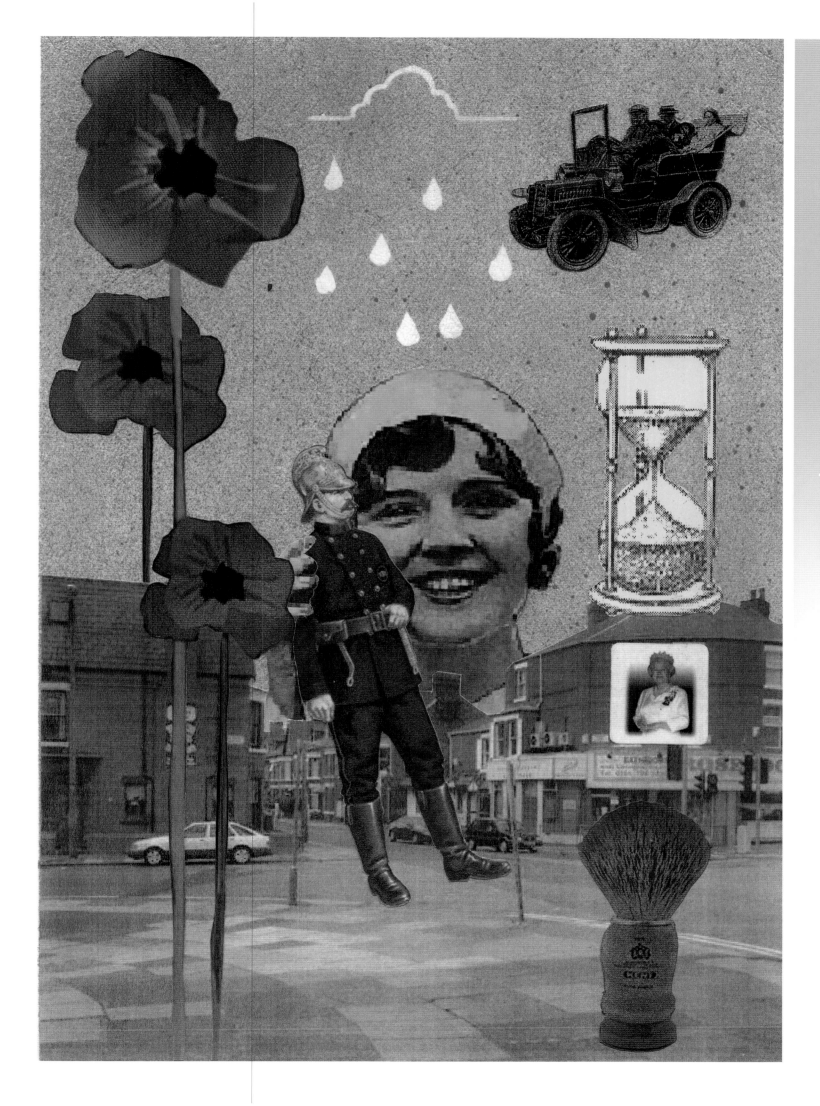

*Title:* PENNY LANE

*Artist:* Fabio Sassi

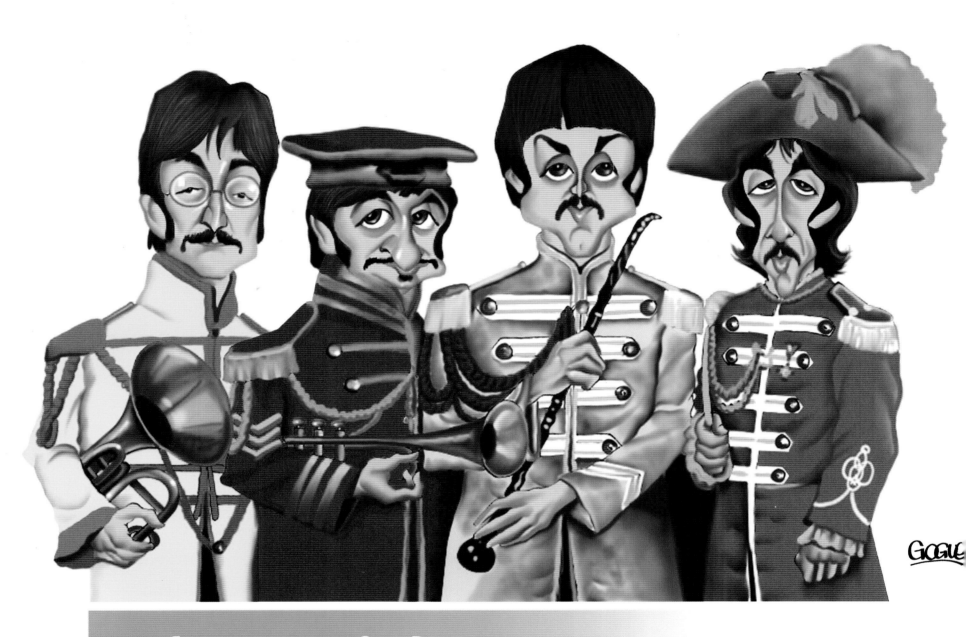

Artist: Gogue    Title: Sgt. Pepper

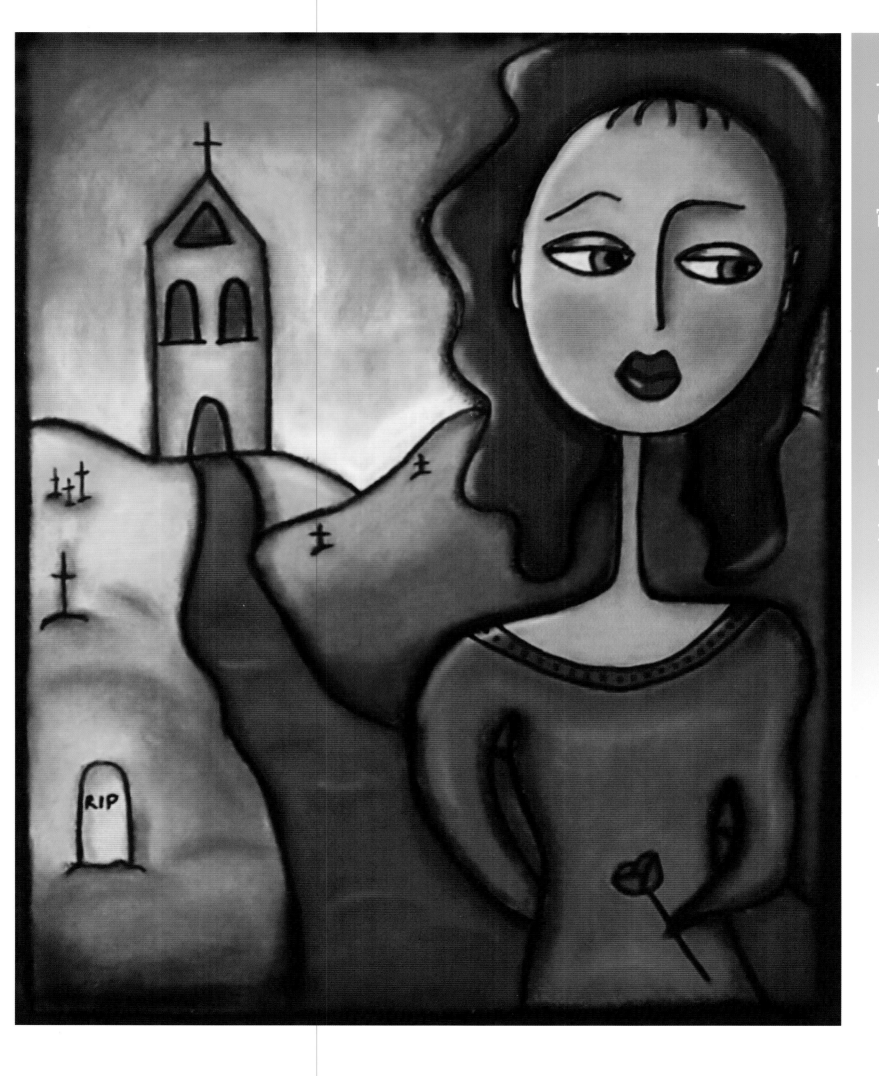

*Artist:* Mary Ann Farley    *Title:* Eleanor Rigby

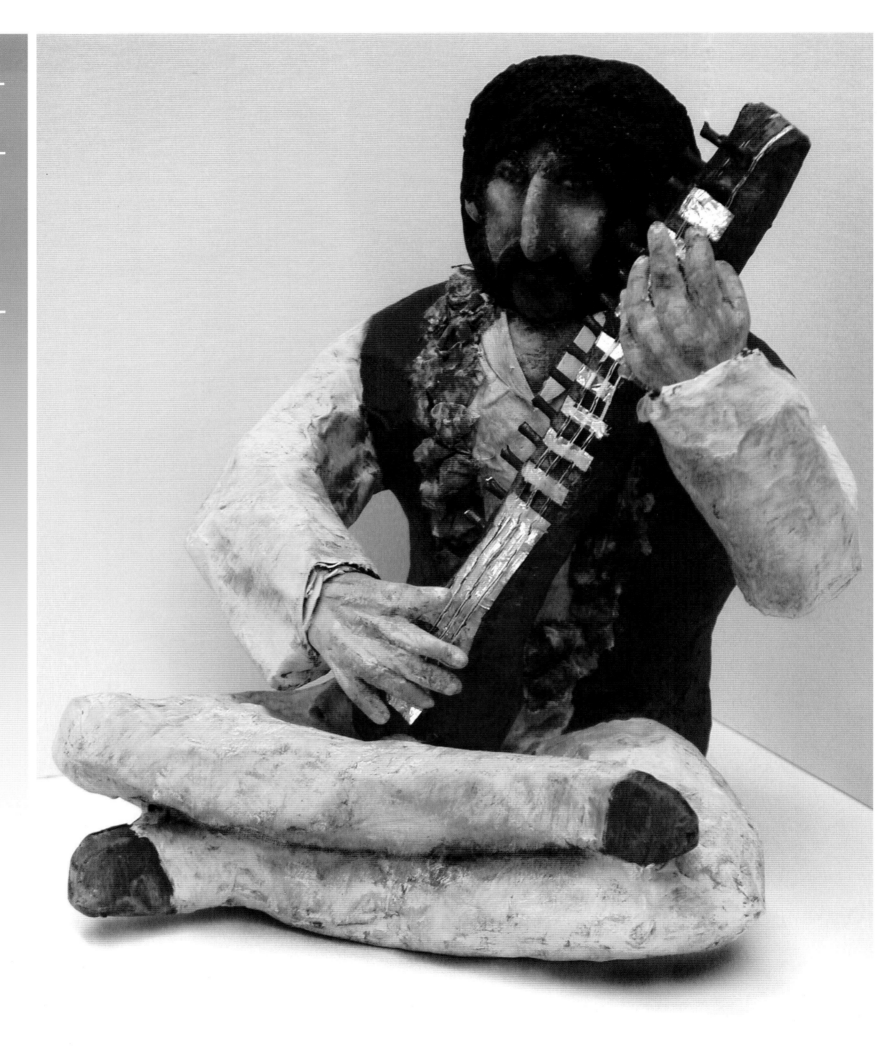

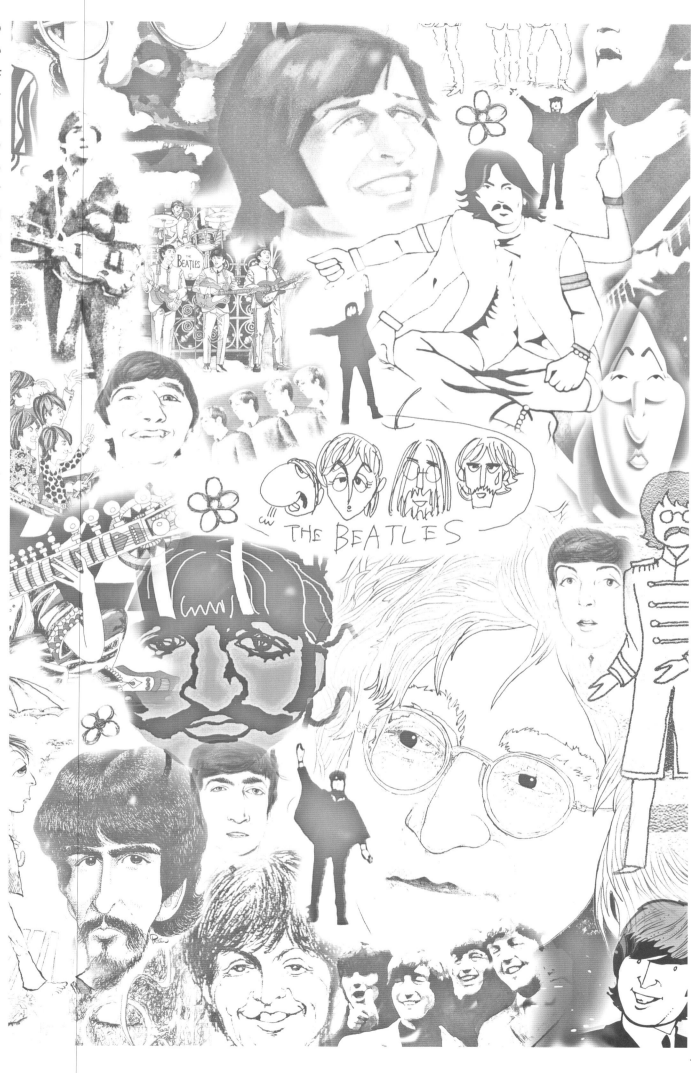

"I've always had a deep respect for George Harrison because of the calmness that surrounded him and his sense of peace and right. He seemed to know more than he let on, but rather than conveying it through speech, he conveyed it through his music.

"At times he even surpasses Lennon and McCartney. His musical skill is sometimes under-respected while with The Beatles. He turned a 3,000-year-old instrument call the sitar into a vehicle for 60's pop. After he left The Beatles, he amazed everyone with his solo career and philosophy.

"George, you will always be remembered for your peace, your love, your music, humor, spiritualness... the list goes on. Although 'All Things Must Pass' and you have, you will always be missed, loved, and respected."

Tim Parker

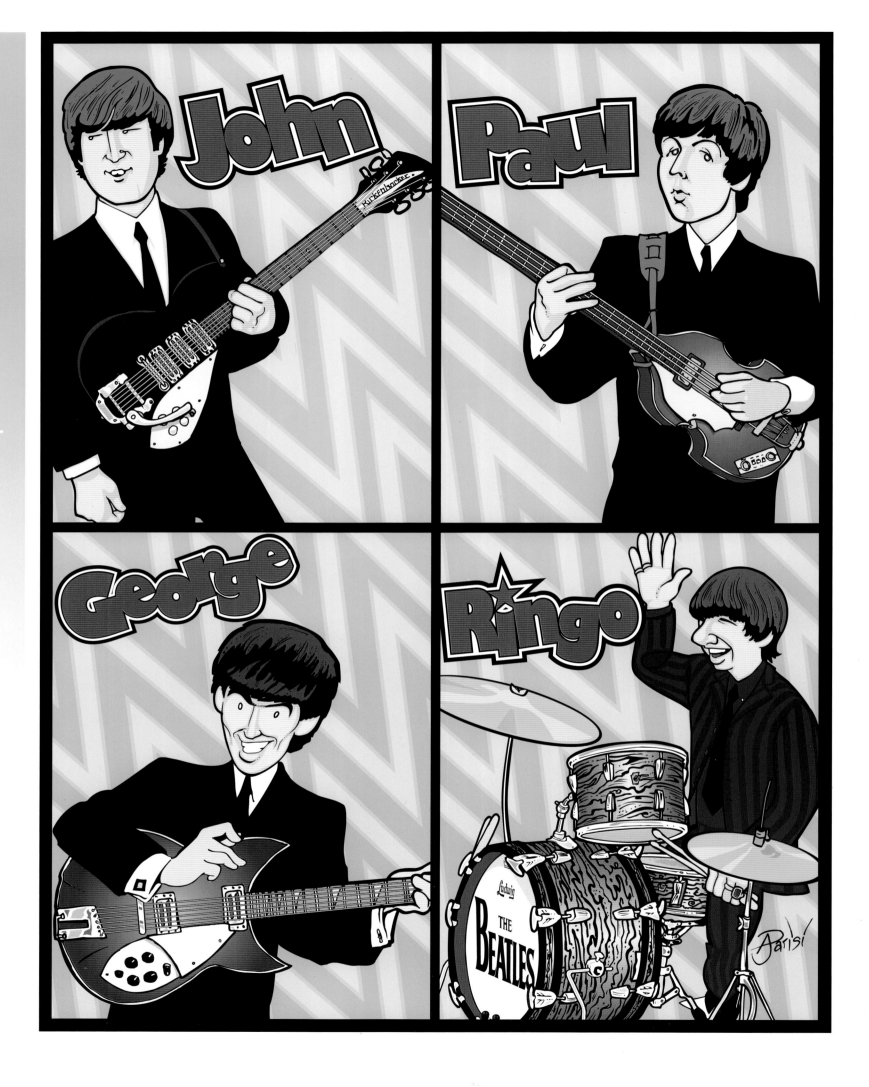

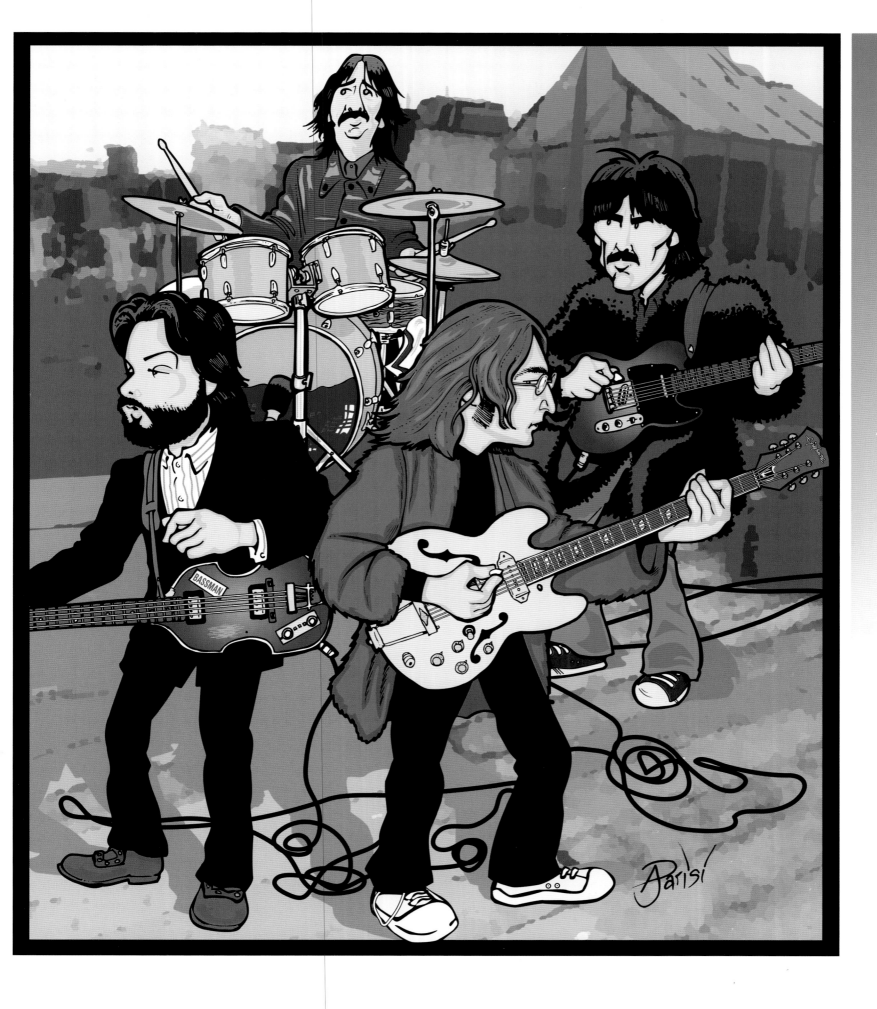

*Artist:* WANDA BURTON

*Title:* While My Guitar Softly Weeps

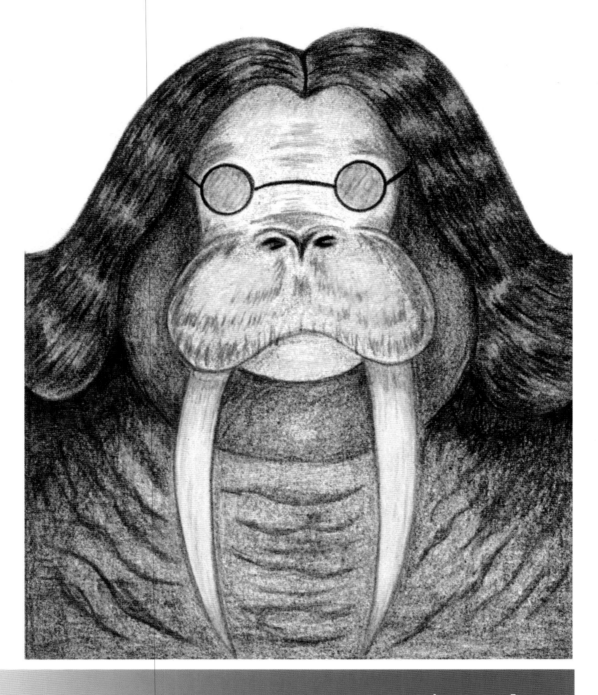

_Artist:_ WANDA BURTON          _Title:_ I Am The Walrus

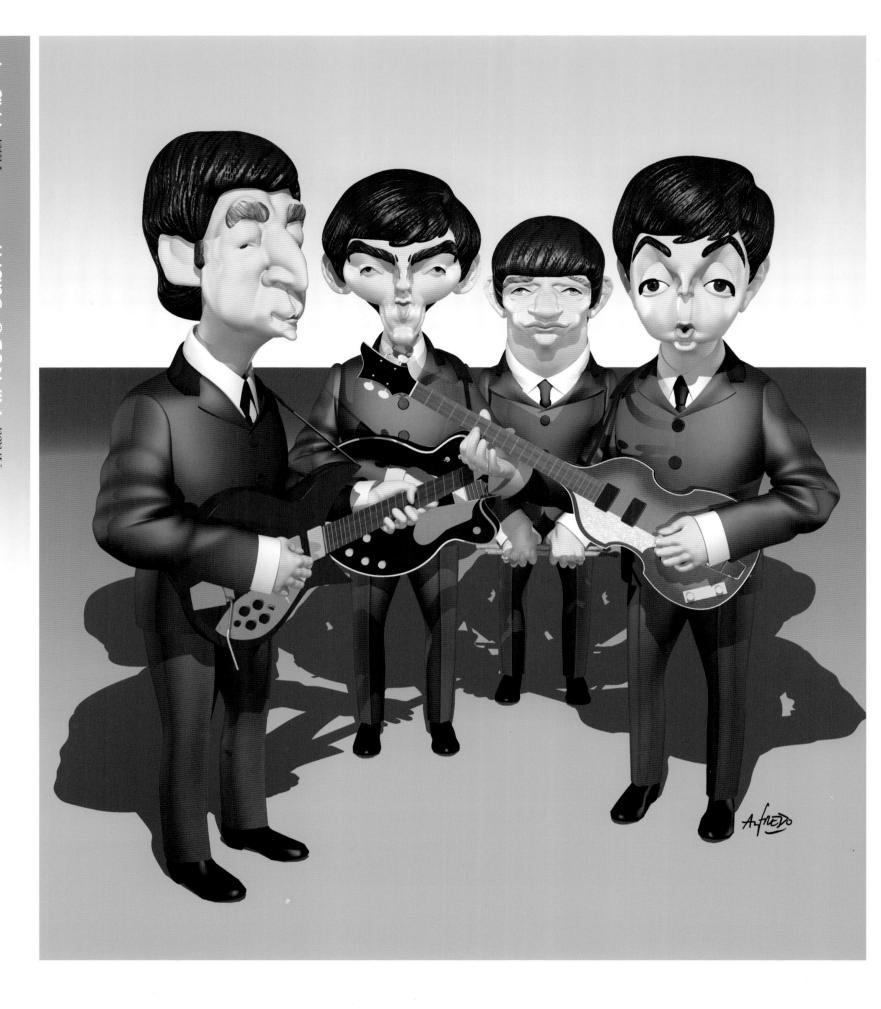

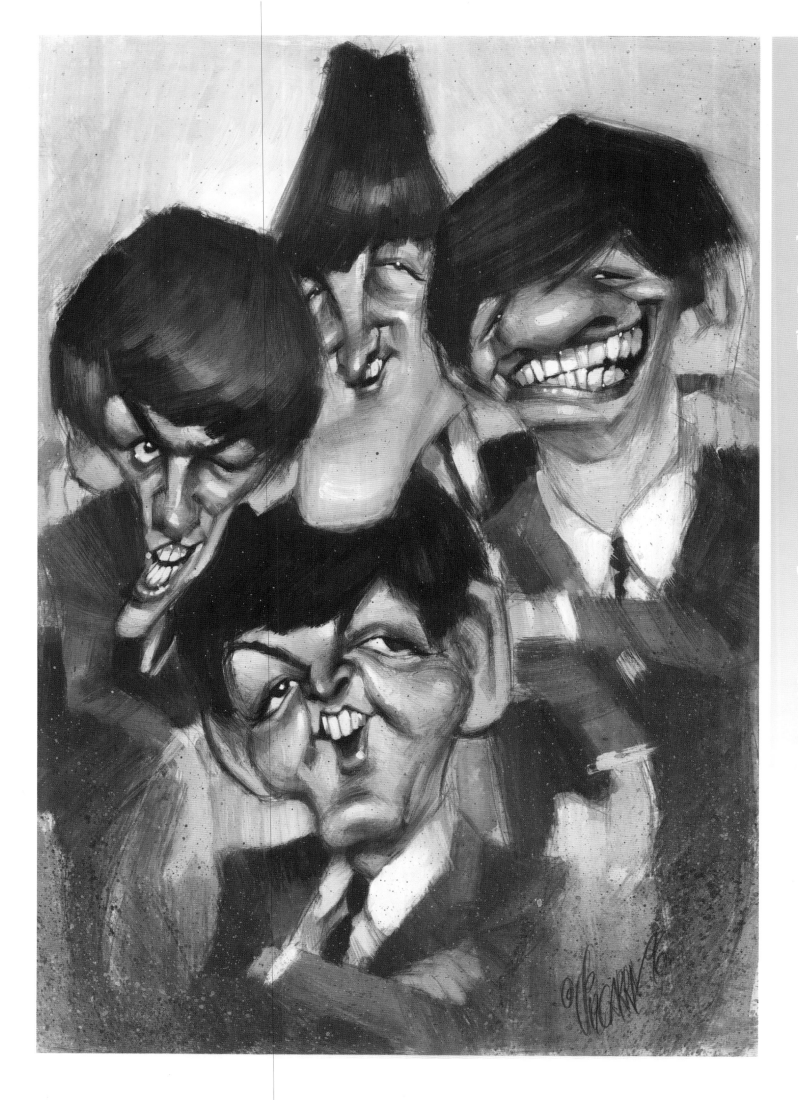

*Artist:* Stephen Kinsey    *Title:* Beatles Dress-Up

"There was always The Beatles. I was two years old when the band from Liverpool began their invasion on the world of music.

"As a child of the Sixties, I used to listen to Jim Reeves, Eddie Arnold and Elvis Presley. These were my mom's records. But while I was listening to my mom's music, The Beatles were changing the face—and hair—of music. In my life, even though I was unaware, there was always The Beatles.

"I spent most of my teenage years in the Seventies debating with friends who was the better band, Kiss or Aerosmith. Later in the decade, it was Boston or Foreigner. Despite our preoccupation with these other groups, whenever a Beatles' song came on the radio, we never changed the channel. Even during the decade of our battles of the bands, there was always The Beatles.

"The Eighties were riddled with too many one-hit wonders. Whatever happened to Mr. Mister, a-ha, or Dexy's Midnight Runners? Some of these bands are a distant memory, and some of us can still remember 'The Safety Dance'. The fact is, though, Men Without Hats came and went, but there was always The Beatles.

"In the Nineties, I rarely listened to new music on the radio. I gobbled up CDs of older music like they were M&Ms candy. It was during this time that my taste in music started to change. Oh no! I was beginning to mellow. I was no longer screeching along to 'Walk this Way', but preferred a more relaxing tune by Carly Simon or the Eagles instead. And I started to develop an appreciation of music by that band from Liverpool. That band that had been cranking out hit after hit my entire life. There was always The Beatles.

"The new century gave us new music technology and many other ways of getting exactly the music we wanted to hear. I went online and uploaded stuff I hadn't heard in years. I found 'Spiders and Snakes', 'Me and You and a Dog Named Boo', and 'Dancin' in the Moonlight'. I downloaded several songs by the Rolling Stones, Stevie Wonder, Ray Charles, and Steely Dan. But I also downloaded 'Hey Jude', 'Yesterday' and 'I Want To Hold Your Hand', to name just a few. Tastes change, but there will always be The Beatles."

Stephen Kinsey

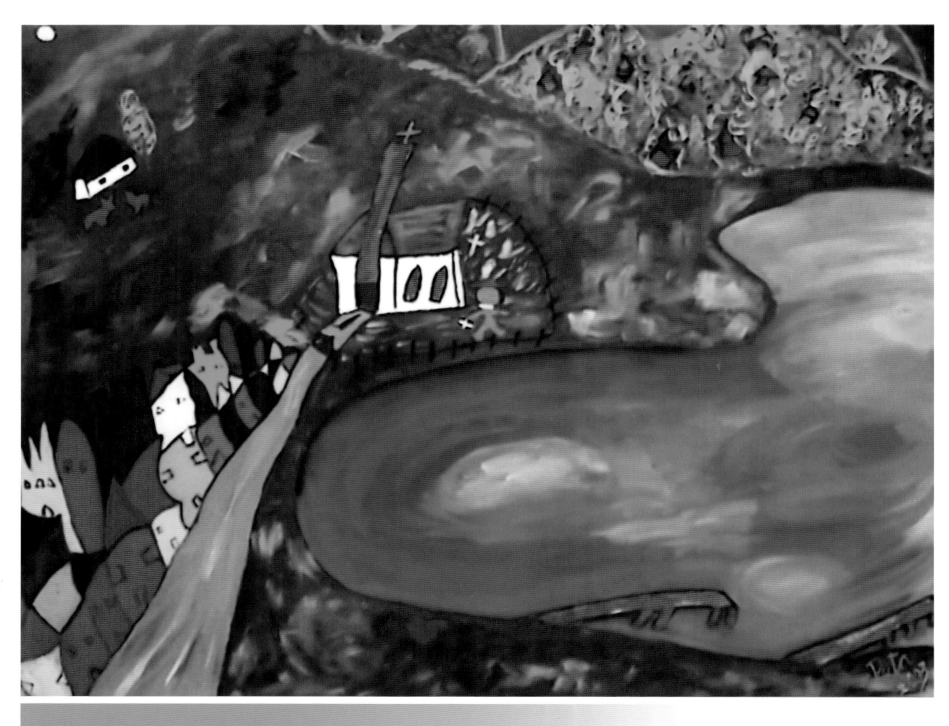

Artist: Peta Wright    Title: Eleanor Rigby

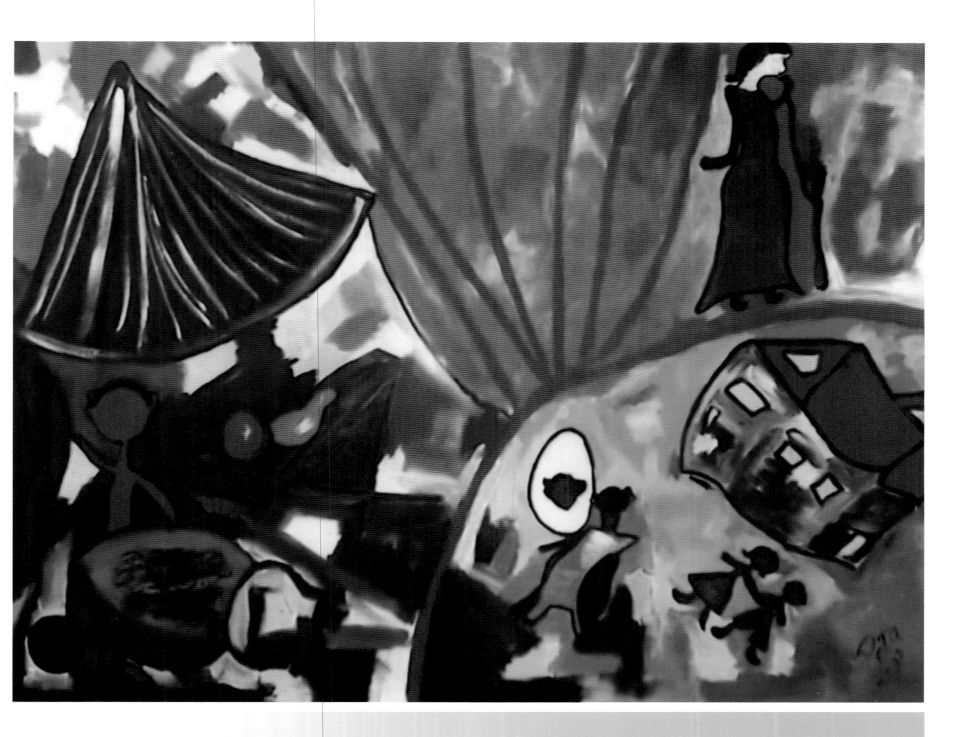

*Artist:* Peta Wright    *Title:* Ob-La-Di Ob-La-Da

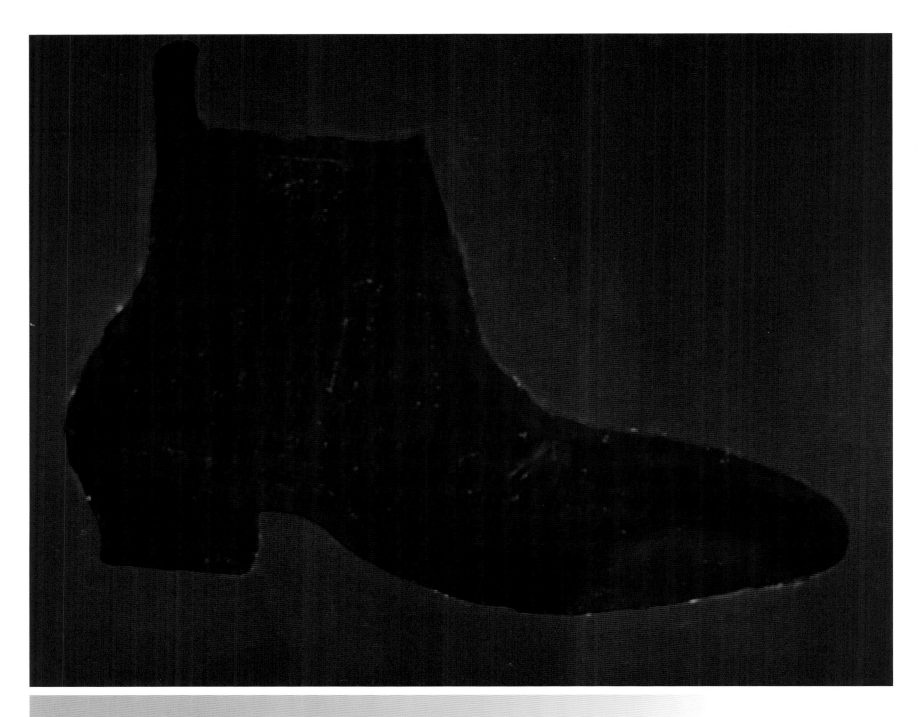

*Artist:* Carol Bertolotti  *Title:* Cavern Style

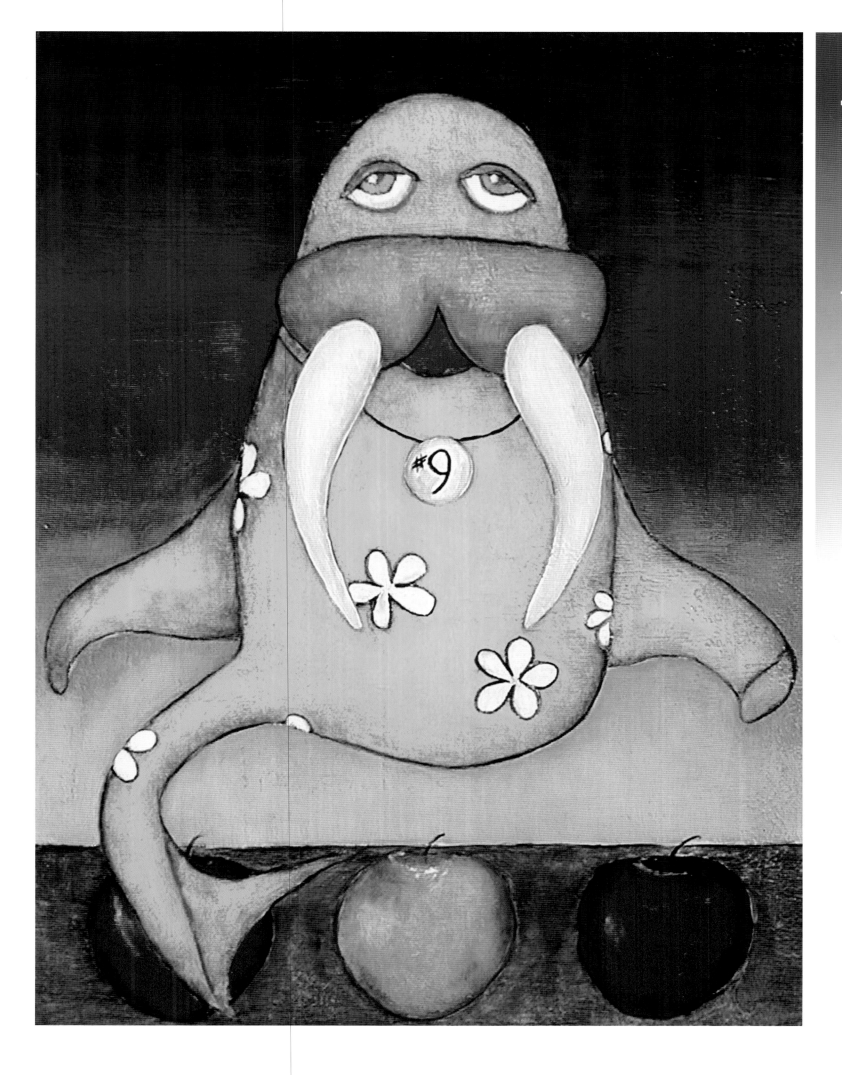

*Artist:* Victor McGhee   *Title:* WALRUS

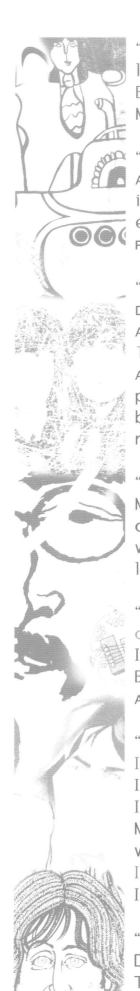

"I was freshman at the University of Maryland in December of 1963. On December 17th, a local DJ named Carroll James played, 'I Want to Hold Your Hand.' He was the first to play a Beatles song in the U.S., thanks to a letter from 15-year-old Marsha Albert of Silver Spring, Maryland. Nothing would ever be the same.

"My college years coincided with the British invasion, Vietnam, the hippie movement, peace and civil rights marches. It was a time of change and mistrust. The Beatles were a major influence on my generation. They captured our young feelings, made us think and always evolved into greater things. Their songs and antics offered a positive refuge from a world filled with conflict and hate. Their talent inspired so many, including me.

"As a fine arts major, I crea         ces of Beatle art. One was a portrait of all four done in pen and ink with a dark ink wash. In 1966, I put this in a nice frame and took it to a promoter named Irving Feld. He was bringing The Beatles to DC. for a concert on August 15t. I asked him if I could meet them and show them my work. He smiled and said, "Yeah, you and every other kid in town." Irving liked the painting and had his people hang it up at their press conference. The next night, on the TV news, there were The Beatles with my painting behind them. I remember John stopping to look at it as they got up. A photographer sent me a nice photo of them with my painting. I still have the photo and painting today.

"The 'Welcome Home Boys' piece is a new version of a stone lithograph I drew in college. My only original print was lost years ago. Using an old photo of it, I recreated the same composition with a lot more detail. Notice that the jet engines are backward. This is my way of going back in time. Can you spot Mick Jagger, Brian Epstein and the Pattie Boyd look-alike? That's really my wife, Lee.

"The 'Day in the Life' painting started as a portrait of John Lennon, then turned into a time capsule of his life. I guess this was my version of hero worship back then. People ask if I'll do one for Ringo, George and Paul. I probably will one day. John was once my favorite Beatle, but not anymore. I realize now that all four together made the group what it will always be.

"I did grow up with this group:
I was in college when they came to America.
I saw them at Shea Stadium—the first concert.
I have a picture of The Beatles with my first drawing of them at RFK Stadium.
My wife and I met Paul and Linda when we produced a TV report on her veggie cookbook. It was a funny story.
I was never a fanatic but a respectful fan.
I wanted to make some lasting impressions with my art.

"Funny, my younger brother—by 17 years—went to see McCartney last night in Washington, DC. He called me from the concert. All I heard was Paul singing on the other end. That's my brother."

Bob Casazza

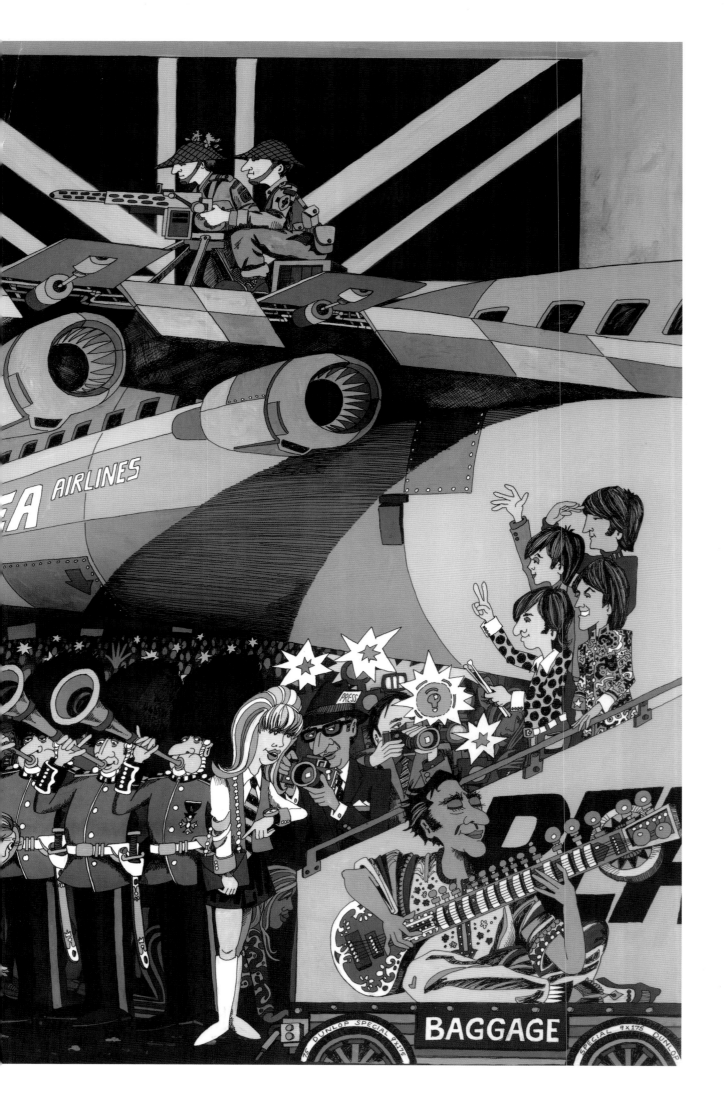

Artist: Bob Casazza     Title: Welcome Home Boys

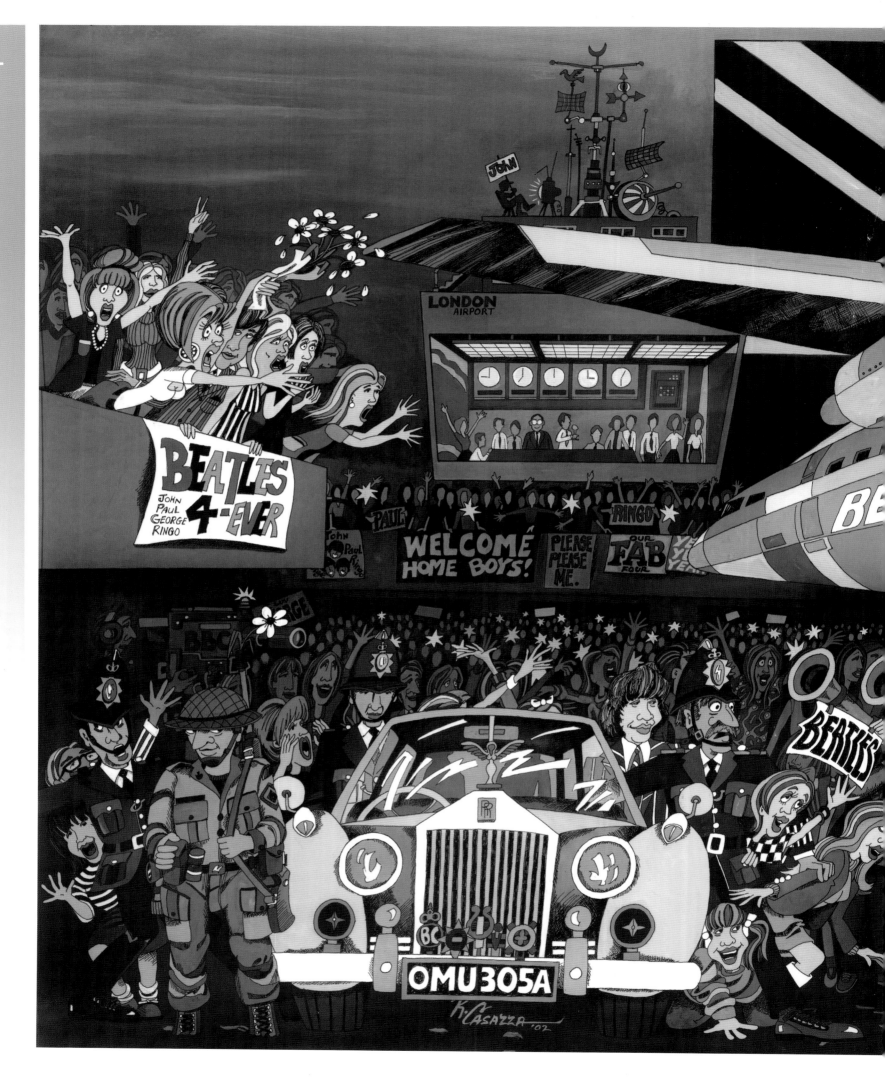

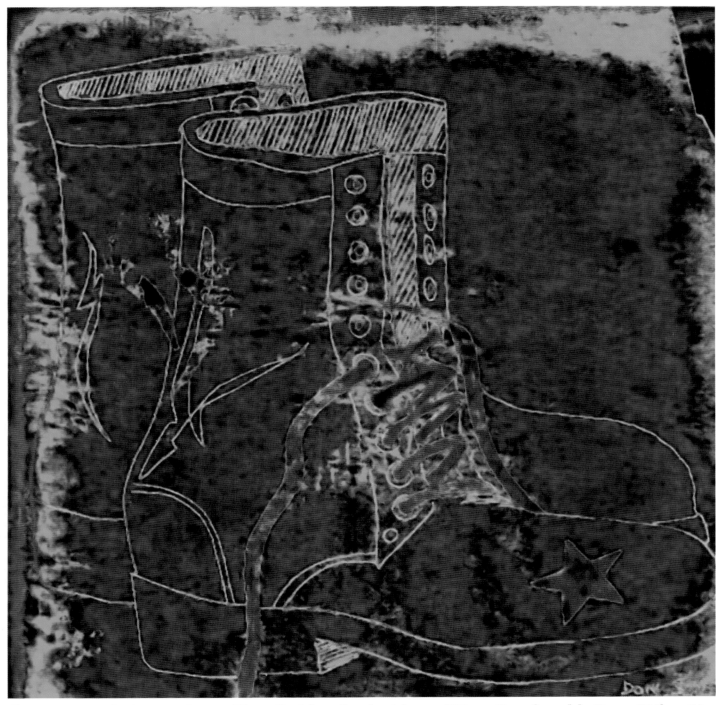

"Ringo Starr's Cosmic Boots Have Rubber Souls-Always Wear Comfortable Boots When You Travel The Long and Winding Road of Life's Helter Skelter Journey"

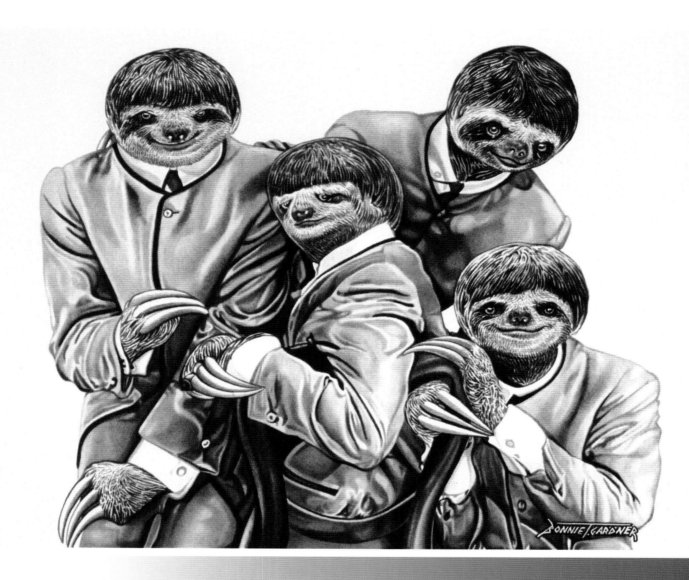

_Artist:_ Bonnie Gardner          _Title:_ The Slothles

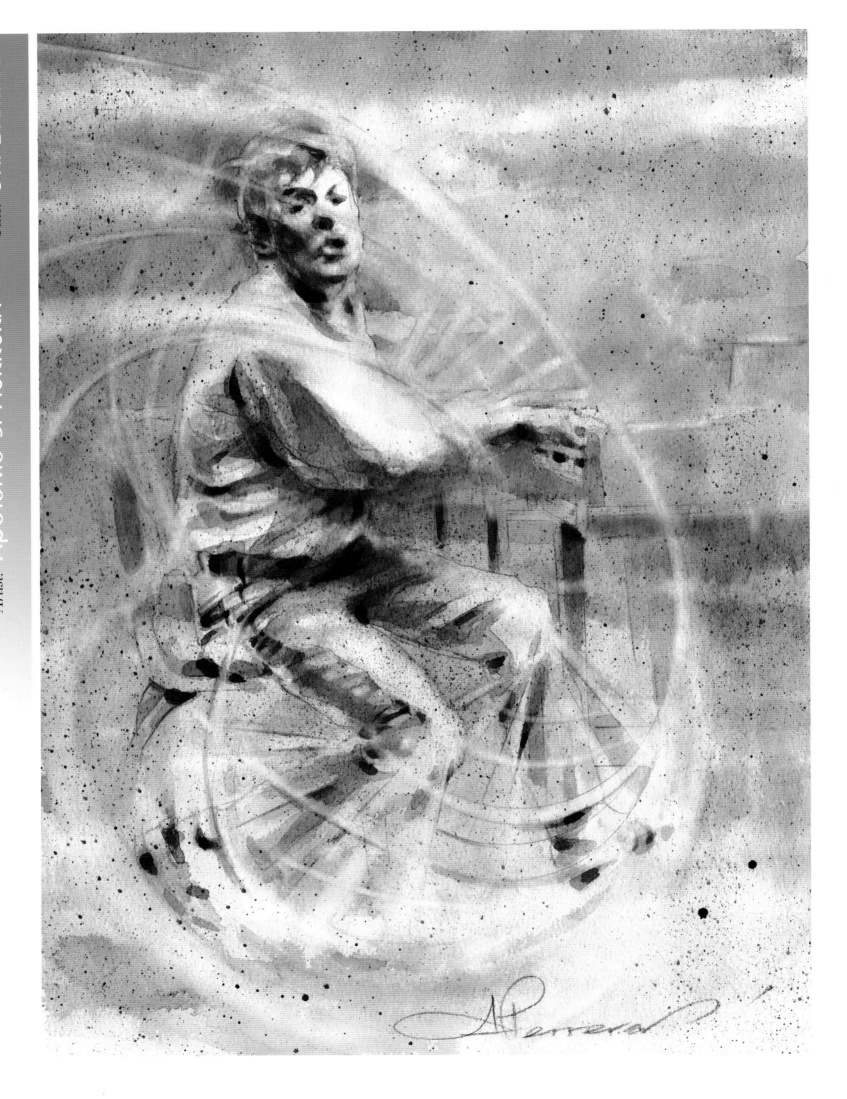

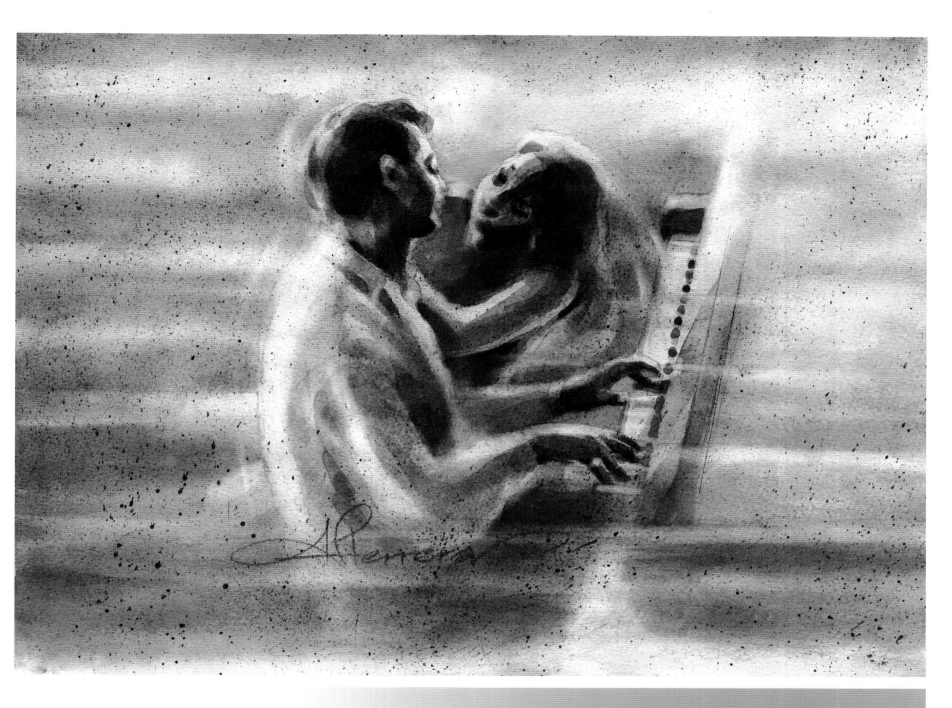

*Artist:* Apolonio S. Herrera     *Title:* If I Fell

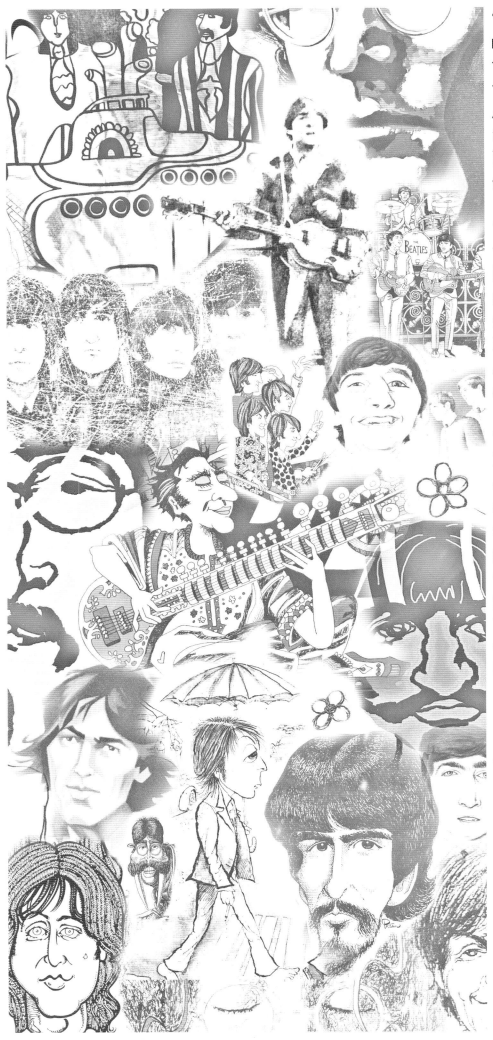

"It was more than 40 years ago today when I first heard The Beatles on the radio. I began to like their music, especially when I first saw the Fab Four on the Ed Sullivan Show. It left a lingering imprint of their lyrics and melody in my mind that inspired me, and I began to learn their music and use it in my art at the same time.

"Beatle music gave me the inspiration and theme for my art. I remember when I was in high school, I talked often about The Beatles, dressed and wore my hair like The Beatles, sang and played their music, and most of all, I painted and drew The Beatles. I gave the art away to my girlfriends, to the point they called me Beatle-Pol, 'The Fifth Beatle.'

"When I finally moved to the United States, I attended several of the Beatlefests and enjoyed each time. I never missed buying memorabilia. I enjoyed being with people who shared the same passion. I even shared this passion for The Beatles with my then high school-age daughter, and she started playing their music with her classmates. She, too, started to appreciate their music. So every time we had a chance we attended the Beatlefest together.

"I followed what was happening in their personal lives. I was saddened when John got shot. It felt as if something died in me. Then George followed.

"After all these years, I'm still excited and even longing to meet Paul McCartney and Ringo Starr, to enjoy their company where I can jam, play music with them and share my art with them."

Pol S. Herrera

"DURING the early 1960's when I was at the Liverpool Art College, I met the Beatles while John was also attending. I used to go down with John to the Cavern Club as they used to play at lunchtime. This was before Ringo Starr, and Sila Black was the cloakroom girl.

"As the Cavern was alcohol-free, I used to go across the road to the pub called The Grapes and reserve a table for the group during their break. In those days, there used to be all-night jam sessions where the Beatles and other groups played all night long, and we took our sleeping bags and slept on the floor in between the gigs. My impressions in those days were that The Beatles were good, and we all expected them to be successful.

"After the Stars Club in Hamburg, they came to Liverpool and never looked back. They continued to play now and again at the Cavern until Brian Epstein became their agent, and then they rocketed to the top of the Hit Parade. One of my favorite songs was 'Roll Over Beethoven' which they interpreted better than Chuck Berry.

"Liverpool was like Nashville in the Sixties: Every house party and every pub had live music. But back in the Sixties, the flavor and atmosphere of the music world was taken over by the sounds of The Beatles and their contemporaries.

"I go back to Liverpool every couple of years now, and it is noticeable that The Beatles have done a great deal for the city of Liverpool. Tourists come worldwide to visit the Cavern Club and walk down the same streets we walked during our lunch break to listen to a young group of gifted musicians, with a style of their own that impressed the world and will remain with us forever."

PAUL YGARTUA

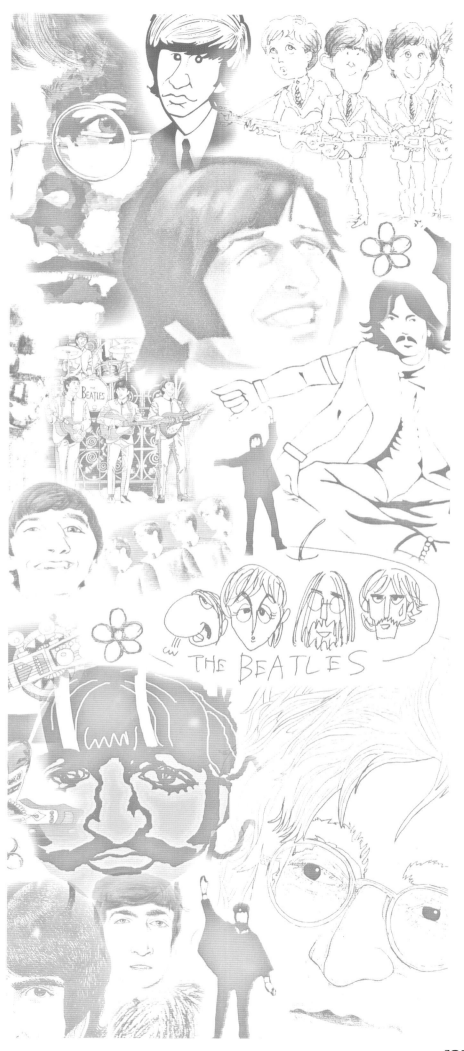

137

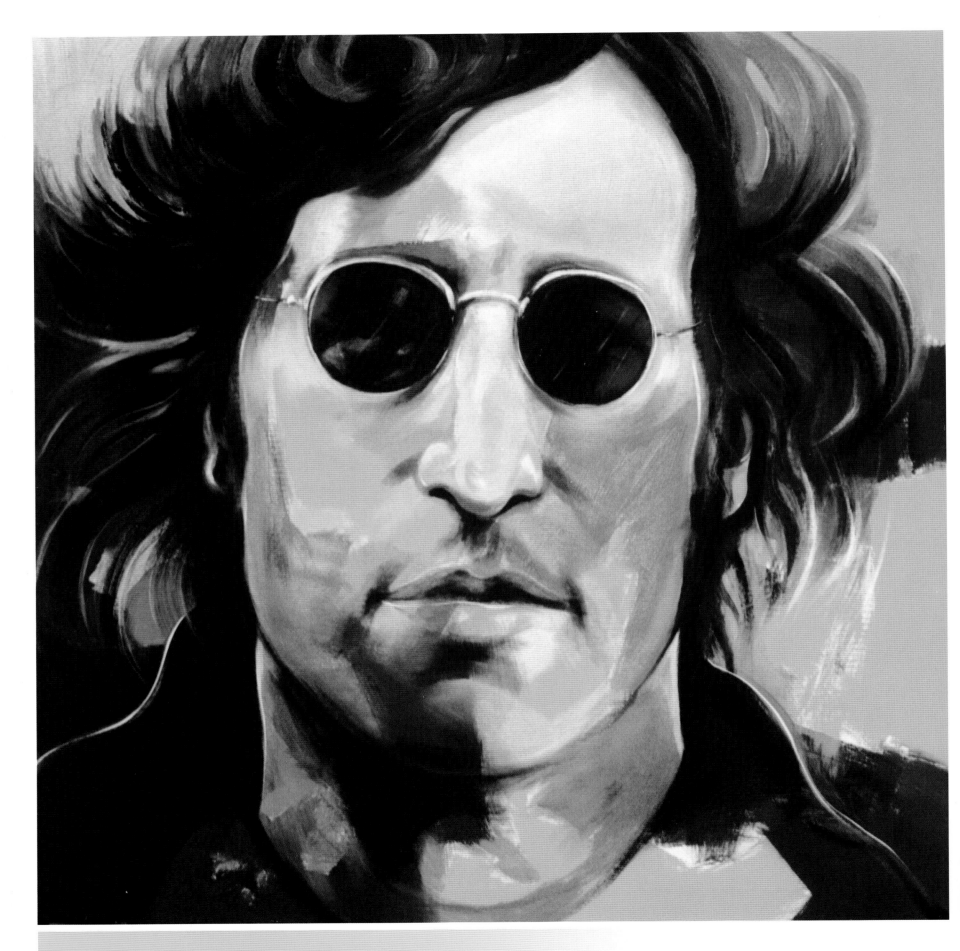

Artist: PAUL YGARTUA     Title: John

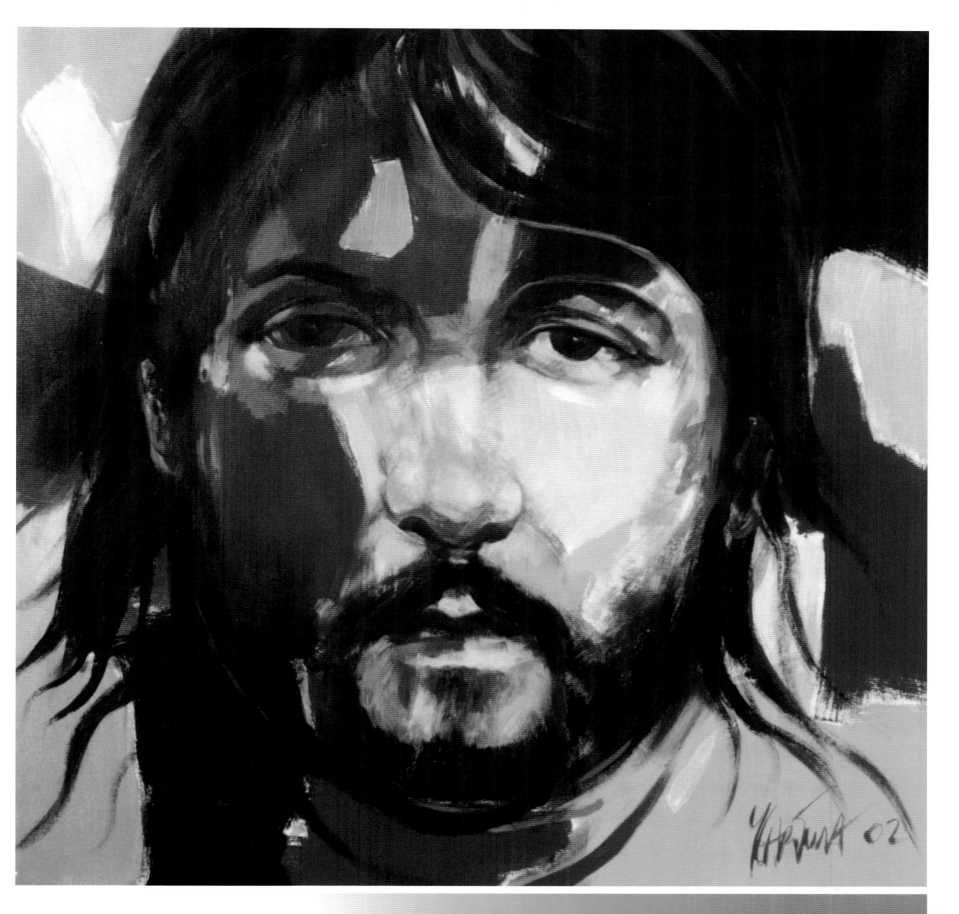

*Artist:* PAUL YGARTUA      *Title:* PAUL

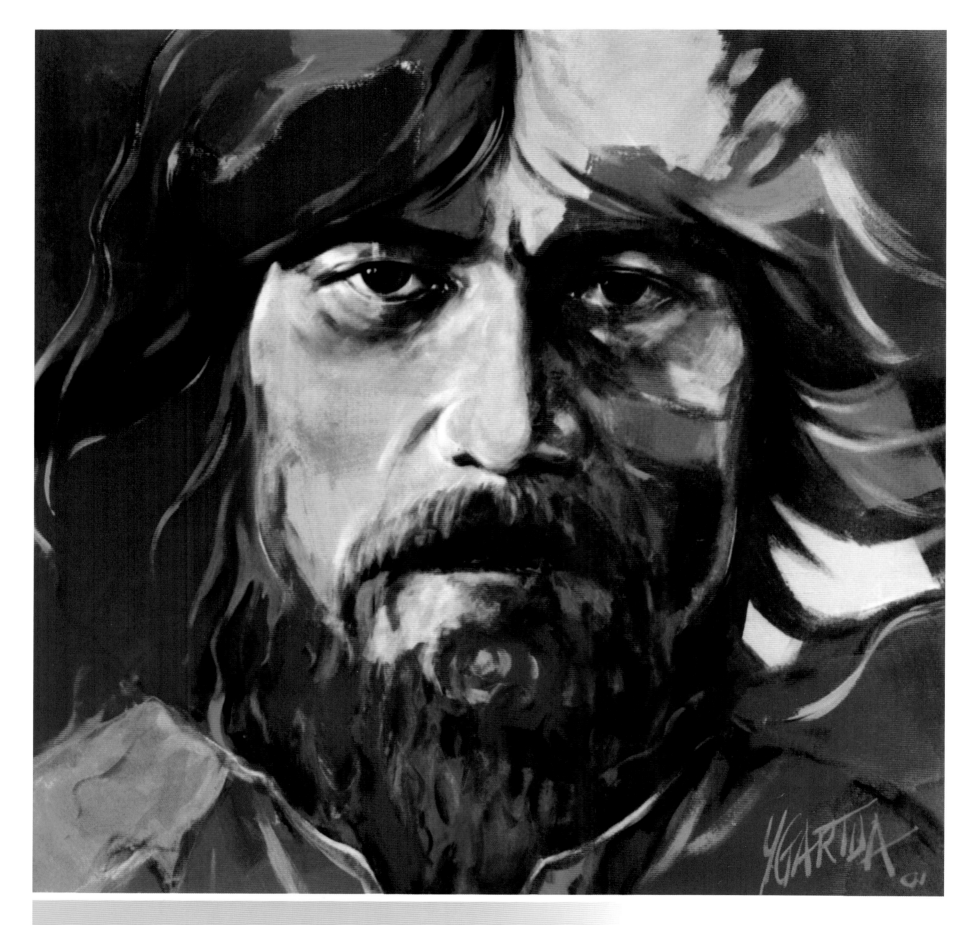

*Artist:* PAUL YGARTUA    *Title:* GEORGE

140

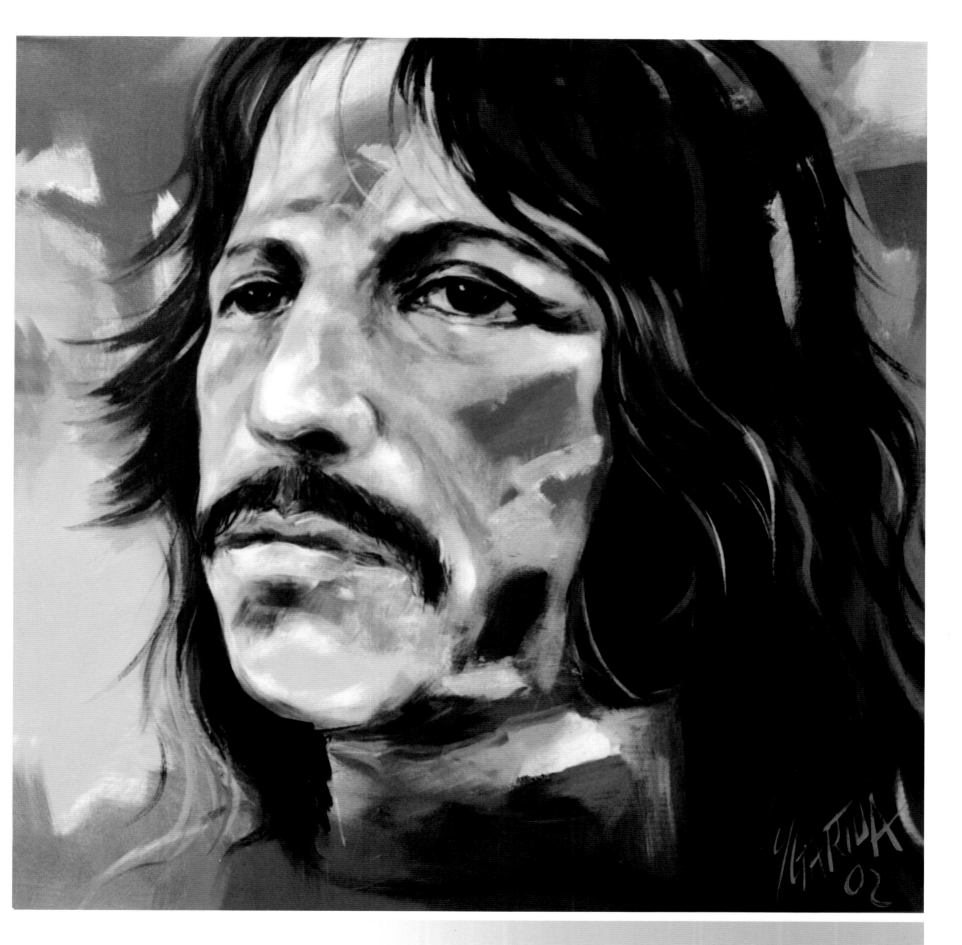

*Artist:* Paul Ygartua    *Title:* Ringo

*Artist:* Katie McGuire

*Title:* Blackbird

142

*Artist:* KATIE MCGUIRE          *Title:* HERE COMES THE SUN

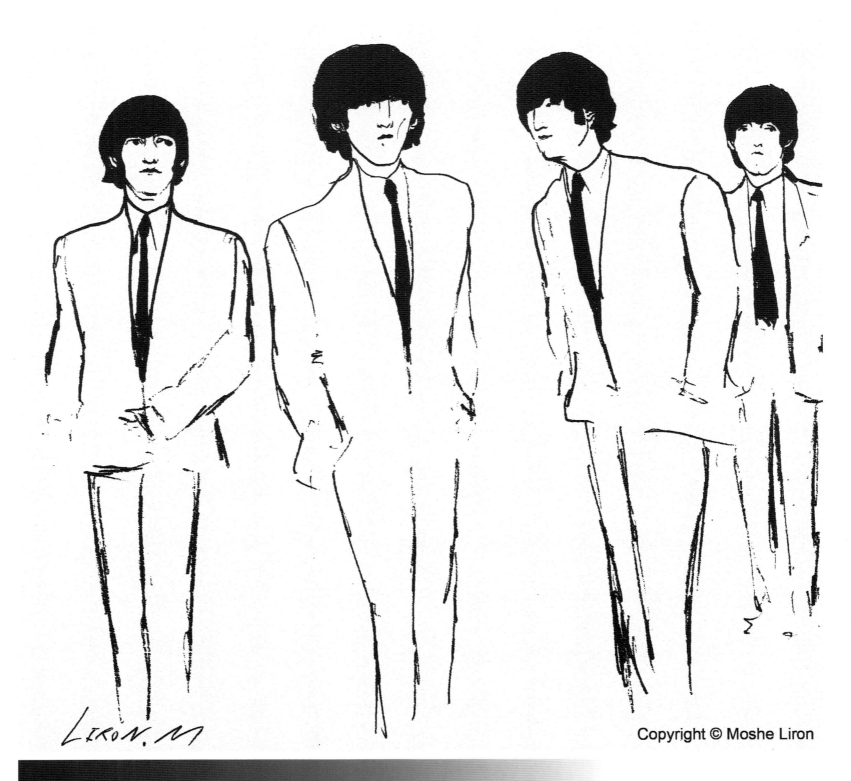

Liron.M

*Artist:* Moshe LiRON     *Title:* The Boys

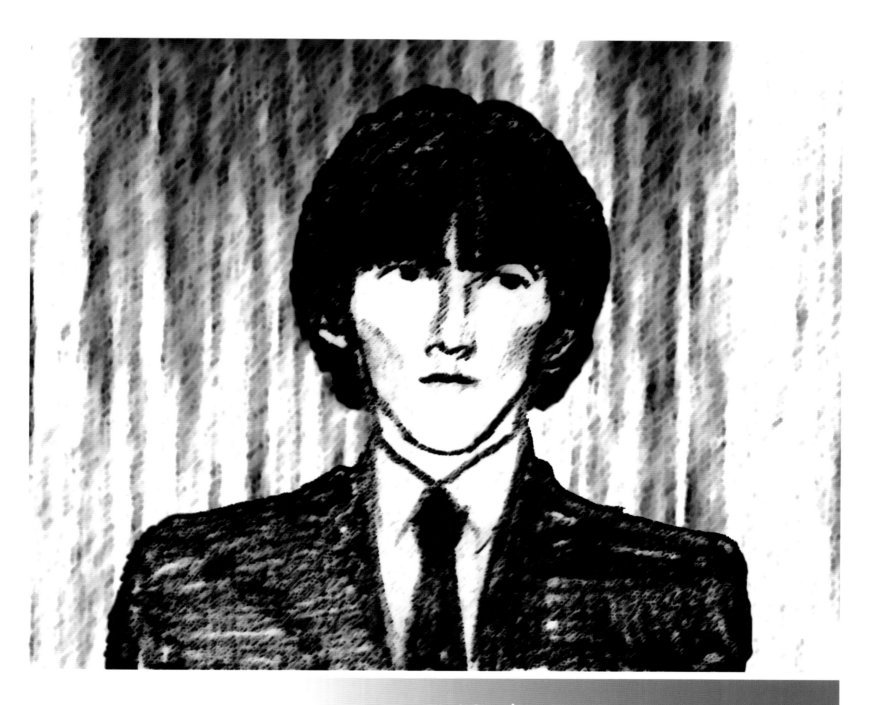

Artist: Moshe Liron  Title: George

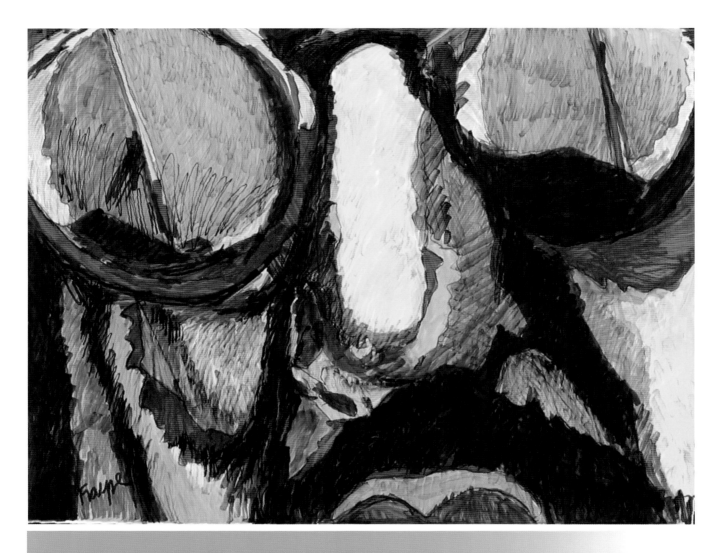

Artist: George Frayne     Title: Ringo

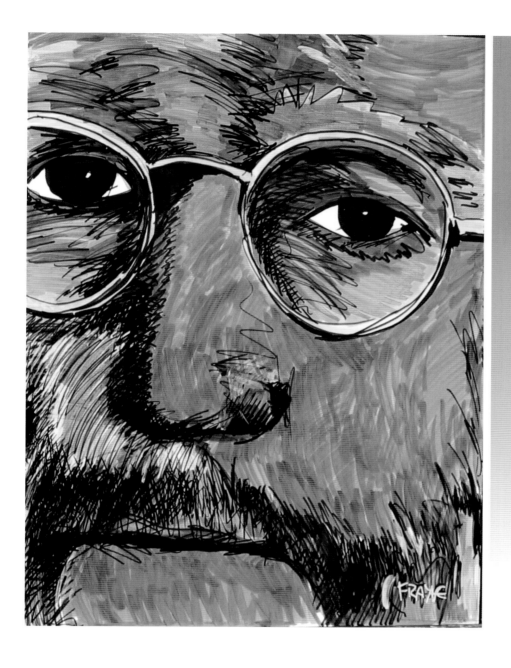

Artist: George Frayne

147

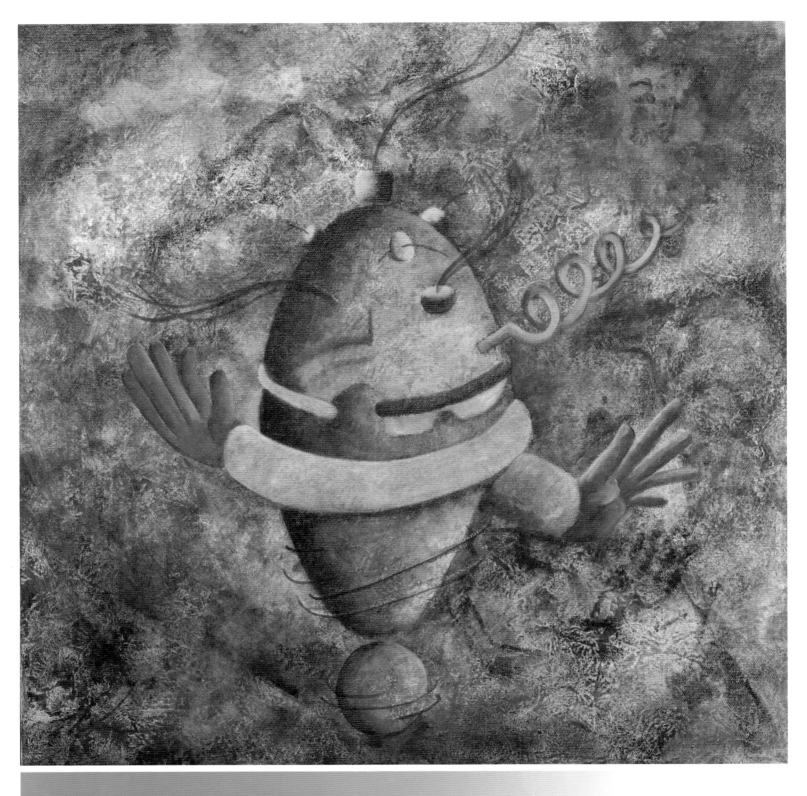

*Artist:* DAVID DERR          *Title:* GOO GOO G'JOOB

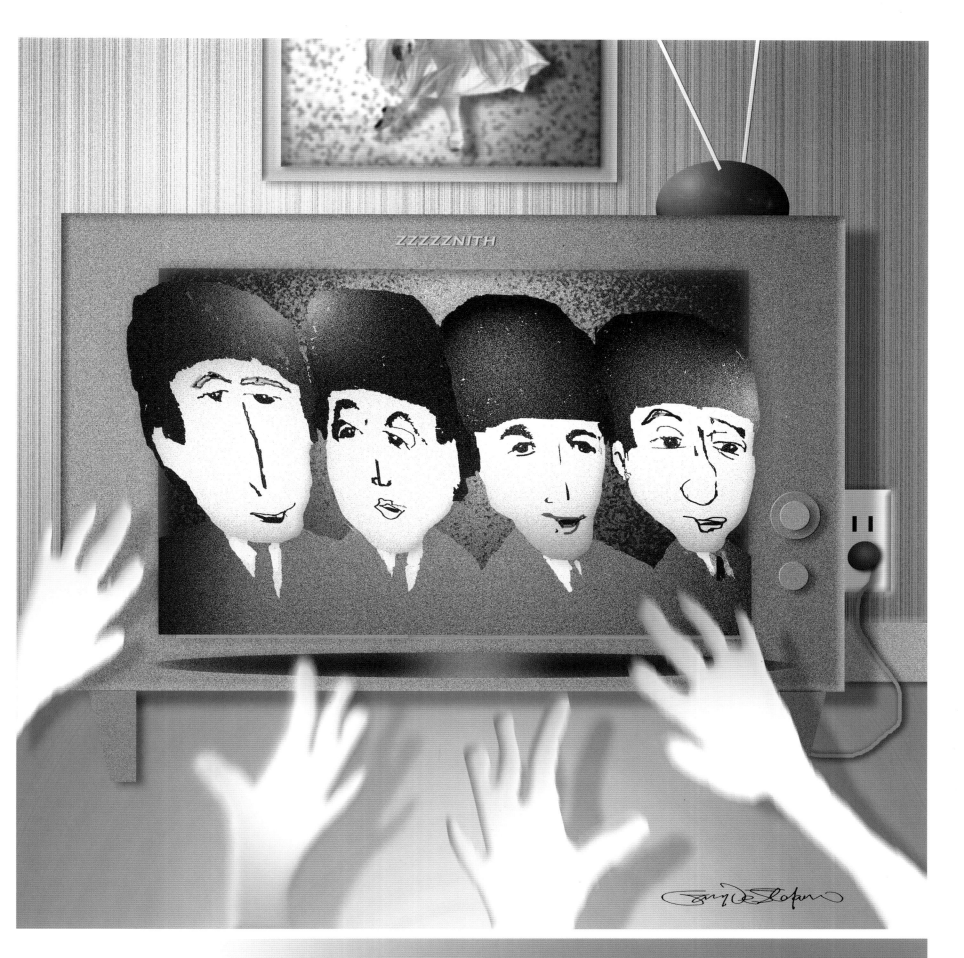

Artist: GARY DeSTEFANO          Title: FEBRUARY 1964

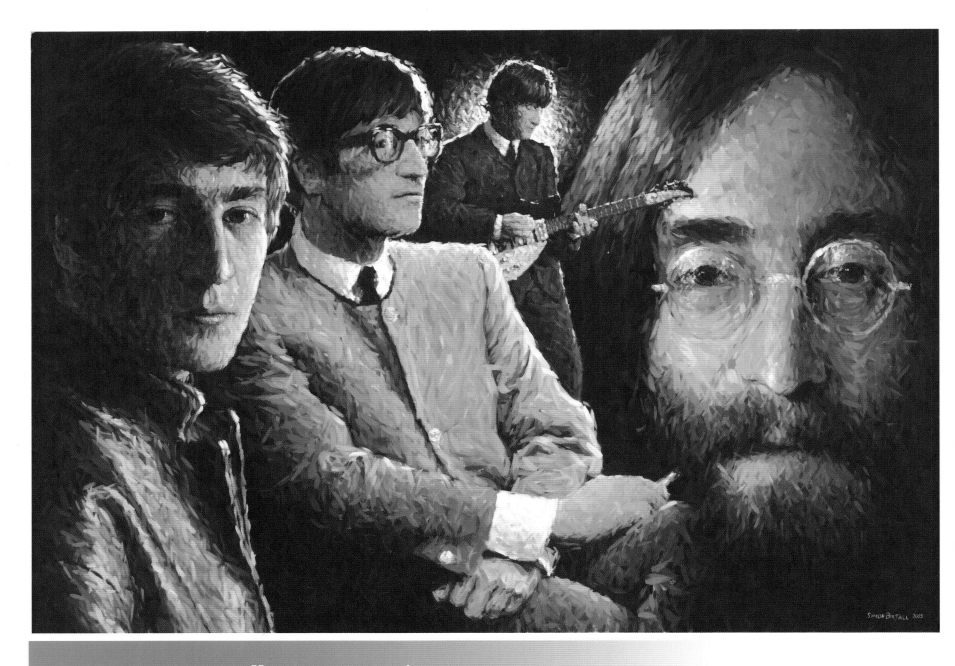

*Artist:* Simon Birtall    *Title:* John Montage

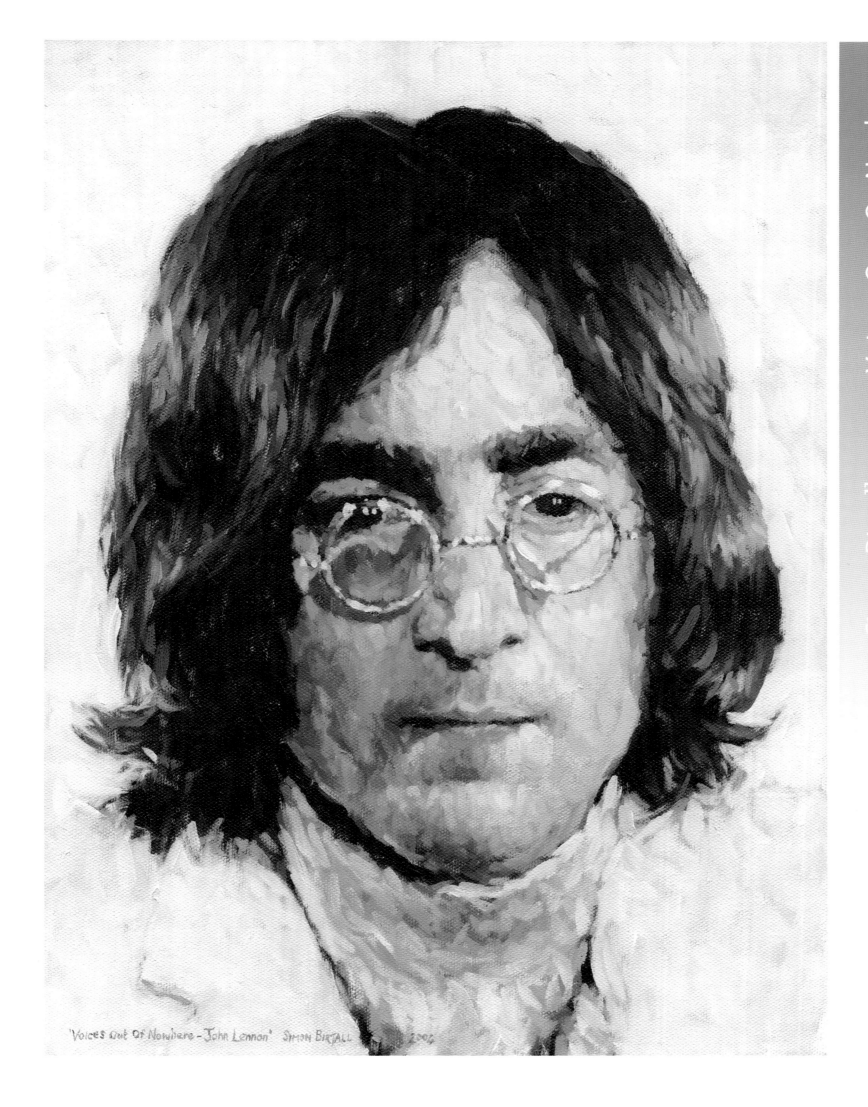

'Voices Out Of Nowhere - John Lennon' SIMON BIRTALL 2004

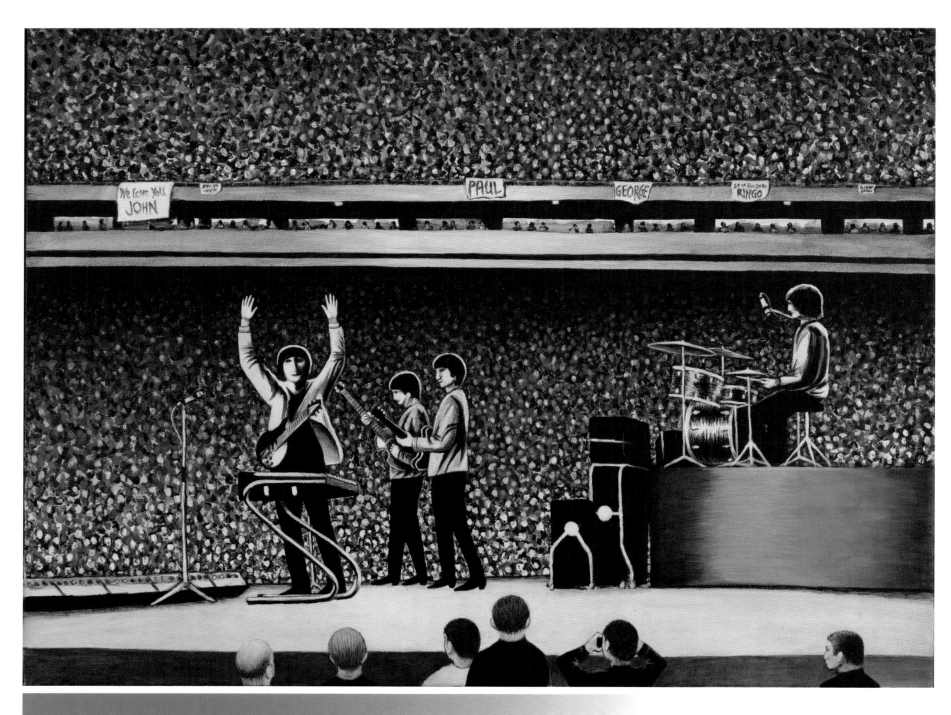

*Artist:* Jock Bartley        *Title:* Shea Stadium

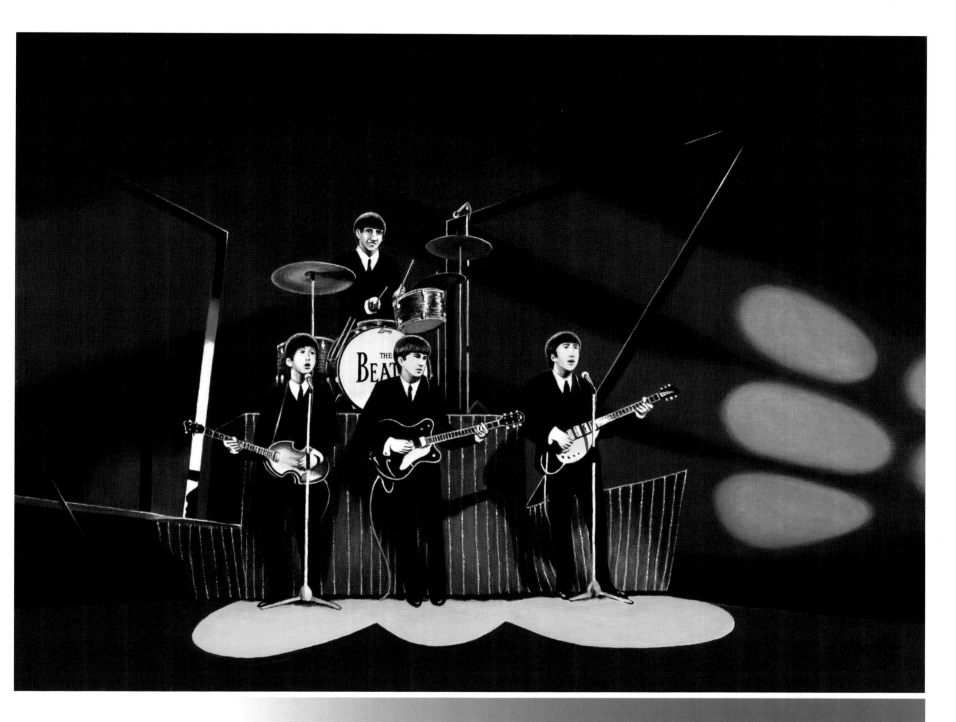

*Artist:* Jock Bartley          *Title:* London Paladium

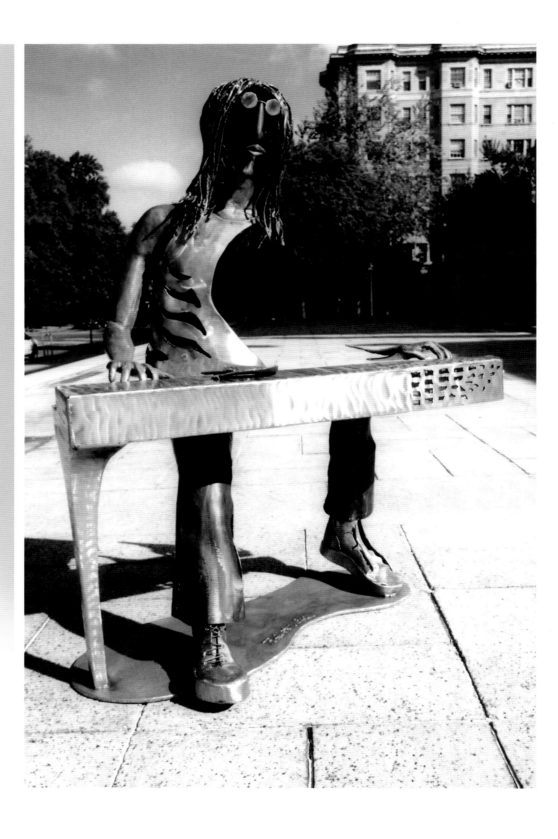

*Artist:* Robert Cole    *Title:* Lennon Sculpture

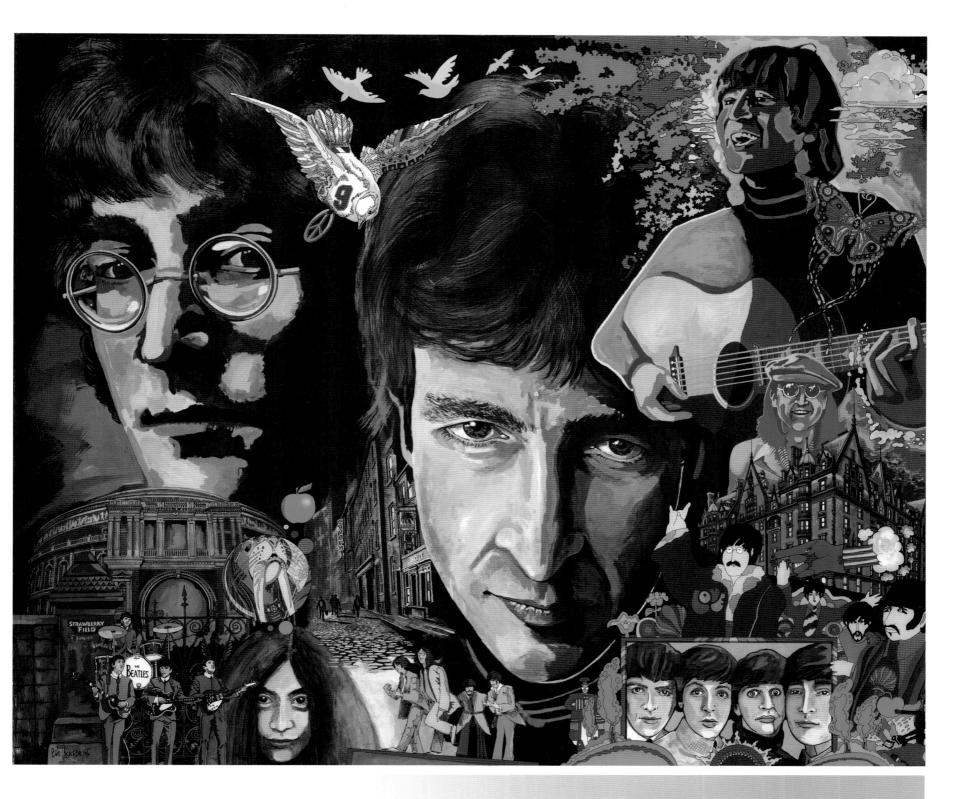

*Artist:* Bob Casazza          *Title:* Day in the Life

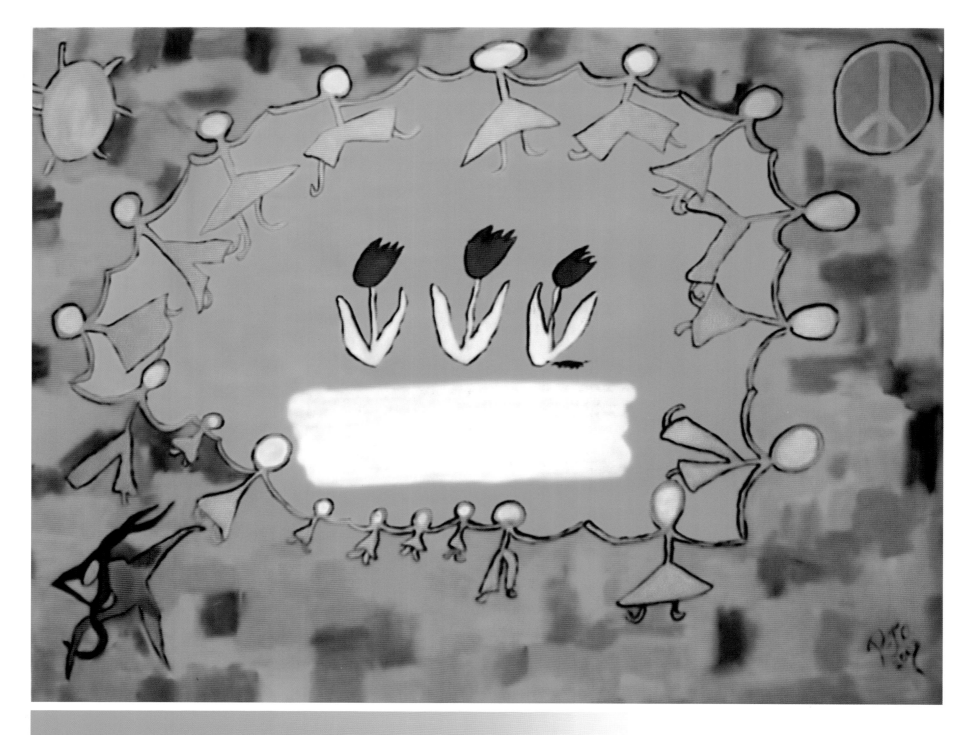

*Artist:* Peta Wright          *Title:* Imagine

"The Beatles' music inspires me to paint! Oh, does it ever!

"When I was young, I felt they belonged to me and somehow gave me freedom to be young! They sang to ME. Their songs are mostly about love and life.

"When I listen to the lyrics, I want to paint. I have to paint. Listening to 'Ob la di Ob la da', I felt frenetic! Quite beside myself—a simple love story about a girl singer in a band and a guy who sells veggies, for goodness sake! Who would have thought it! But they went on to have all the normal ups and downs in a relationship and live happily ever after. The courtship was especially fun.

"'Imagine' has incredible personal directness about life. It makes me want to cry and laugh loudly. Oh, what a joke to imagine our world without greed, hunger or war, and all the people sharing all the world. Just imagine."

Peta Wright

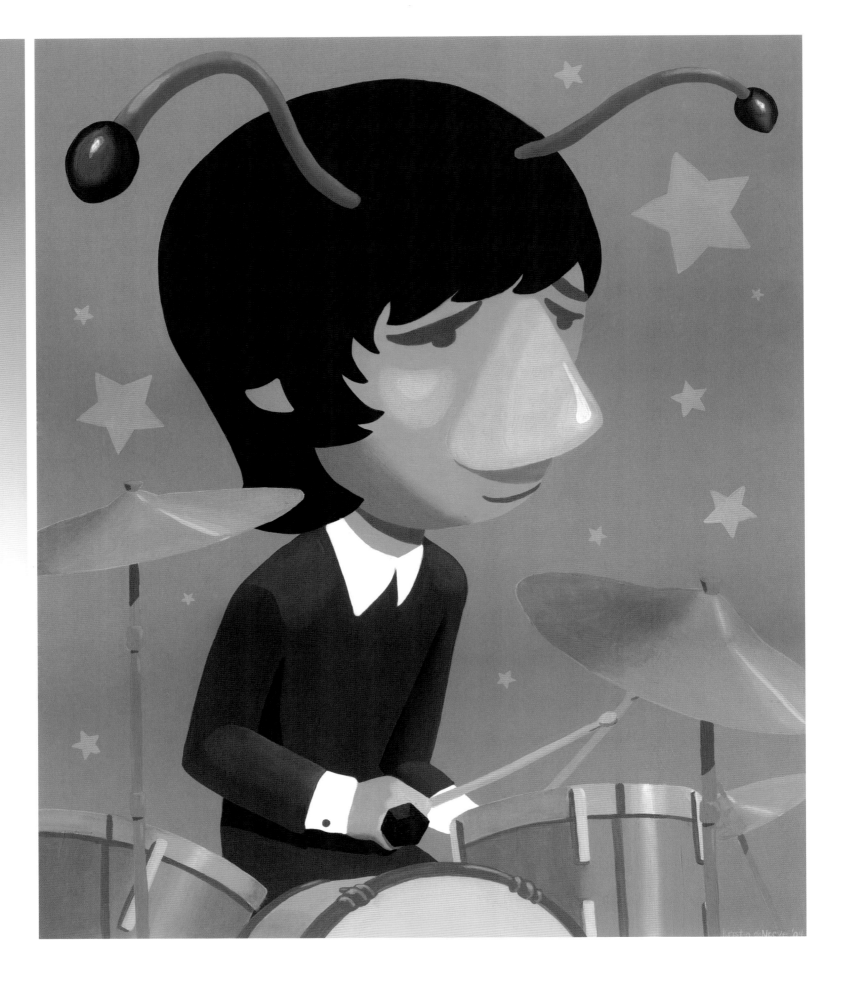

Artist: Kristin deNeeve

Title: RiNGO

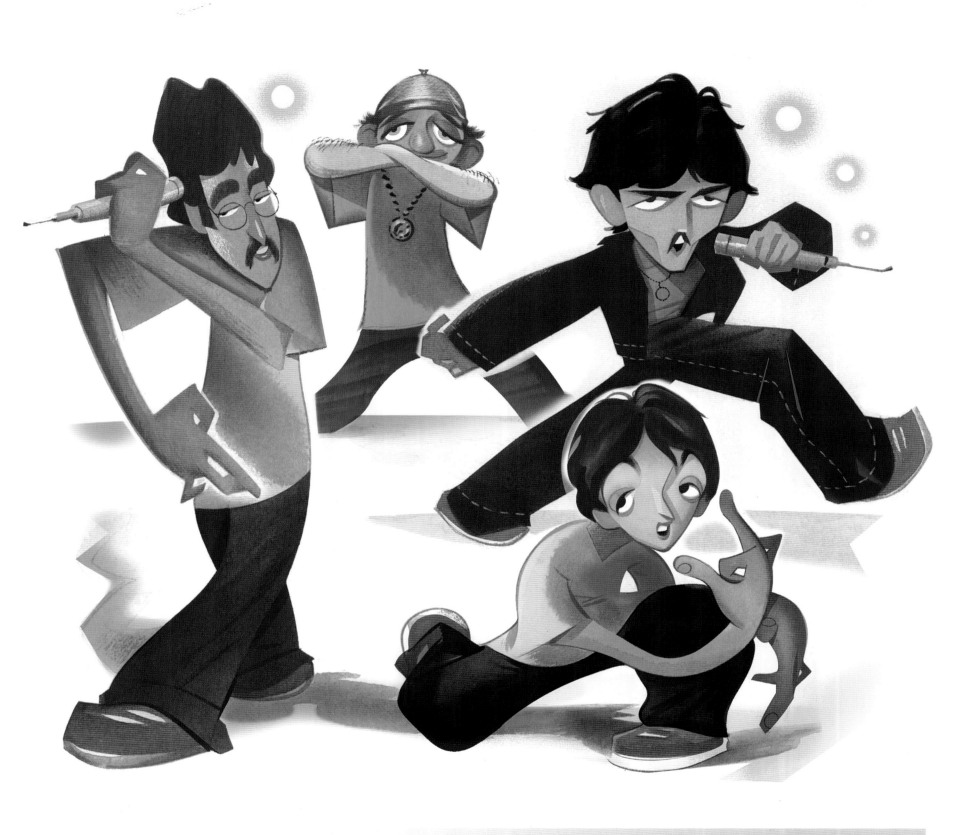

*Artist:* Eric Palma    *Title:* Beatles Rap

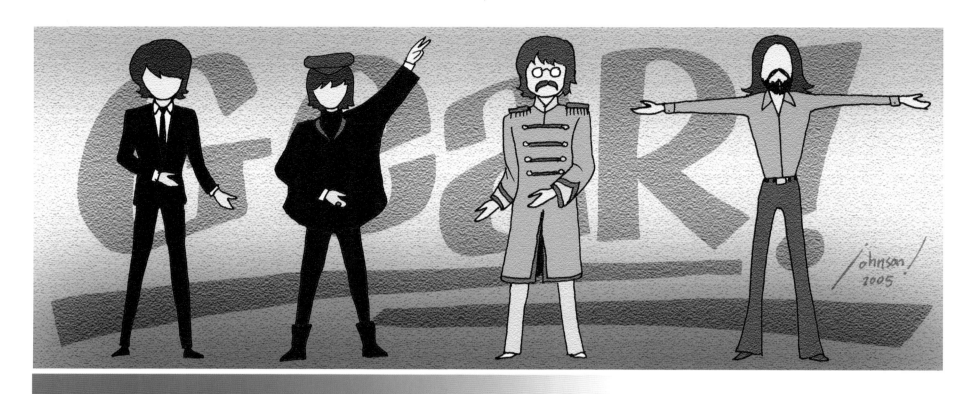

*Artist:* SCOTT JOHNSON      *Title:* GEAR

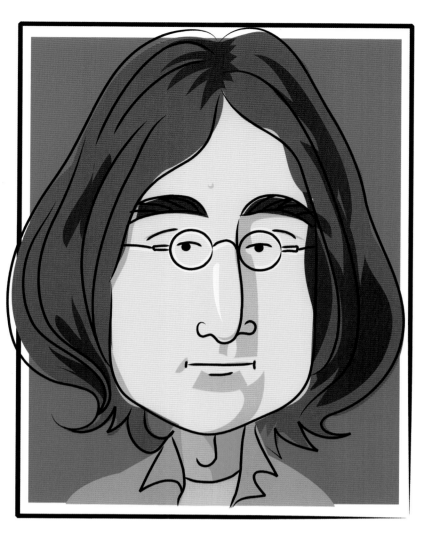
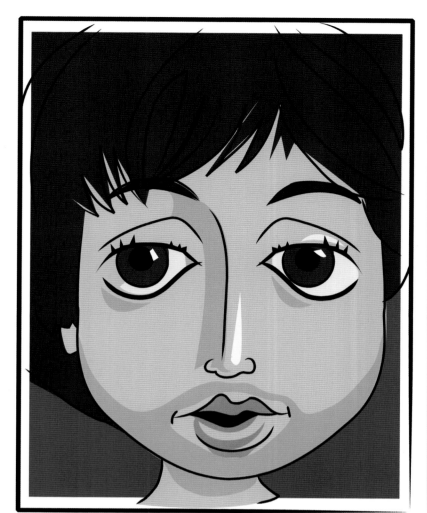
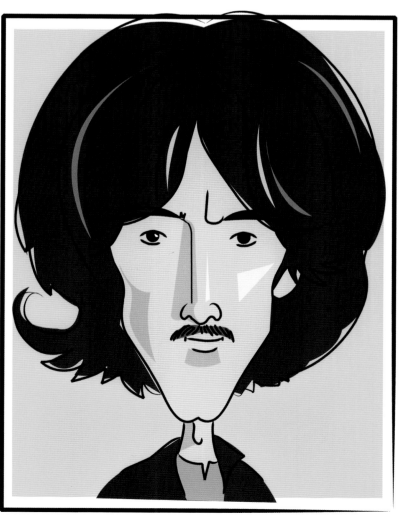
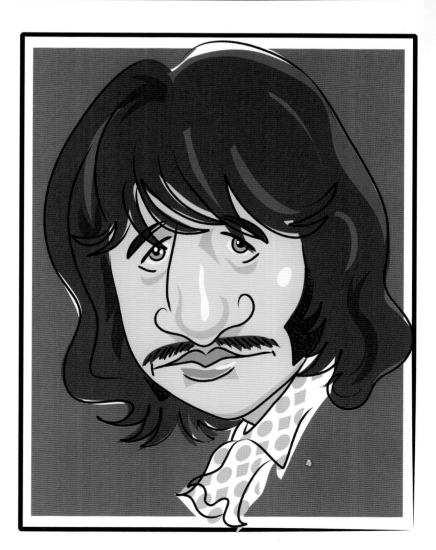

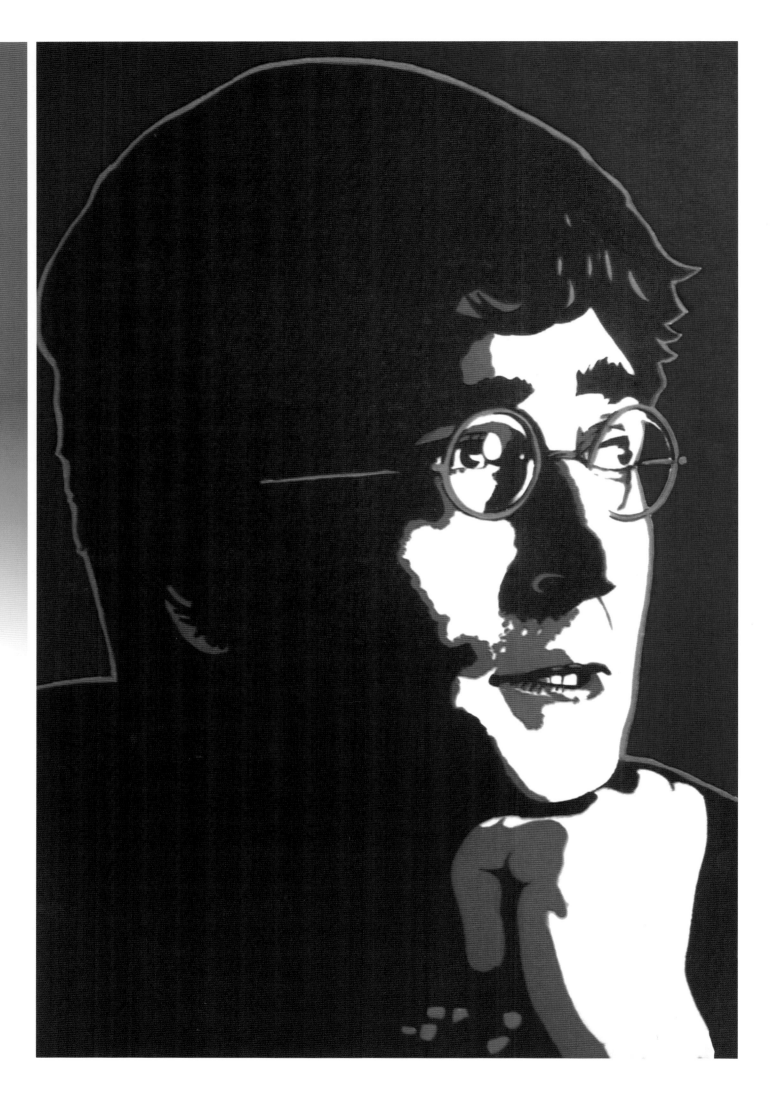

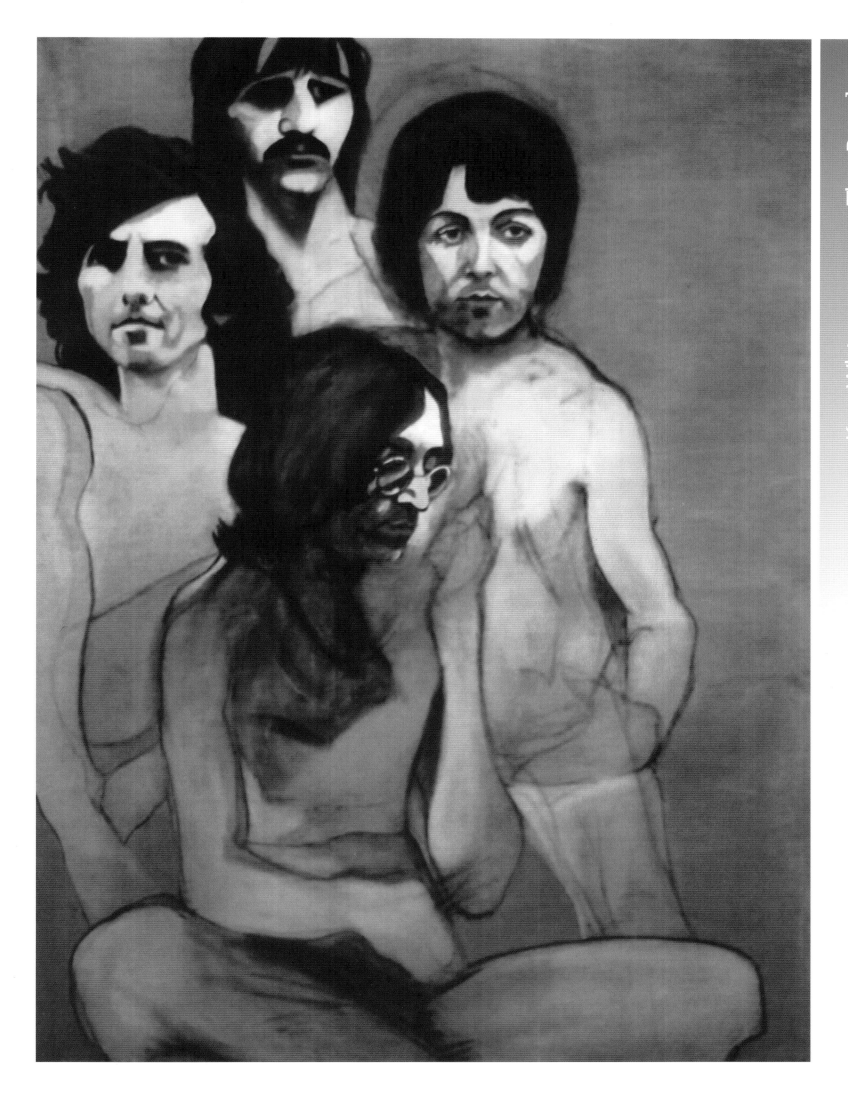

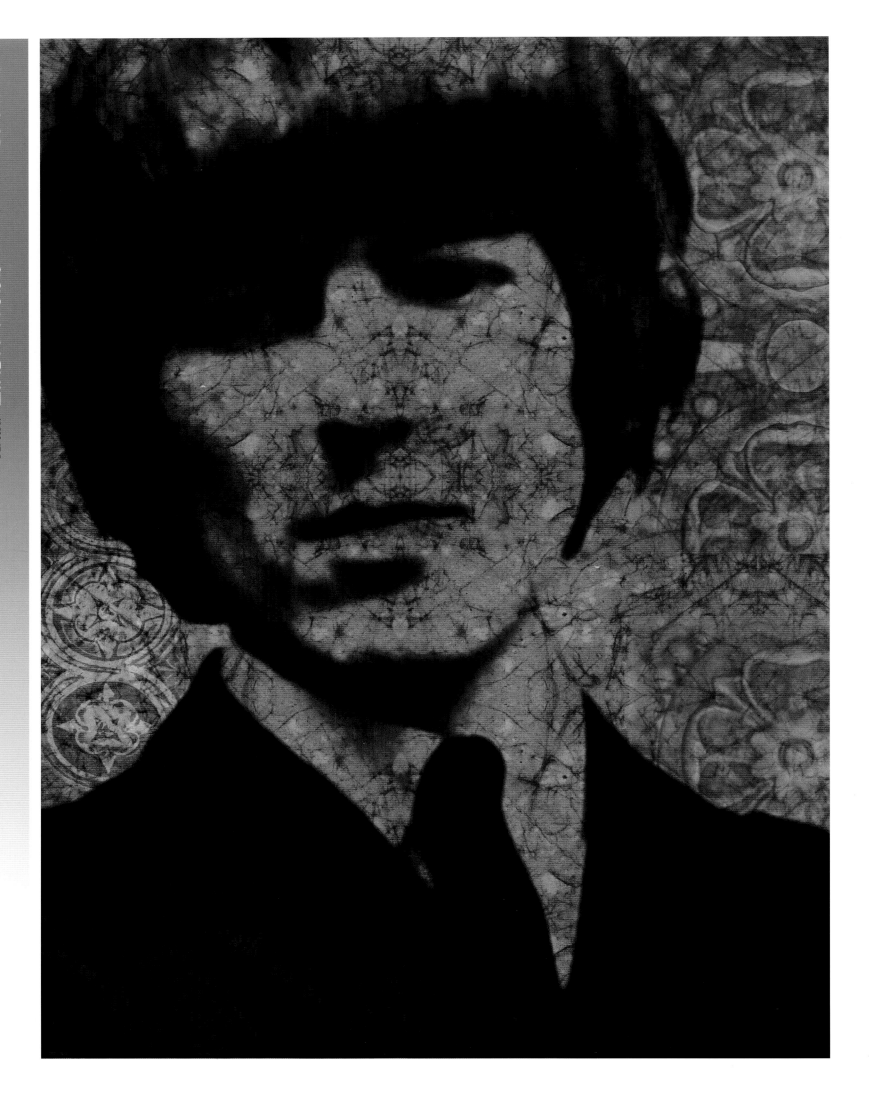

*Artist:* Linda Webb    *Title:* George

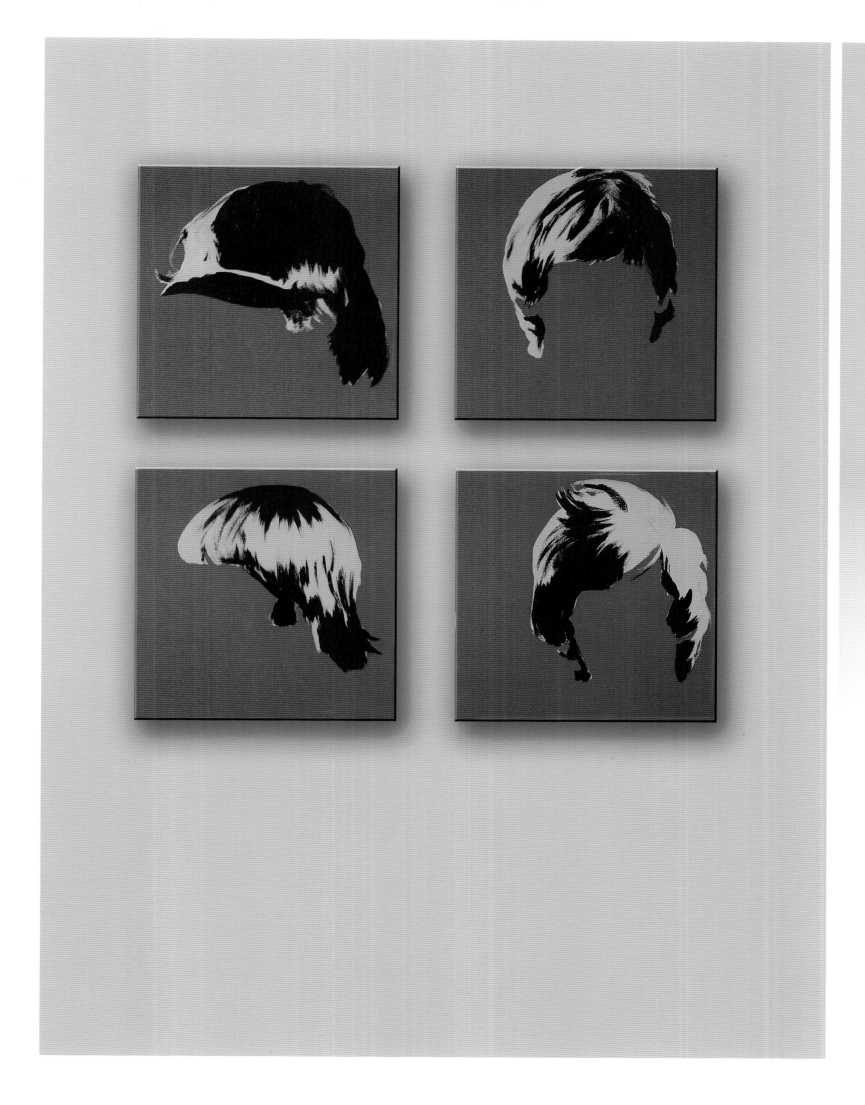

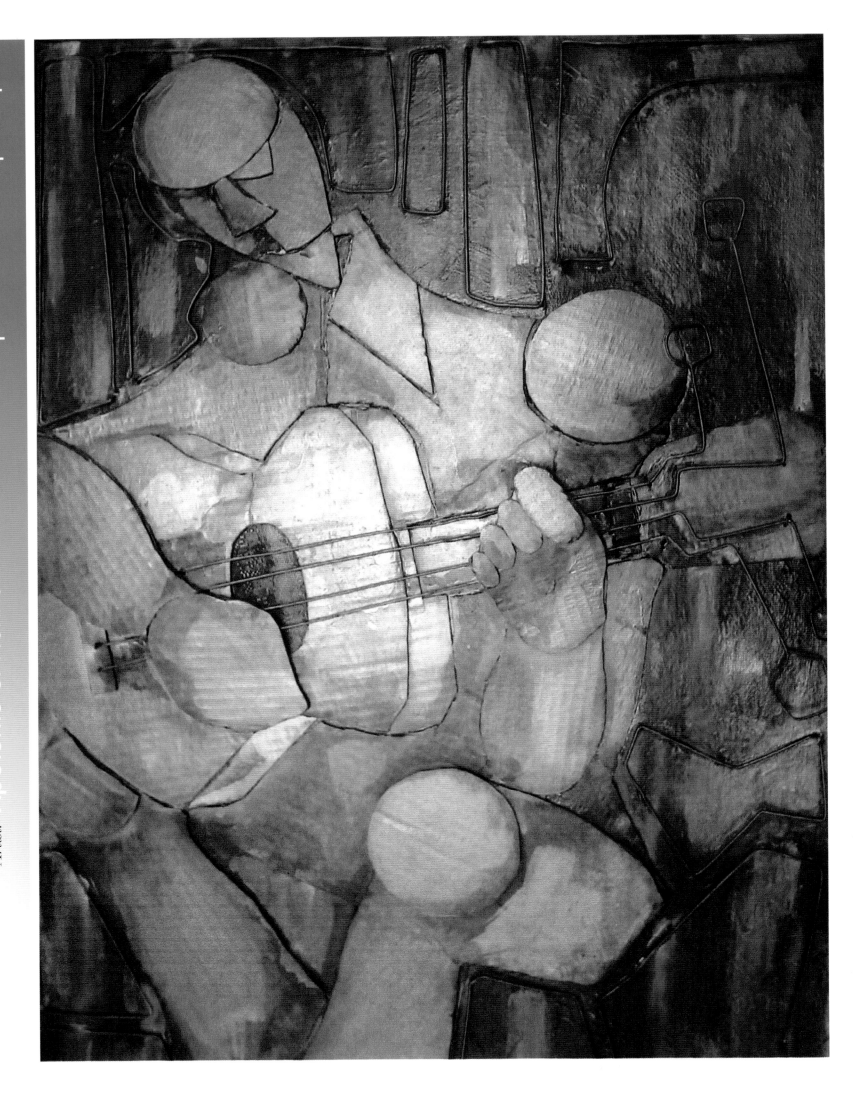

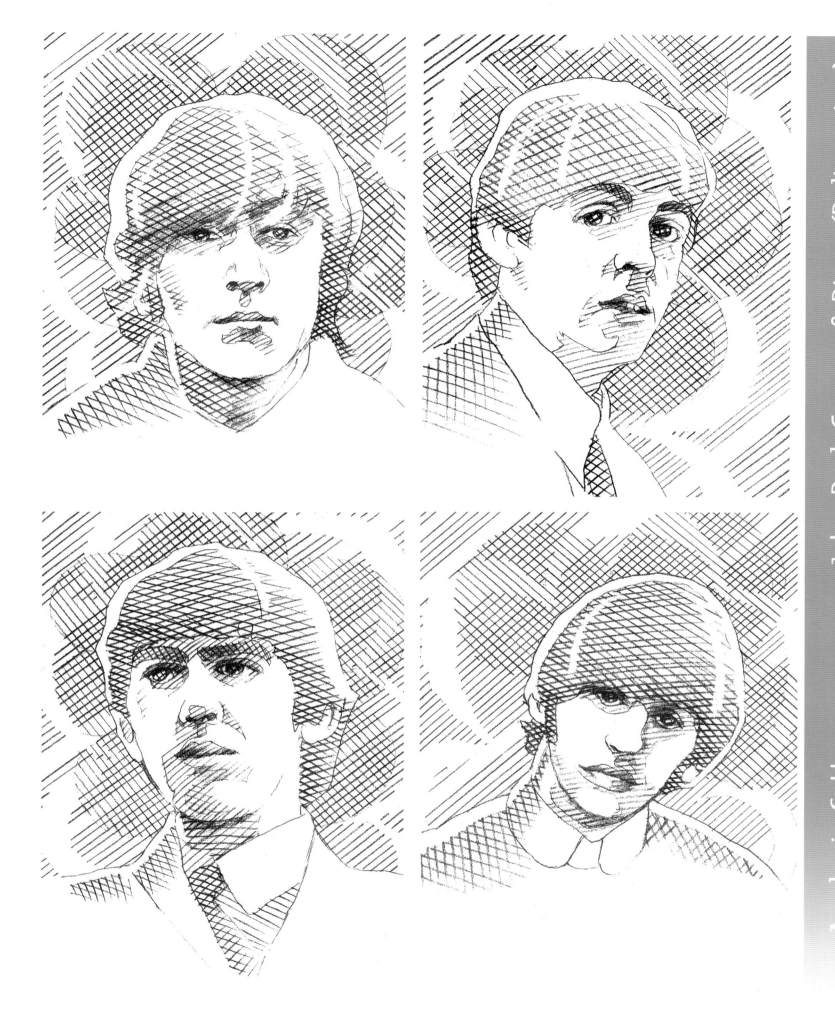

*Artist:* Apolonio S. Herrera    *Title:* John, Paul, George & Ringo (Polinearism)

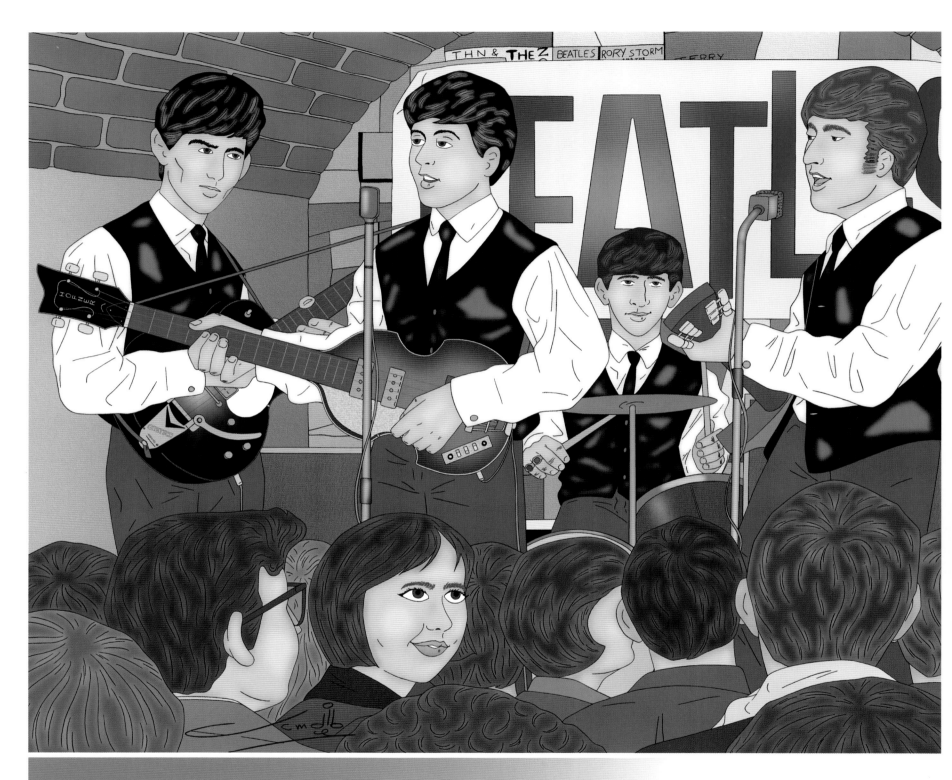

*Artist:* Juan Carlos     *Title:* Cavern Club

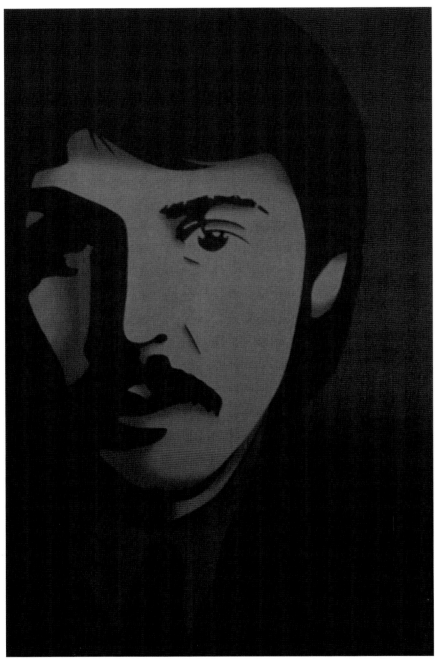

*Artist:* DAViD RUDD    *Title:* JOHN, PAUL

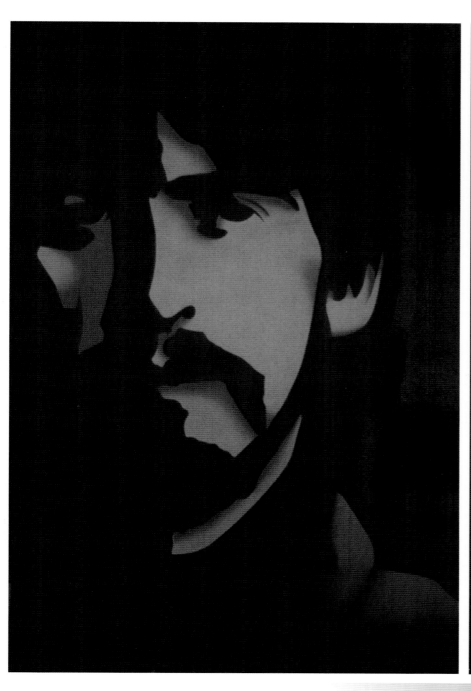
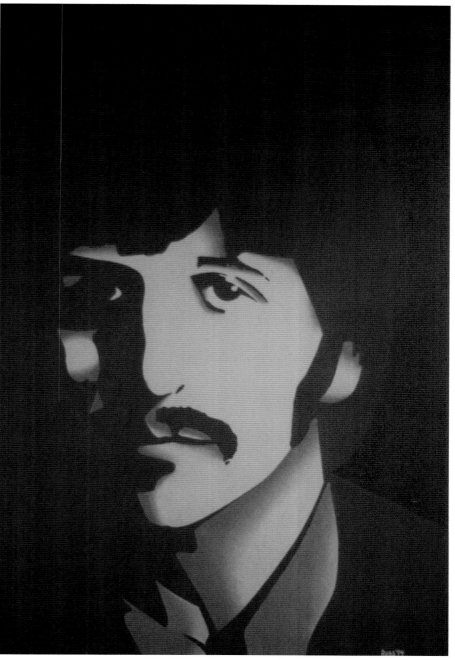

*Artist:* DAVID RUDD    *Title:* GEORGE, RINGO

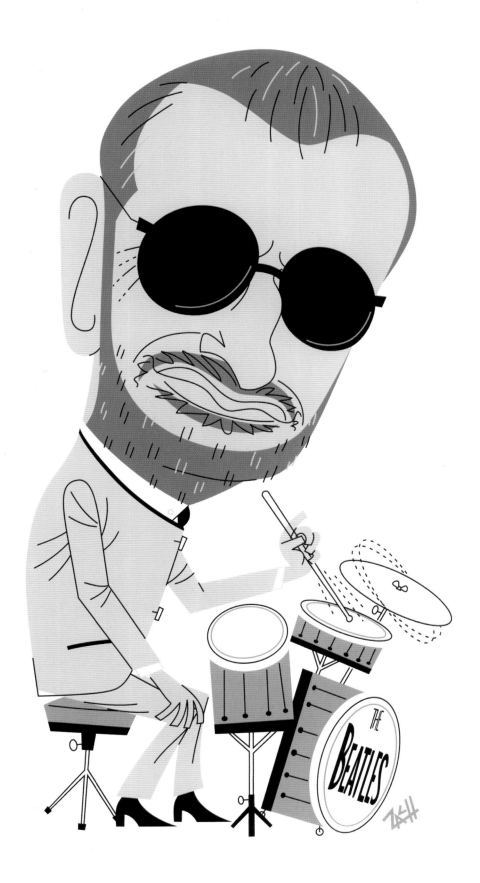

Artist: Zach Trenholm   Title: Ringo Starr

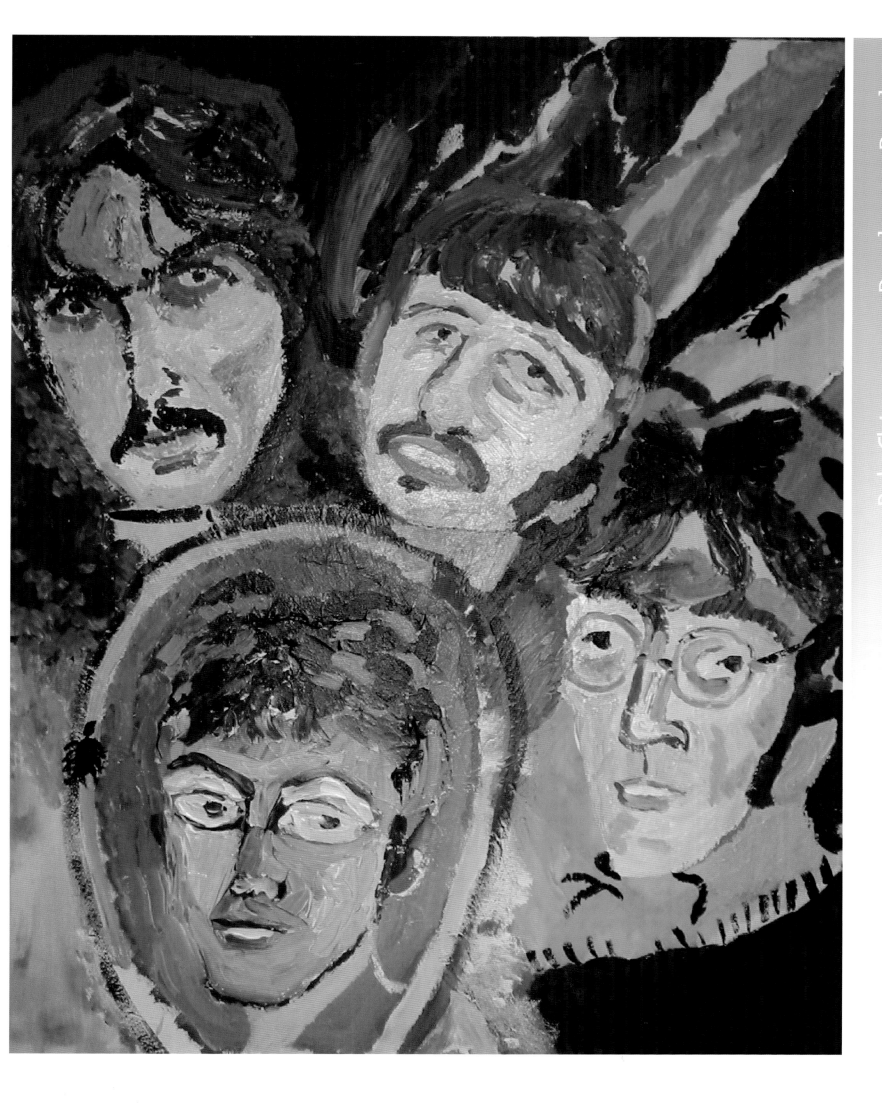

*Artist:* Rob Chin   *Title:* Beetles on Beatles

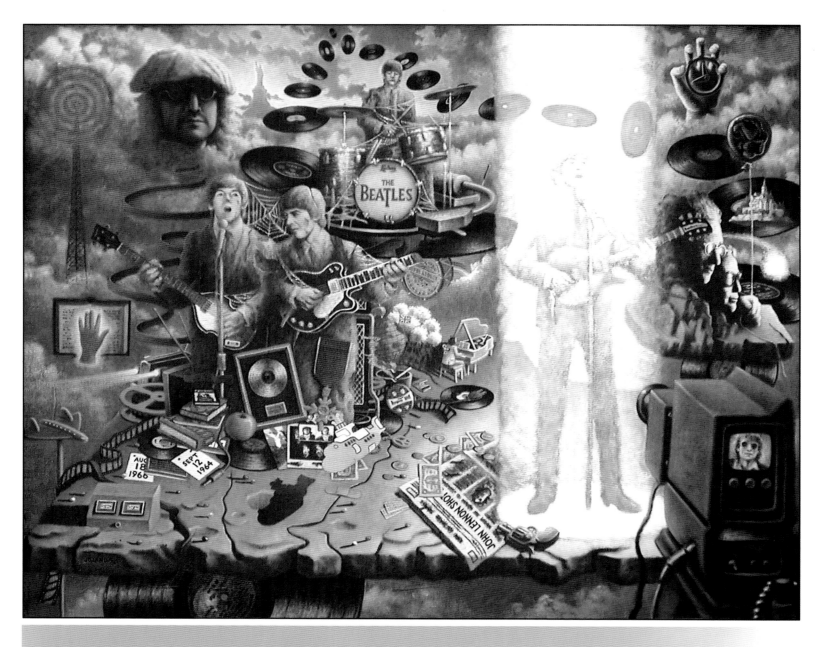

*Artist:* JULIAN LANDA　　　*Title:* REQUIEM (FOR JOHN LENNON)

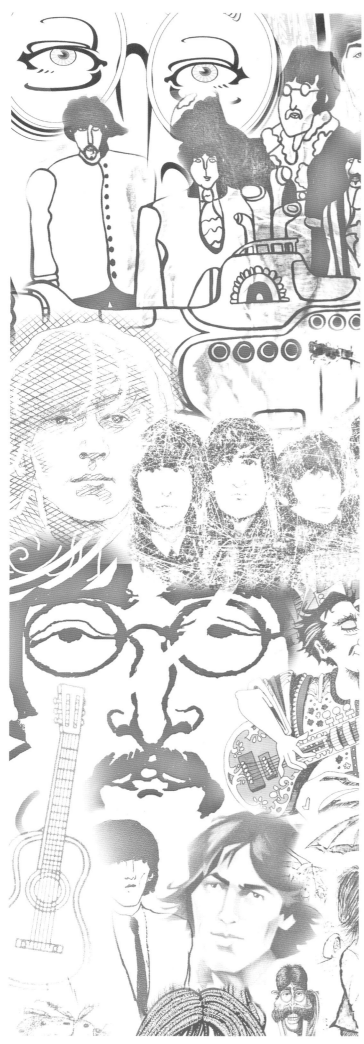

"Like most fans of The Beatles, I was shocked to learn of the death of John Lennon. My painting 'Requiem For John Lennon' was my reaction to the finality of The Beatles. Without John, no longer would there be The Beatles.

"I've been a fan of The Beatles and their music since 1964. Growing up with them, I was inspired by their creativity and originality. As an artist, they inspired me not to be intimidated by the boundaries of convention. I strived to achieve, in my painting, the same high standards found in their music.

"Experiencing their influences in music, fashion, and their messages of peace and love, their growth led the way for my growth.

"'Requiem For John Lennon' is my surrealistic tribute to John. I wanted to show his life through the symbols of The Beatles and his solo career. The painting shows the group on stage, surrounded with various elements that are associated with The Beatles; records, films, books, TV and so on.

"As in The Beatles music, some images are obvious, others are more obscure. They show milestones that I feel represent The Beatles' message and continued growth. I wanted to show John breaking away from The Beatles and included some of his symbols. Some examples would be the white piano from 'Imagine', breaking away with Yoko and the foreshadowing of the birth of Sean. Also, the floating castle represents the Dakota where John spent the rest of his life, the newspaper headline announcing 'John Lennon Shot Dead' and the TV camera showing John just before his death. I tried to show his whole life in this painting.

"I've enjoyed the fact that this painting has always inspired questions and discussion from viewers. The question most people seem to ask is, 'What are those two dates?'

"They're the dates I saw The Beatles in concert!"

Julian Landa

175

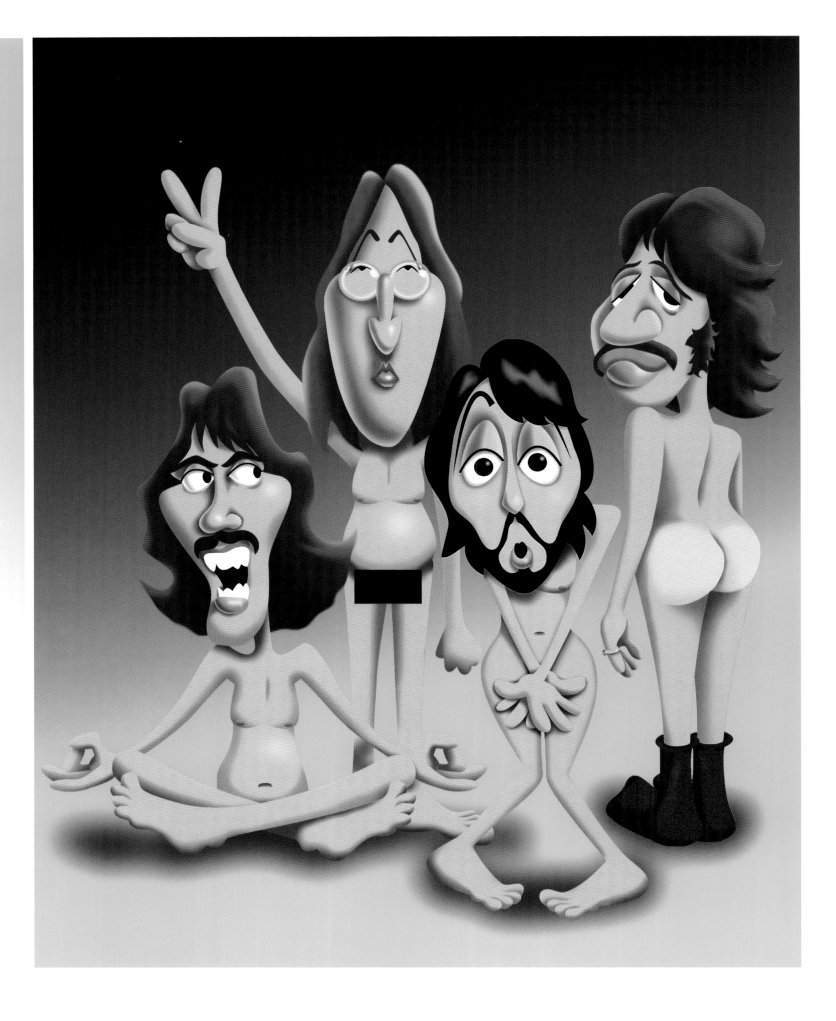

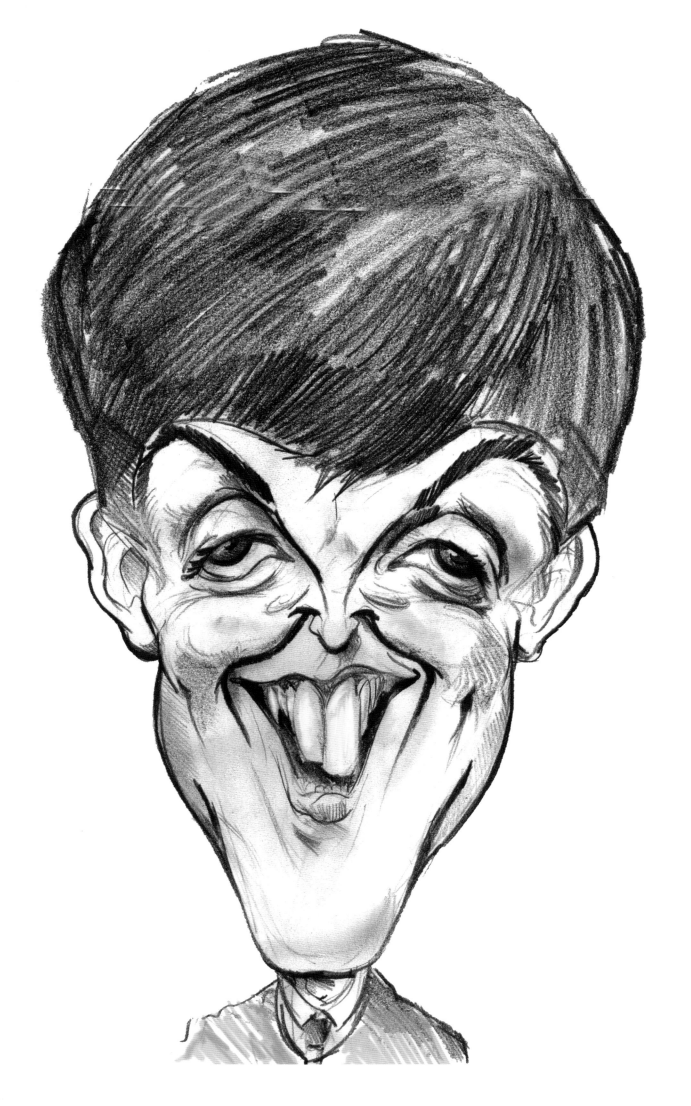

Artist: Niall O'Loughlin    Title: Paul Caricature

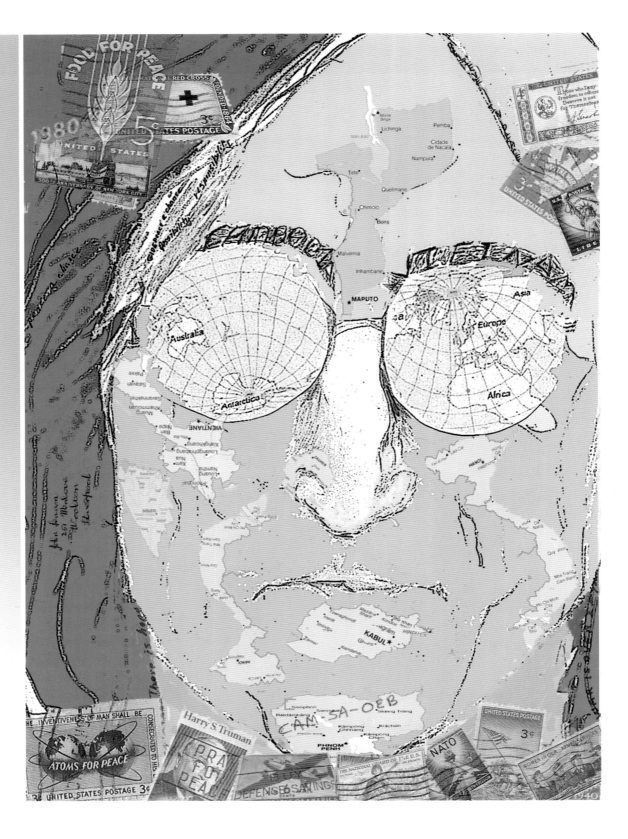

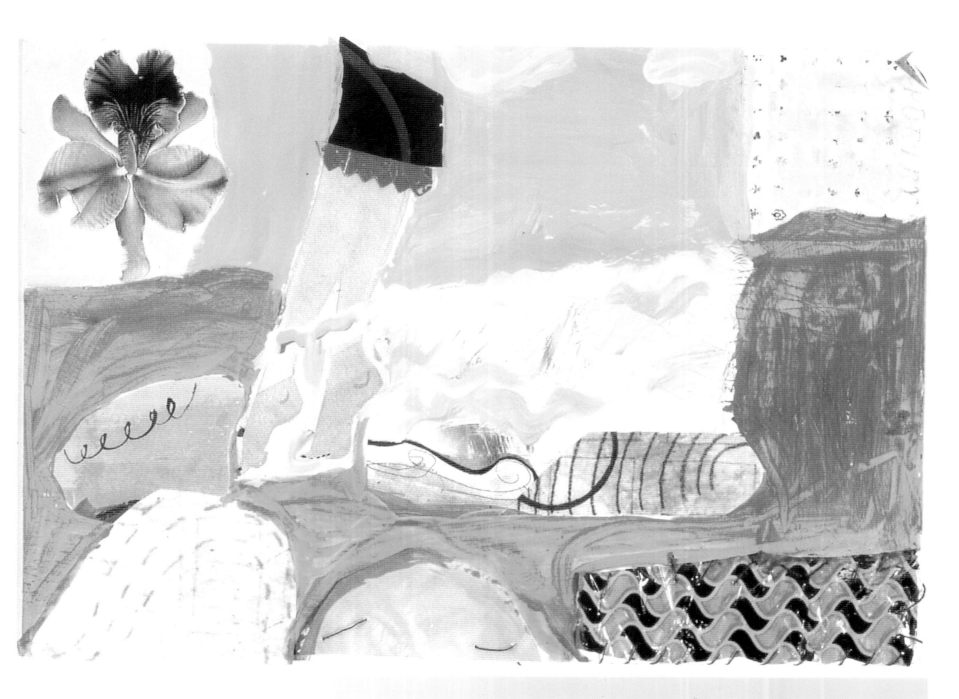

*Artist:* Andrea Fuhrman    *Title:* There's a Place

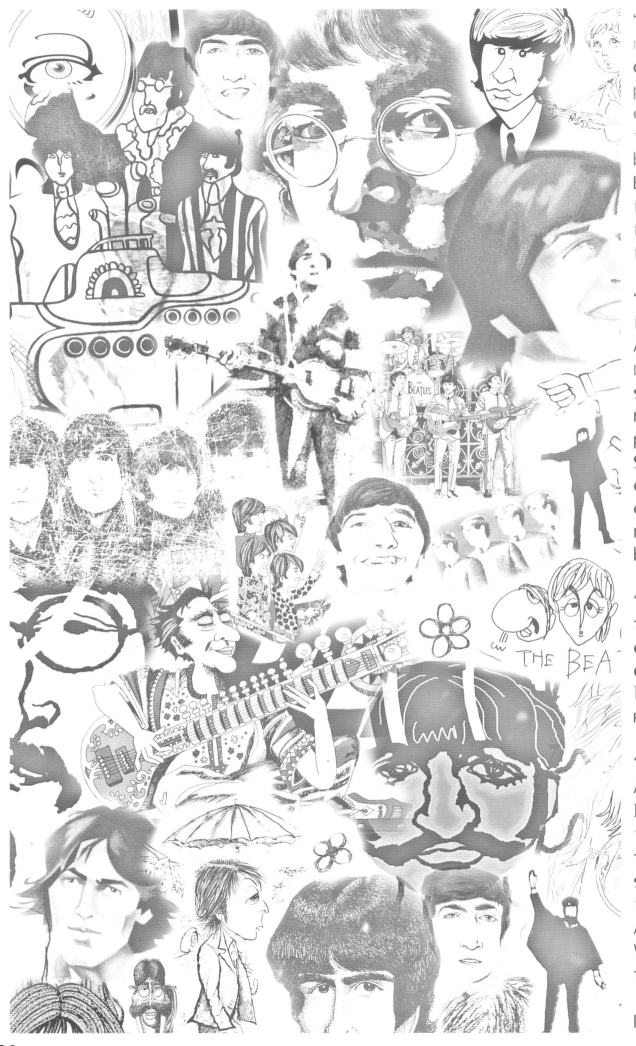

"INSPIRATION? I simply wanted my own version of The Beatles on my wall. So many photographs have been taken of them together and apart that they are practically burned in my mind. As big a Beatle fan as I am, this illustration remains the only image of them I have hanging in my home.

"INSPIRATION? Pick up an instrument, learn how to play, and write your own music. It's discouraging to see that now some choose our future music 'idols' through a phone-in voting system. So-called 'idols' in the past earned that status by changing music and being nothing like anything that came before them.

"INSPIRATION? Live your life as they have lived theirs: with an open mind toward the experiences of life—music, literature, politics, travel, art, film, everything.

"INSPIRATION? Strive for love and peace, not hate and war. It's odd to me that some of the same people who call themselves Beatles fans support ideas and policies that The Beatles stood firmly against. It doesn't match up. We should all take these words to heart: All you need is love."

Rik Sansone

180

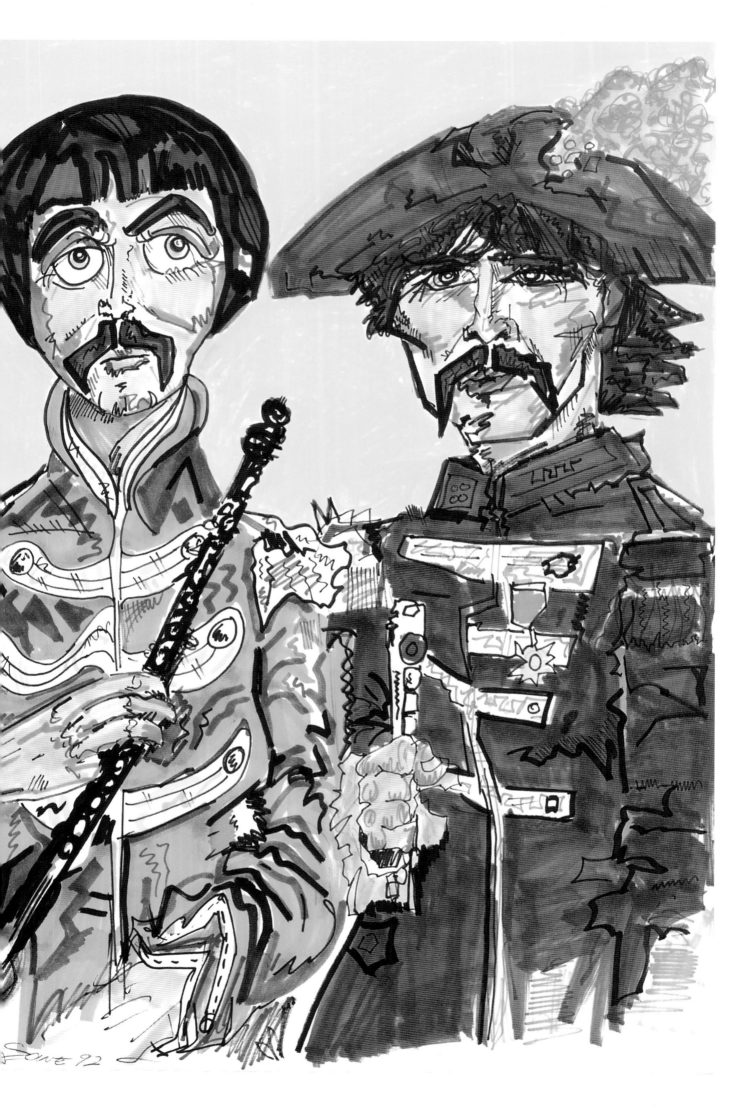

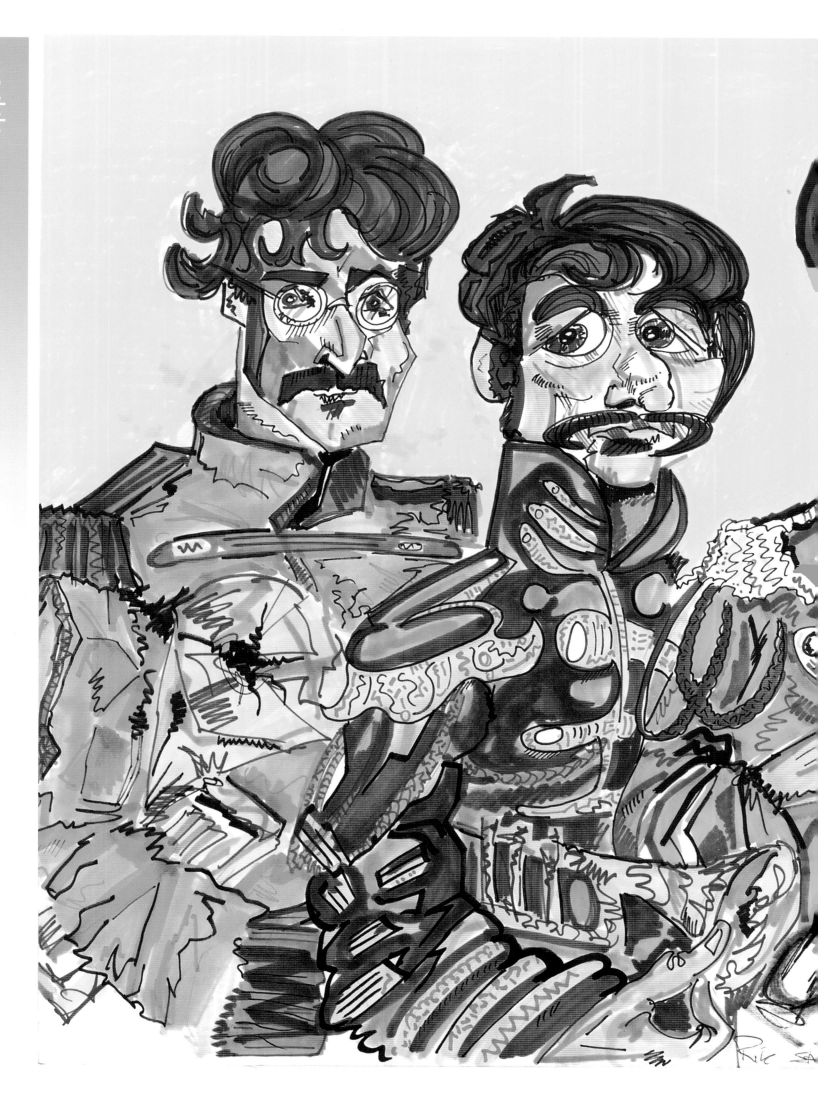

*Artist:* Rik Sansone

*Title:* Pepper

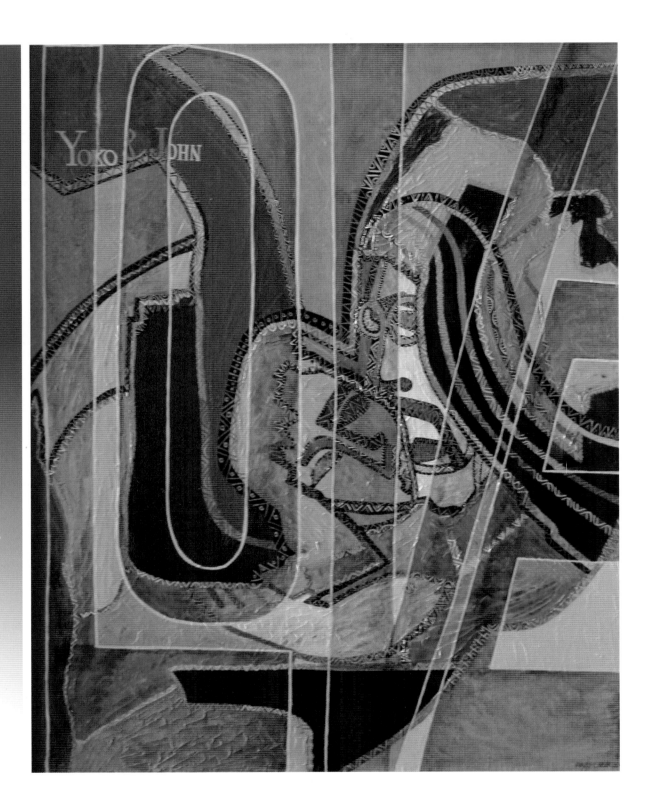

*Artist:* Sergey Parfenuk    *Title:* Love (John & Yoko)

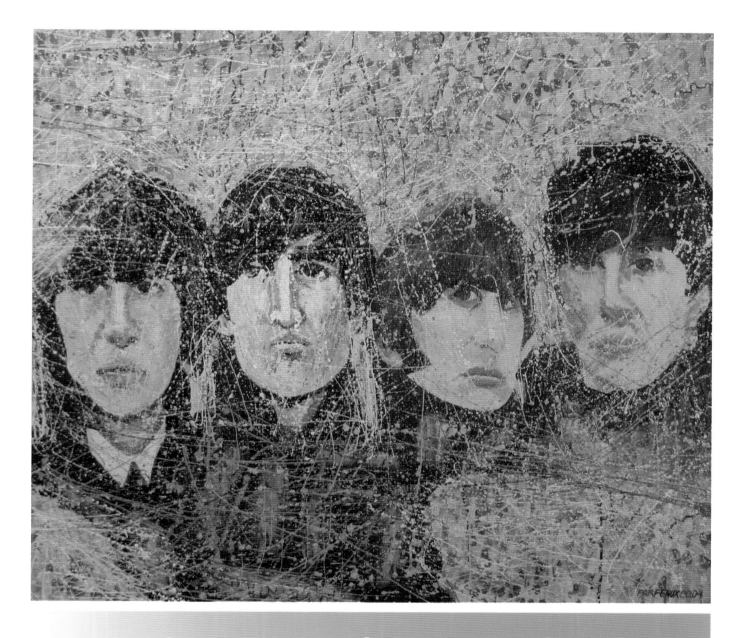

*Artist:* Sergey Parfenuk          *Title:* Beatles For Sale

Photographer: Walter Lippmann

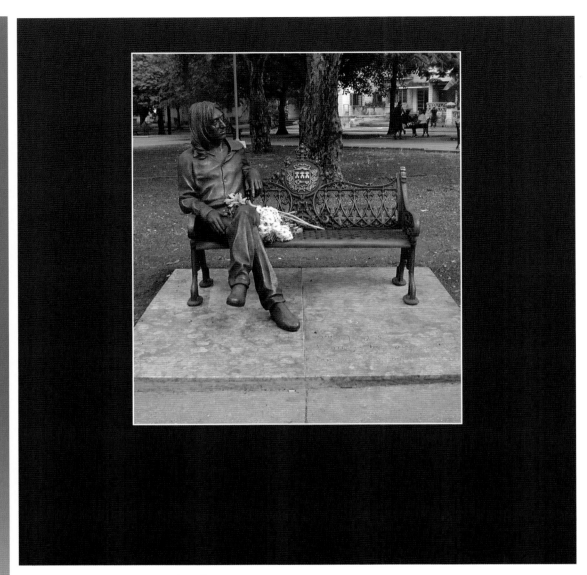

*José Villa's Statue of John Lennon in Lennon Park, Havana, Cuba.*

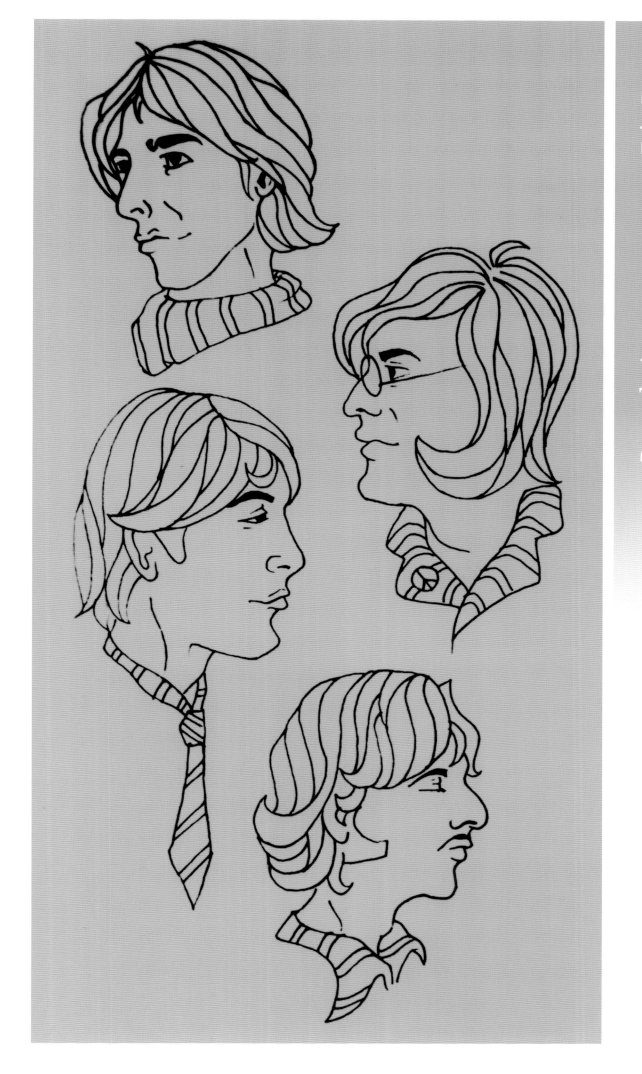

*Artist:* Beverly Langran    *Title:* Fab Four

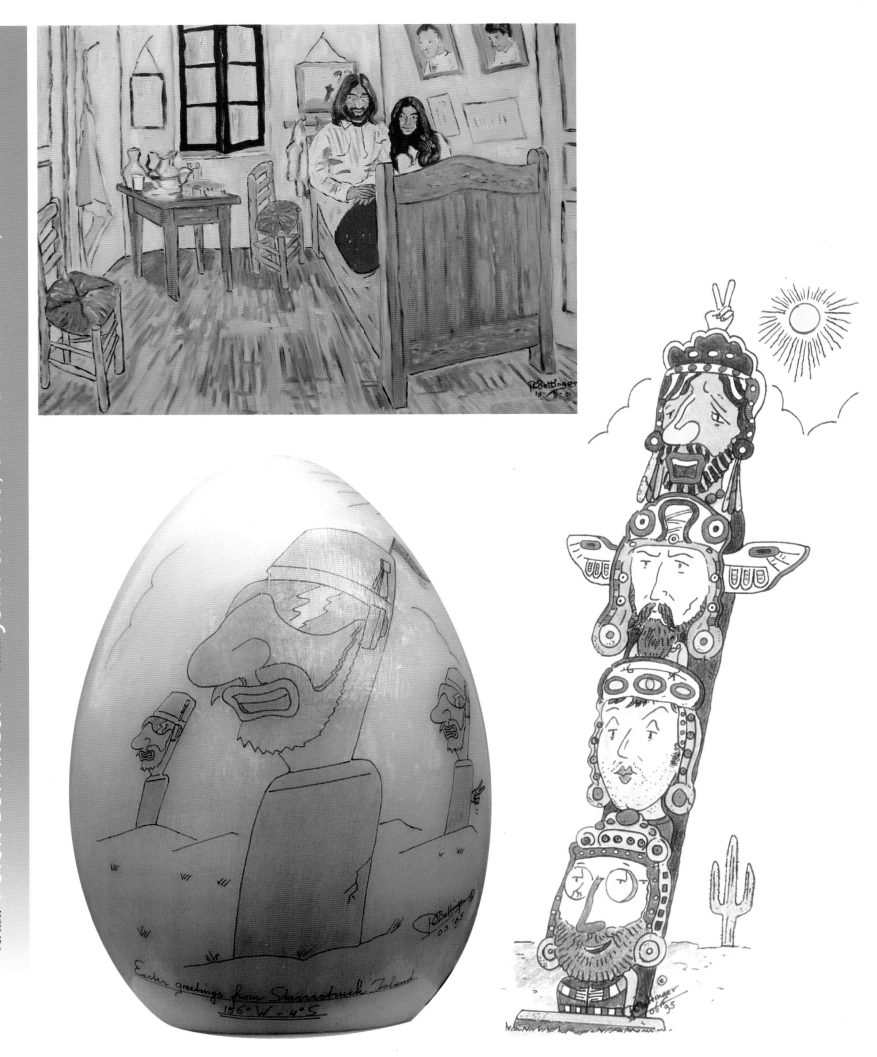

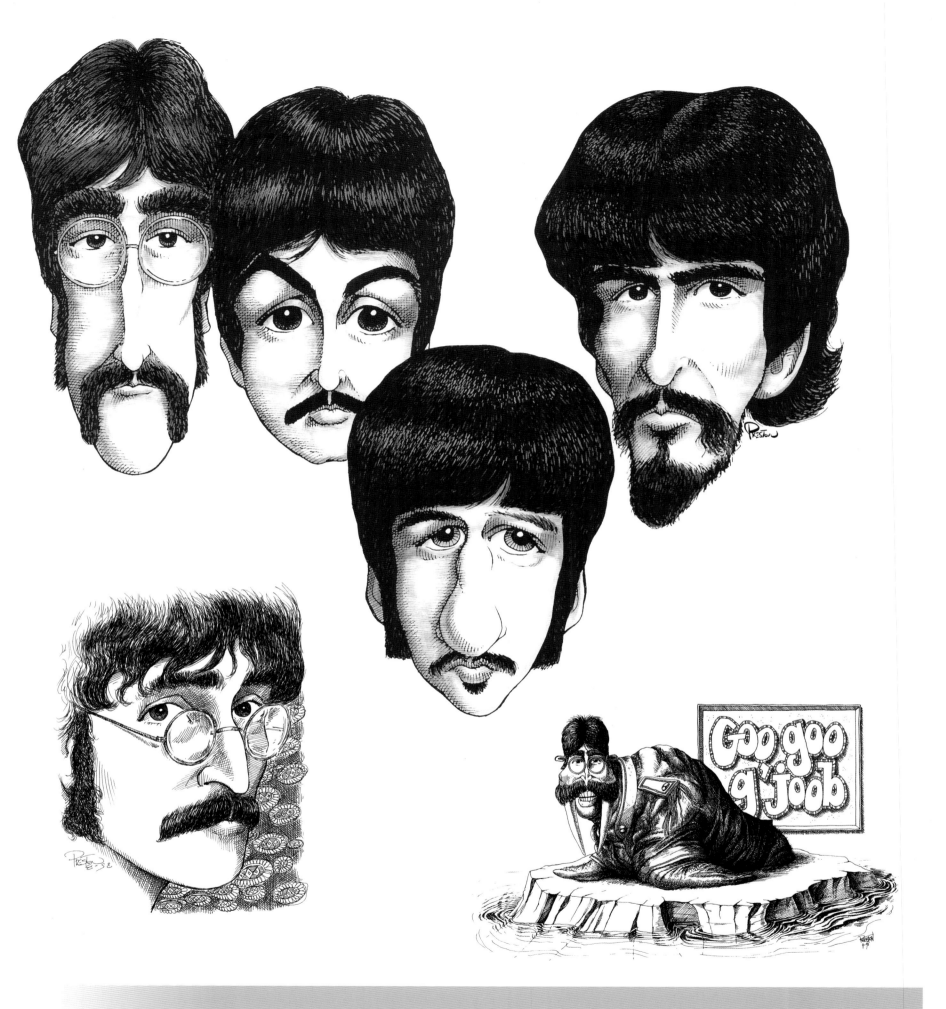

*Artist:* DENNIS PRESTON     *Title:* BEATLES, JOHN, GOO GOO G'JOOB

*Artist:* Alan Peeler    *Title:* Dakota Building

Alan Peeler 1995

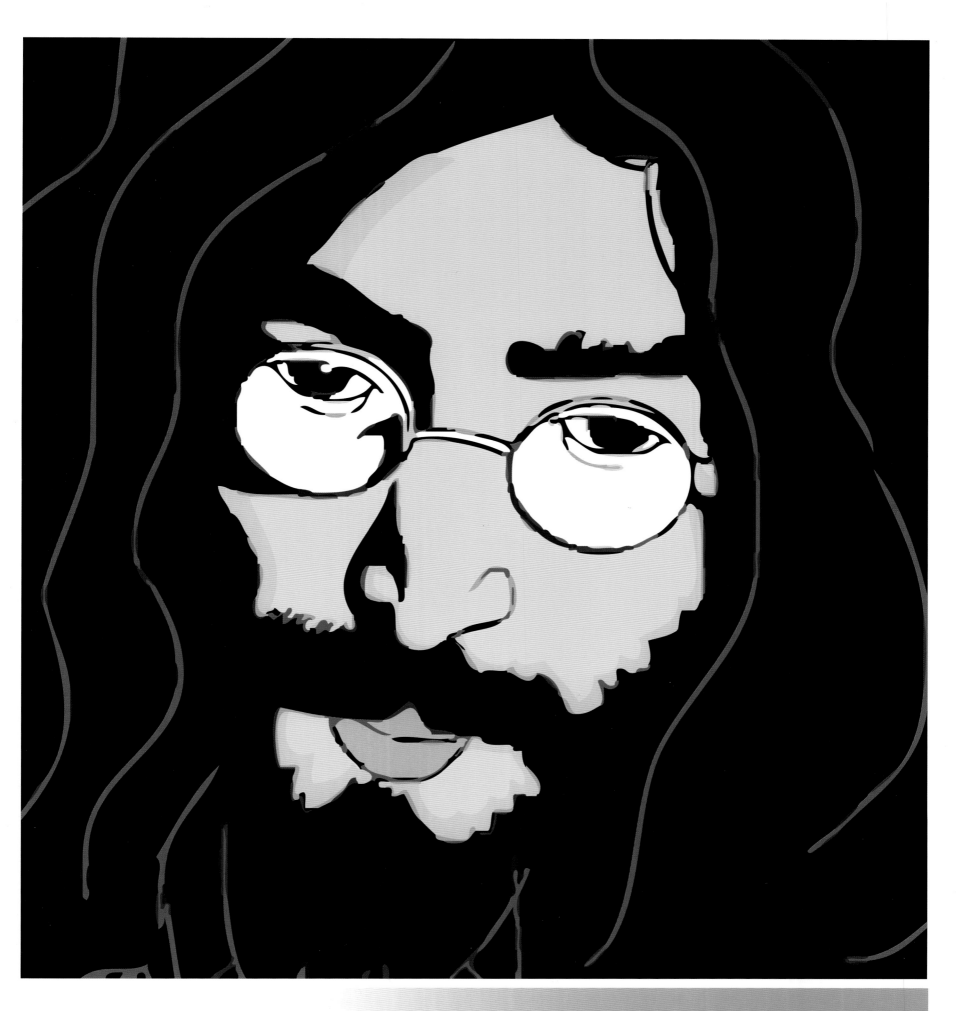

Artist: TOM TRAGER Title: LENNON LEGEND

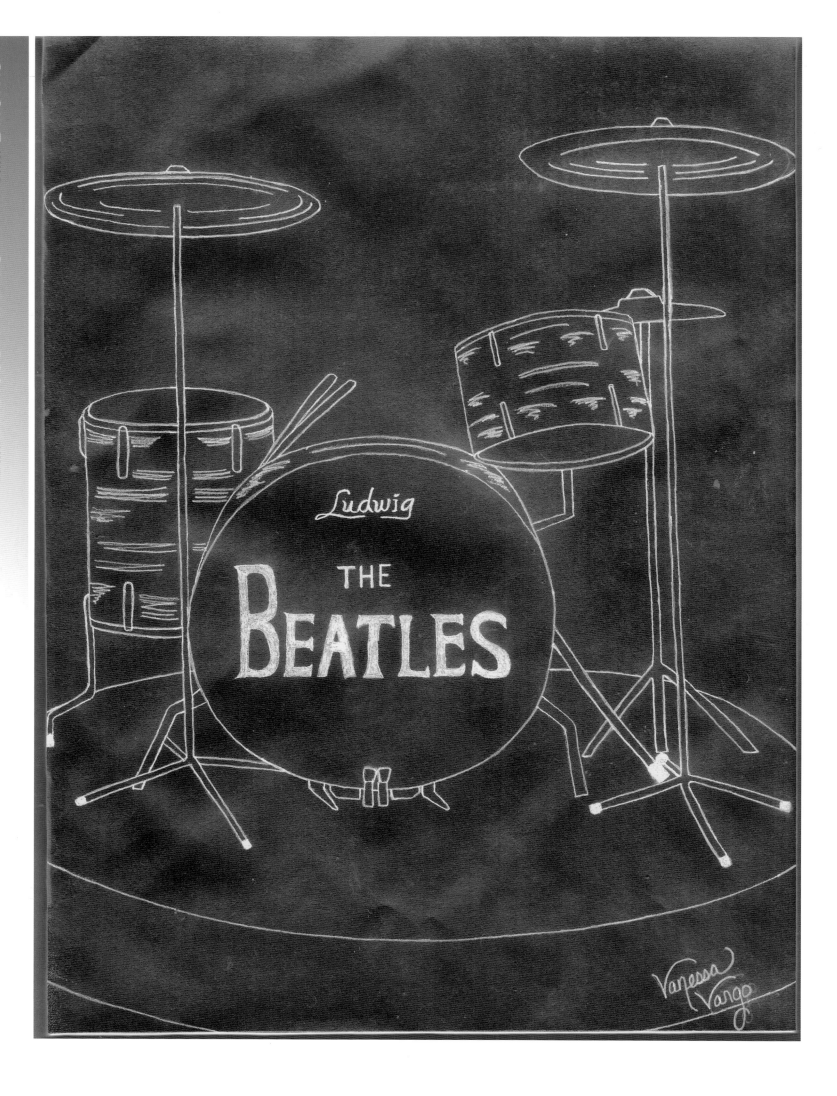

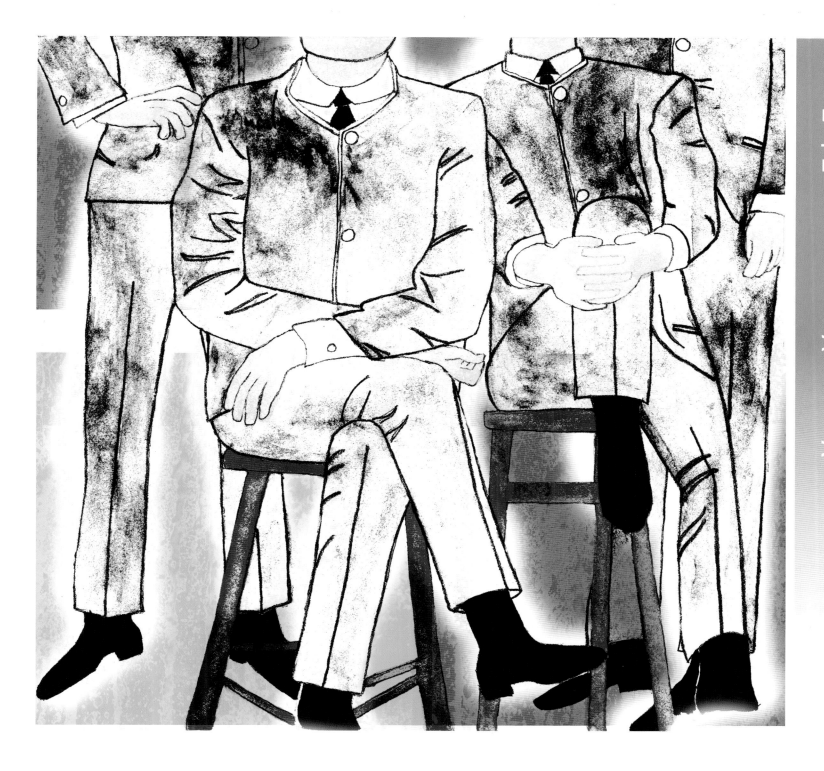

Artist: VANESSA VARGO

Title: FAB FOUR

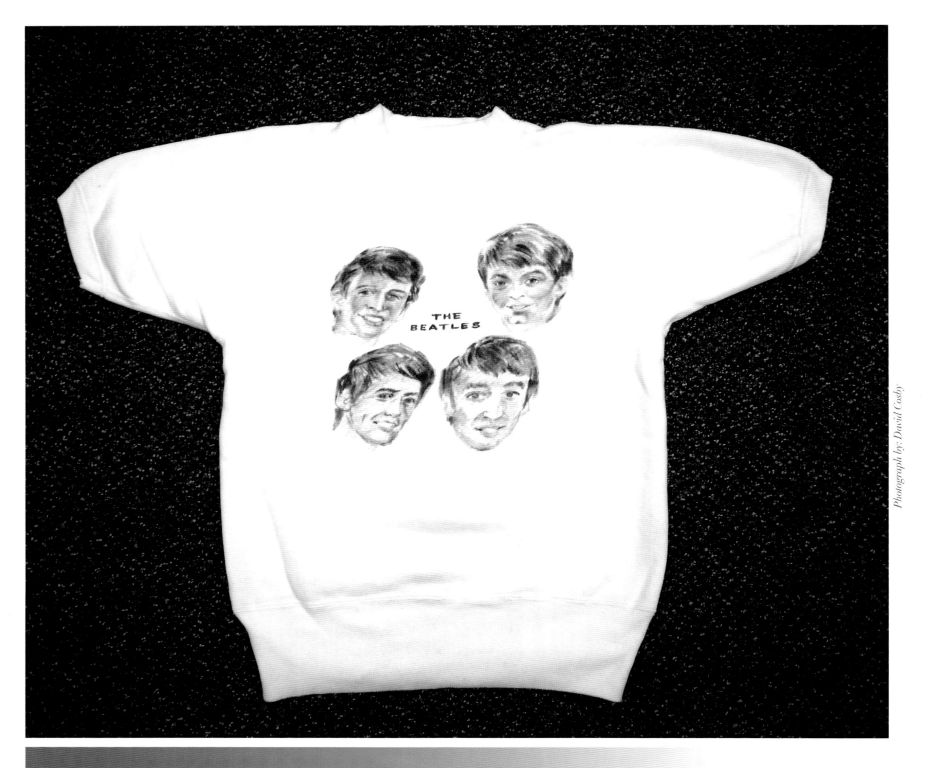

*Photograph by: David Cosby*

*Artist:* Marjorie Rodgers　　　*Title:* Beatles Sweatshirt

"In August of 1965, my two girlfriends and I went to the Hollywood Bowl to see The Beatles! We wore our grade school uniforms. Our seats were in the very back, and all we could see on stage were little figures. It was wonderful! We were swept up in the frenzy of the evening.

"So you can imagine that for months afterward I talked, breathed, and daydreamed of nothing else but The Beatles.

"In February of 1966 for my 14th birthday, my aunt, Marjorie Rodgers, gave me a sweatshirt with the portraits of each of The Beatles that she had designed and painted. I had a wild idea that I would get it signed by all of them!

"Life changed, I started high school, and many years later I am still treasuring that sweatshirt and would like to acknowledge my aunt who painted what is now a remembrance of youth and happy memories for me.

"Now when I look at the sweatshirt a flood of memories comes back. I can feel the passion and adoration, the sheer joy of belonging to a time when you innocently threw yourself into something without abandon."

Frances Ruiz-Wood

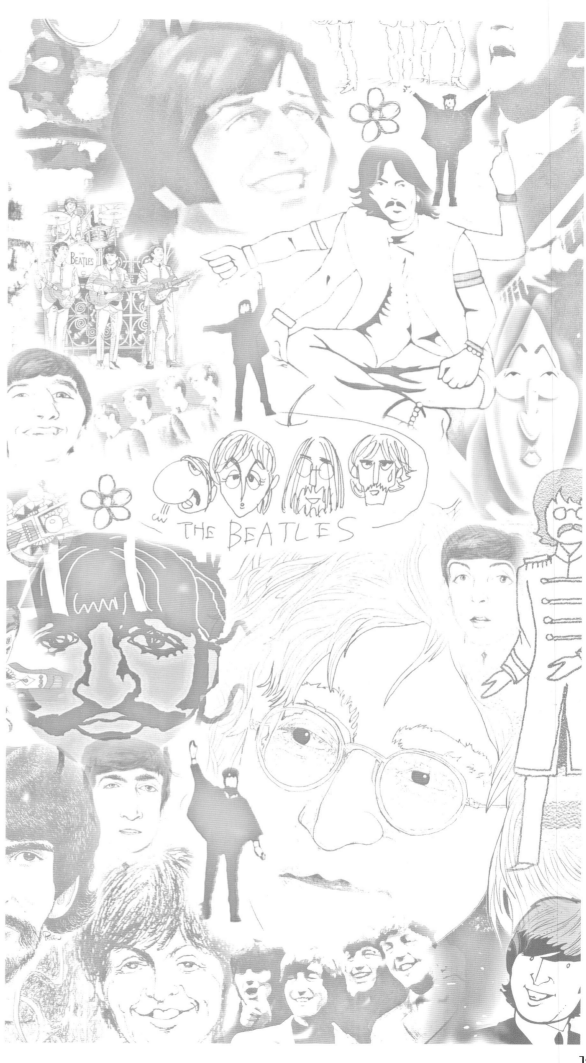

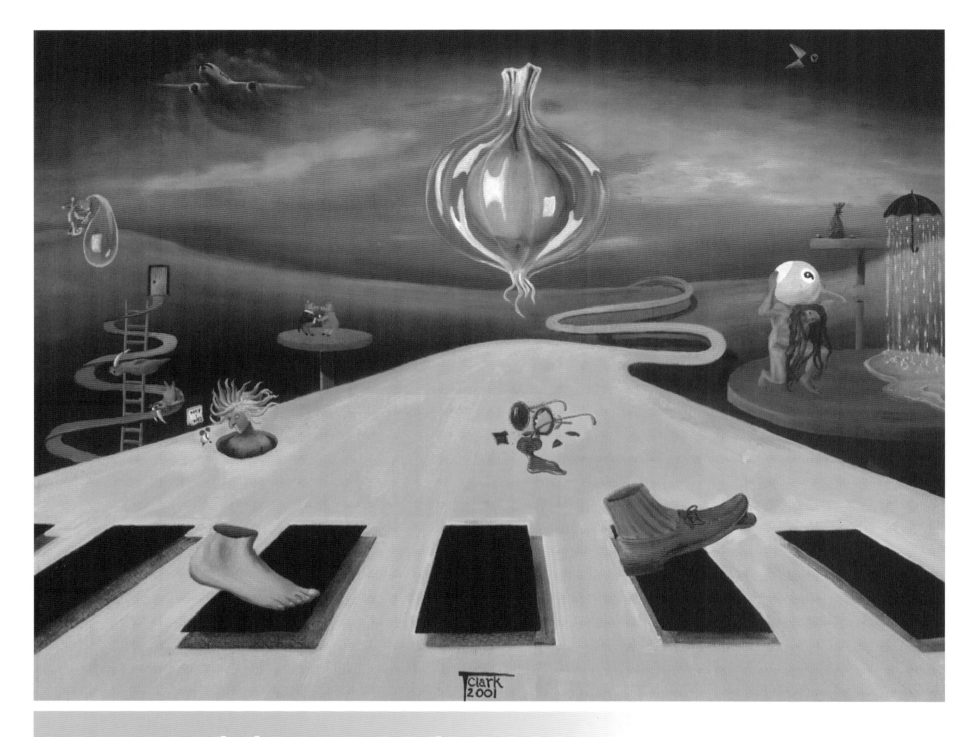

Artist: Trevor Clark  Title: Beatles Juiced

ALL THATS LEFT ARE THE SONGS

JOHN LENNON SONGS

thankyou - thankyou...

I LOVE YOU

2/26/94

Artist: KAReN (Gilly) LaNeY    Title: JoHN LeNNON DOODLe Day

Artist: Michael Cellan    Title: The First Time

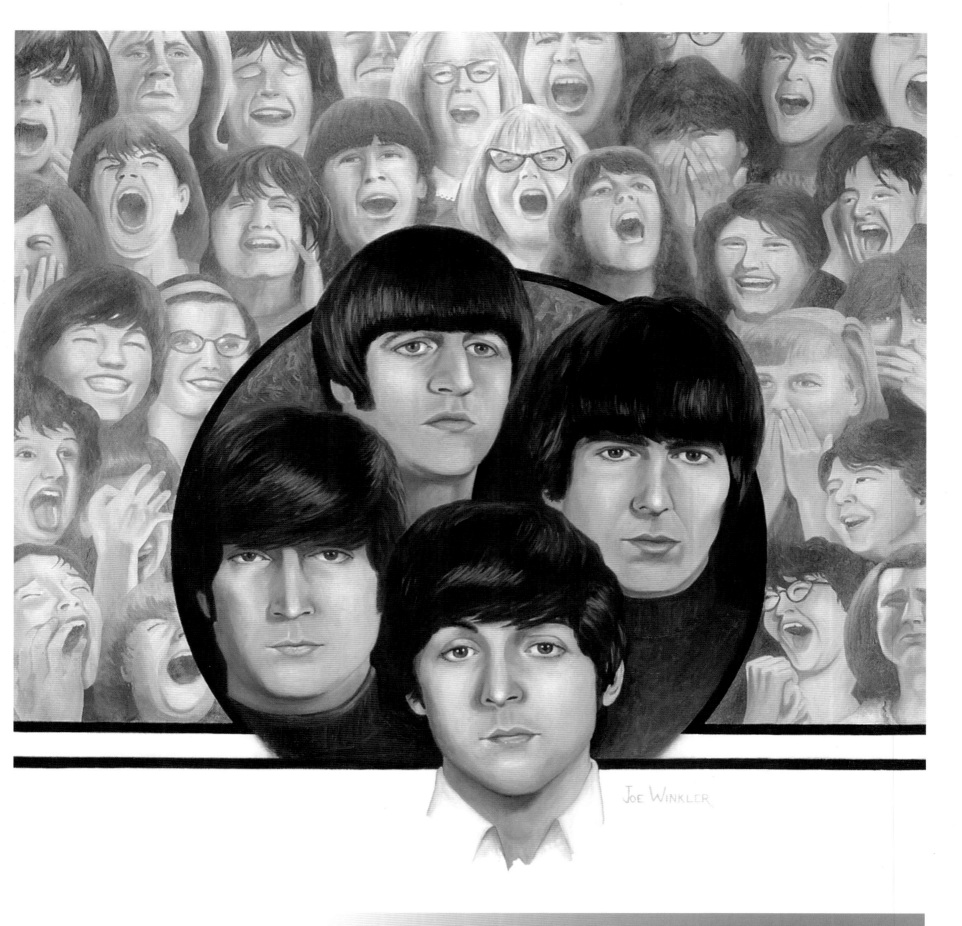

*Artist:* Joe Winkler     *Title:* MANIA

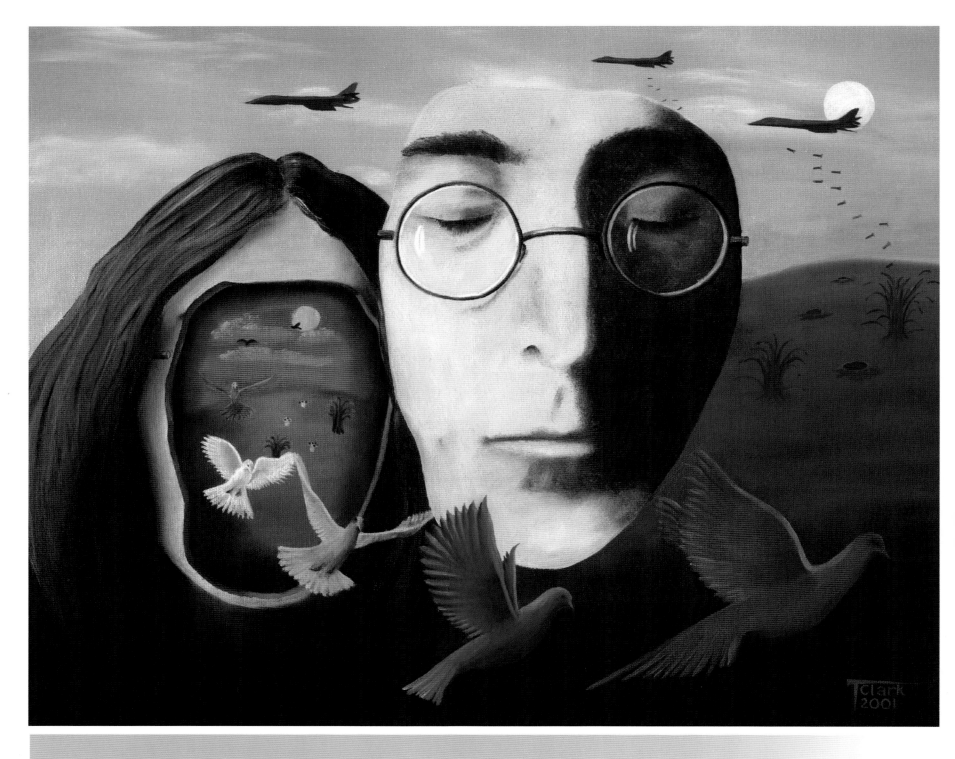

*Artist:* TREVOR CLARK  *Title:* NOTHING'S GONNA CHANGE MY WORLD

"Being born just a little too late to enjoy The Beatles' music properly the first time around, I only truly found them soon after their split in 1970. For this reason, my appreciation of their music started at 'Let It Be', and worked its way backward until it found its favored starting point at 'Revolver'.

"Near the end of this journey, I came across the backward playing tapes of guitar music in 'Tomorrow Never Knows', which spun me back around toward the beginning—end—of The Beatles as I know and love them. Since this time, my enjoyment of their music seems to be playing on one of John Lennon/George Martin's now famous endless tape loops. It plays constantly and mercilessly in both directions, but somehow manages to sometimes take the scenic route, passing by a previously unseen aspect to the overall picture, giving an occasional glimpse of something special, like the Mona Lisa casting you a playful wink.

"Much of the music of The Beatles is the best music I have ever heard, but always it is the best music I have ever 'seen'. I don't believe that it is possible to listen to a track like 'A Day in the Life' or 'Lucy in the Sky With Diamonds' without one's mind taking itself off to the cinema to view the movie that is involuntarily projected onto one's brain.

"The Beatles, for me, somehow managed to merge musical mastery with a lyrically driven visual art that had not been seen before their arrival. It is simply impossible to listen to the music from The Beatles in their later years and not be inspired at least in the smallest way. There is no more powerful visual image than the one seen from the corner of your mind. Those are the images that haunt you forever and make you wonder if you ever really saw it at all.

"Inspiration is a cannibal: It feeds off its own kind. Artists of all media have always drawn inspiration from other artists. It makes no difference if they are good or poor artists; they are all of a similar bent. As The Beatles borrowed little bits of rock and roll, blues, and R&B, and then mashed them all together, it would naturally follow that others would draw blood from the spiritual vein of the Beatles. Fortunately, most artists recognize that inspiration is a gift rather than a commodity, and share it freely. The Beatles, more than anyone else gave a lot more than they got back!

"Being a Beatles fan is somewhat like being perpetually pregnant, but without the desire to eat a soap and banana pizza. You are always expecting something new to emerge, even after all these years. You can look back in time and remember the event that started the pregnancy, and it was good. It was fantastic—the best Beatlemania we ever had! However, further on down the line, we have lived with the pregnancy for a while now. In fact, it went past term in 1970, but is somehow not yet over. The embryo that began life over 40 years ago has still not fully matured. It still keeps surprising us with new developments. We long one day to hold the baby in our arms and congratulate ourselves on a job well done, but the little bugger still keeps us hanging on with new revelations!

"Q. What the hell is a semolina pilchard?
"A. It doesn't matter!

"As a surrealist, the ridiculous is sublime inspiration. I bask in the camel custard that was the randomly barbed tooth of John Lennon. The walrus was Paul? The way that John played with the British press and anyone else that would try to figure him out was the sweetest music of all. Personally, I don't paint icons, I don't paint portraits, and I don't paint fan-tasies. I do my best to paint mind games of some sort, the kind of thing that keeps the viewer guessing. Thanks for the tip, John. I will keep it in my aardvark purse."

Trevor Clark

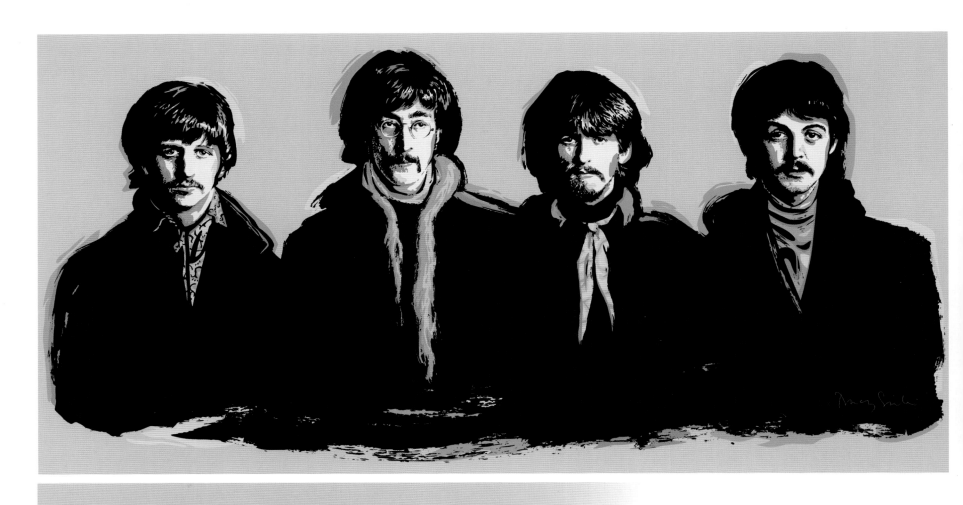

*Artist:* TRACY SABIN  *Title:* Beatles

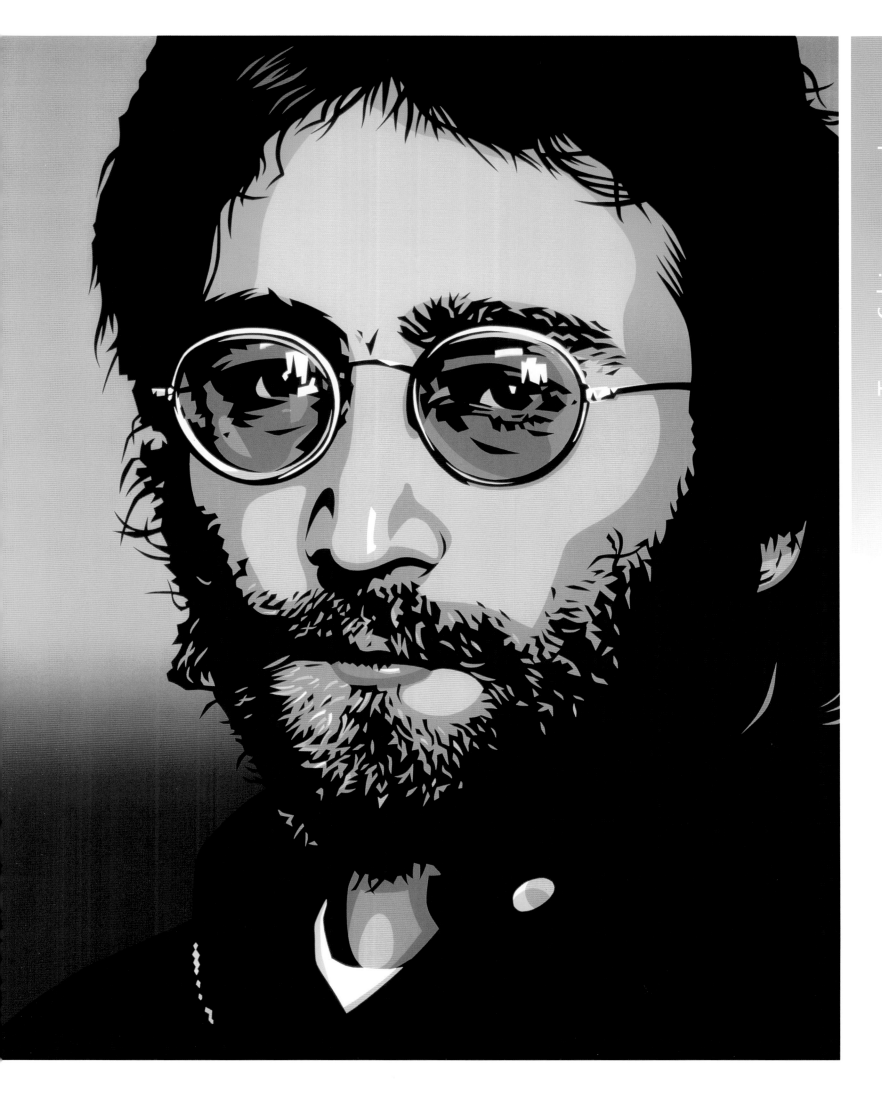

Artist: TRACY SABIN    Title: LENNON

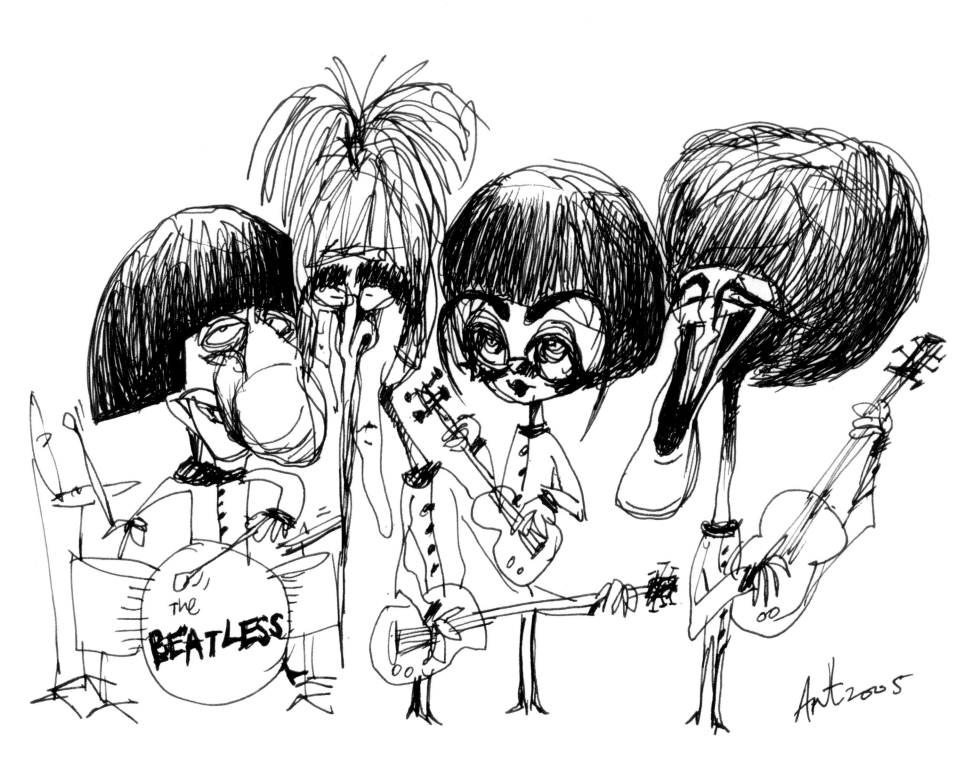

Artist: Anthony Garner    Title: Beat

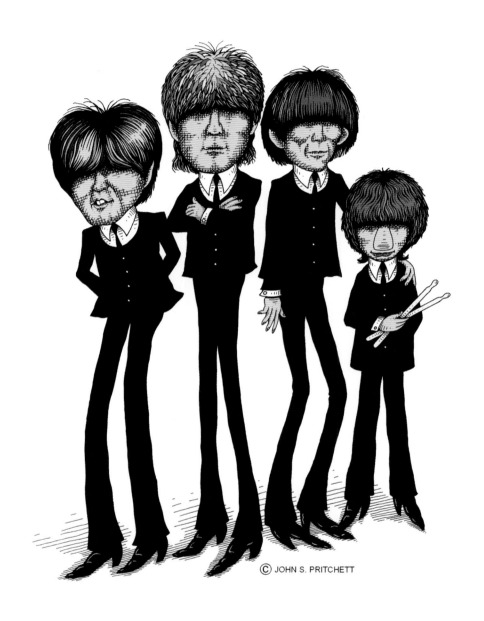

© JOHN S. PRITCHETT

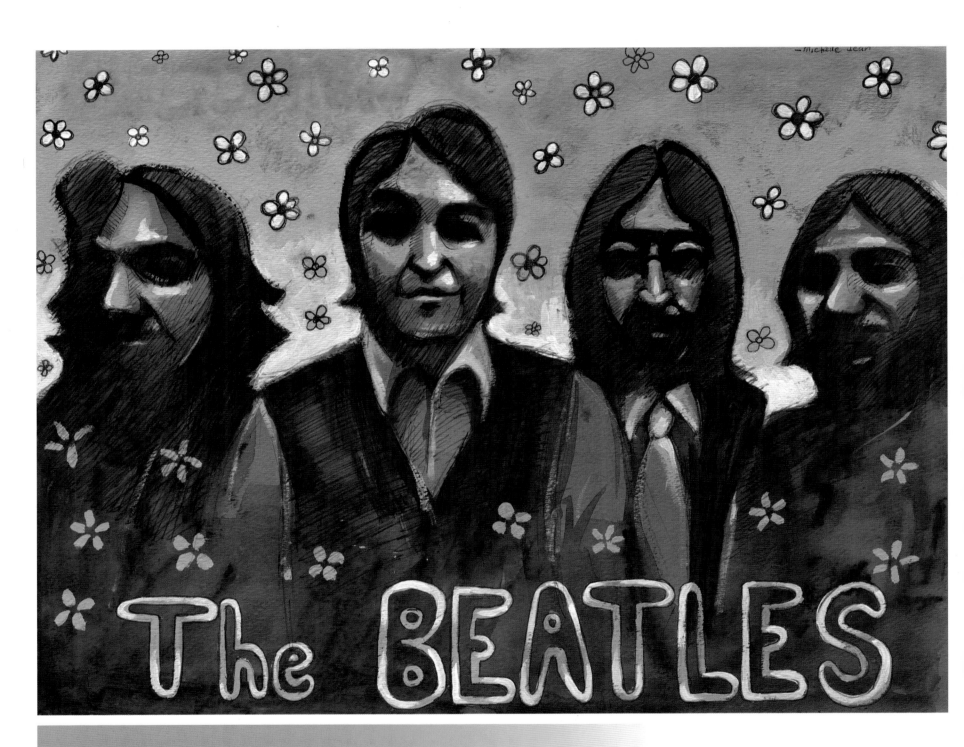

Artist: Michelle Jean    Title: Guess Who?

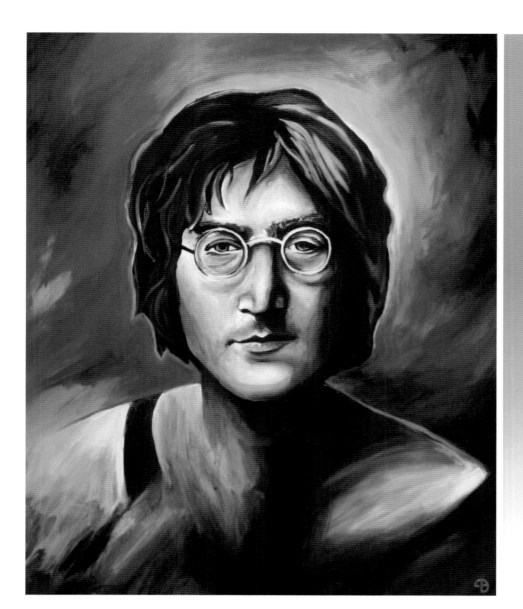

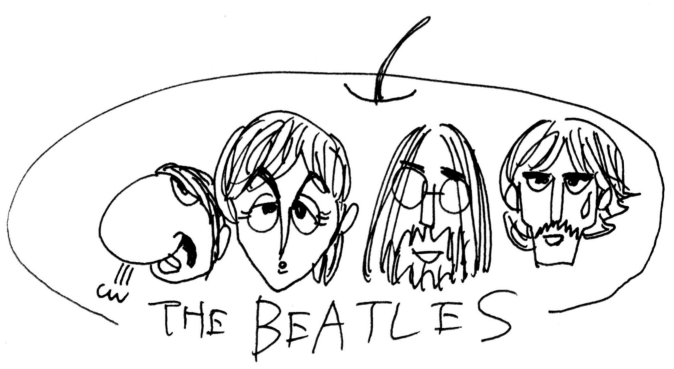

*Artist:* KATSUYUKI KIMURA      *Title:* DOODLE

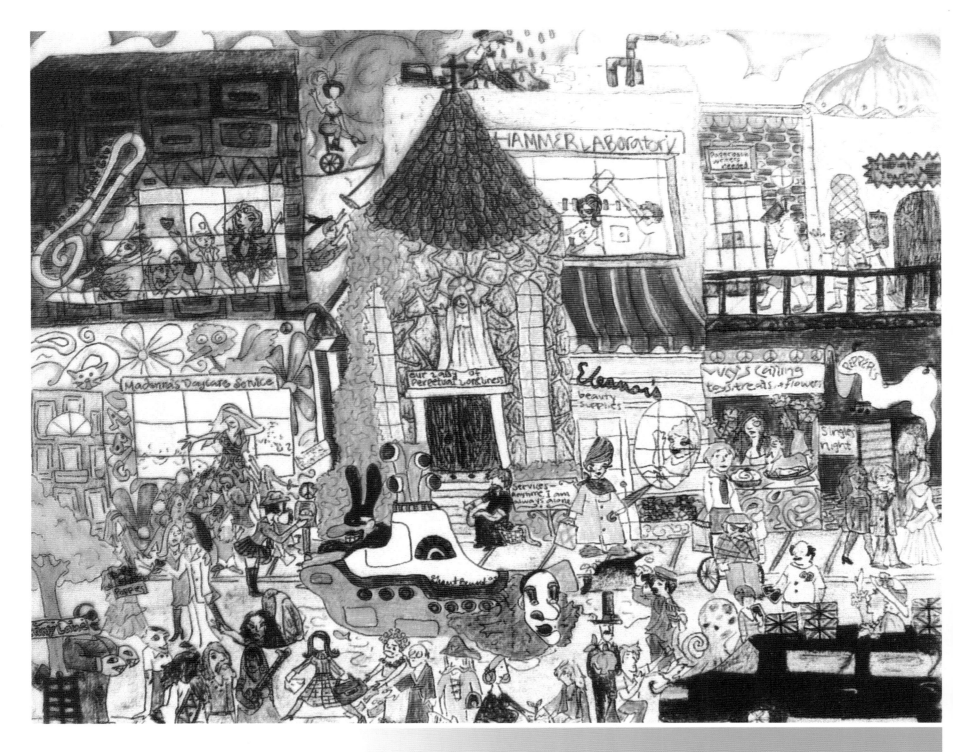

Artist: GRANT BENOIT

Title: PENNY LANE

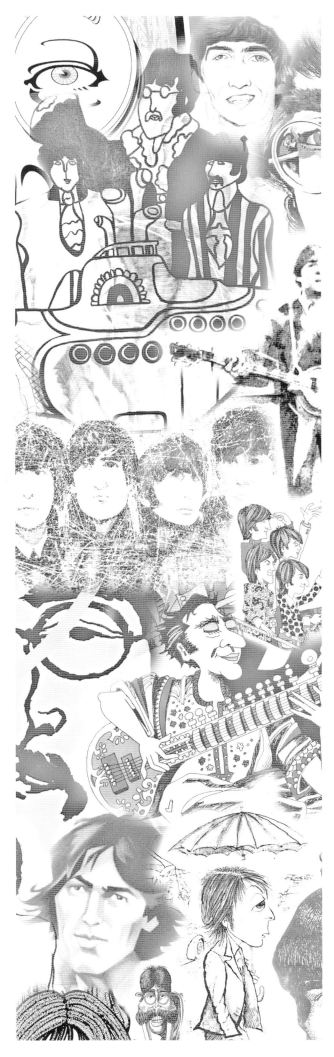

"IN PENNY LANE THERE IS A PLACE... IN PENNY LANE THERE IS A PLACE FOR MOST OF THE BEATLES CHARACTERS FROM THEIR SONGS! STARTING FROM THE LEFT THERE IS MADONNA'S DAY CARE SERVICE ('LADY MADONNA') AND ABOVE THAT WE HAVE THE SILVER SPOON NIGHTCLUB ('SHE CAME IN THROUGH THE BATHROOM WINDOW'). JOHN LENNON AND HIS FIRST WIFE, CYNTHIA, BUY POPPIES FROM PENNY ('PENNY LANE'), WHILE YOKO ONO TRIES TO 'SNARE' JOHN. A TANGERINE TREE ('LUCY IN THE SKY WITH DIAMONDS') BEARS THE STREET PLATE. GEORGE HARRISON STROLLS WITH AN INDIAN GURU. RITA THE METER MAID CHECKS THE METER ('LOVE RITA') WHERE THE YELLOW SUBMARINE IS PARKED ('YELLOW SUBMARINE'). SHE IS LATE FOR AN APPOINTMENT SHE MADE ('SHE'S LEAVING HOME').

"A FIREMAN HAS A CLEAN MACHINE AND A PORTRAIT OF THE QUEEN ('PENNY LANE'). MR. KITE'S BENEFIT IS SURE TO BE A SMASH ('BEING FOR THE BENEFIT OF MR. KITE'). FATHER MACKENZIE SITS DARNING HIS SOCKS IN FRONT OF 'OUR LADY OF PERPETUAL LONELINESS' ('ELEANOR RIGBY'). MICHELLE ('MICHELLE') IS LOOKING QUITE LOVELY AFTER A VISIT AT ELEANOR'S BEAUTY PARLOR ('ELEANOR RIGBY'). HE FIXES A HOLE WHERE THE RAIN COMES IN ('FIXING A HOLE') TO KEEP THE HAMMER LABORATORIES EMPLOYEES' ('MAXWELL'S SILVER HAMMER') MINDS FROM WANDERING.

"NORWEGIAN WOOD IS FAR BETTER THAN BRITISH WOOD WHEN IT COMES TO ATTRACTING A 'FRIEND' ('NORWEGIAN WOOD'). WORKING UP A PROPOSAL TO THE QUEEN TAKES A BELLY FULL OF WINE—JUST ASK HIM ('HER MAJESTY'). RINGO AND HIS FRIEND FROM THE SEA TAKE A STROLL ('OCTOPUS'S GARDEN'). POLYTHENE PAM ('POLYTHENE PAM') BRINGS MEAN MR. MUSTARD ('MEAN MR. MUSTARD') TO SEE THE QUEEN—YOU KNOW HE WILL SHOUT SOMETHING OBSCENE!

"THERE IS A BARBER SHOWING PHOTOGRAPHS ('PENNY LANE'). LUCY'S CALLING SELLS ALL KINDS OF TREATS: MARSHMALLOW PIES, CELLOPHANE FLOWERS IN YELLOW AND GREEN, AND ROCKING HORSE PEOPLE ('LUCY IN THE SKY WITH DIAMONDS'). PAUL MCCARTNEY TRIES OUT SINGLES NIGHT AT PEPPER'S KARAOKE BAR ('SGT. PEPPER'S LONELY HEARTS CLUB BAND'). A PAPERBACK WRITER WRITES A STORY ABOUT A DIRTY MAN AND HIS CLEANING WIFE THAT DOES NOT UNDERSTAND ('PAPERBACK WRITER') AND WHILE PAPERBACKS DO NOT SEEM TO BE ALL THE RAGE, NEXT DOOR INDIAN THERAPY IS. AND, WAIT, HERE COMES THE SUN ('HERE COMES THE SUN')!"

GRANT BENOIT

# Index of Artists

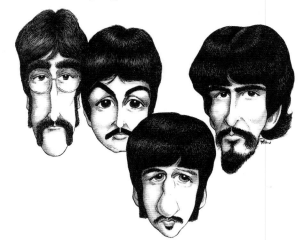

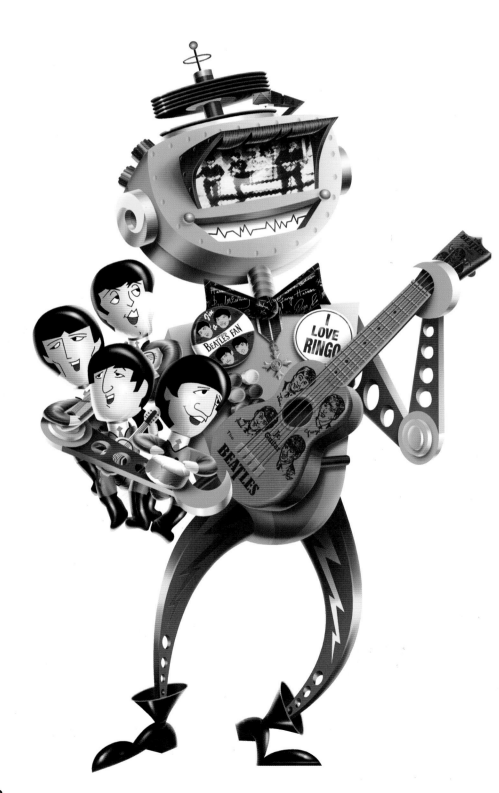

# Index of Artists (continued)